The Declaration in Script and Print

FIGURE 1 *Centennial Memorial of American Independence.* Philadelphia:
Joseph Leeds, 1873 (no. 79). Print Collection, New York Public Library.
Astor, Lenox, Tilden Foundations.

The Declaration in Script and Print

A Visual History of
America's Founding Document

JOHN BIDWELL

The Pennsylvania State University Press
University Park, Pennsylvania

This publication is supported by contributions of David J. Supino and a grant from the American Historical Print Collectors Society through the Wendy Shadwell and Ewell L. Newman Funds.

Library of Congress Cataloging-in-Publication Data

Names: Bidwell, John, 1949– author.

Title: The Declaration in script and print : a visual history of America's founding document / John Bidwell.

Other titles: Visual history of America's founding document | Penn State series in the history of the book.

Description: University Park, Pennsylvania : The Pennsylvania State University Press, [2024] | Series: The Penn State series in the history of the book | Includes bibliographical references and index.

Summary: "Examines the publishing history of United States Declaration of Independence prints and broadsides, illustrating a growing appreciation of its symbolic significance and an increasing desire to view it in reliable reproductions"—Provided by publisher.

Identifiers: LCCN 2024008488 | ISBN 9780271097305 (paperback)

Subjects: LCSH: United States. Declaration of Independence. | United States. Declaration of Independence—Bibliography. | Printing—United States—History—19th century. | Broadsides—United States—19th century—Bibliography. | Prints—United States—19th century—Bibliography. | LCGFT: Bibliographies.

Classification: LCC E221 .B59 2024 | DDC 973 .3/13—dc23/eng/20240304

LC record available at https://lccn.loc.gov /2024008488

Published by The Pennsylvania State University Press,

University Park, PA 16802–1003

10 9 8 7 6 5 4 3 2 1

The Pennsylvania State University Press is a member of the Association of University Presses.

It is the policy of The Pennsylvania State University Press to use acid-free paper. Publications on uncoated stock satisfy the minimum requirements of American National Standard for Information Sciences— Permanence of Paper for Printed Library Material, ANSI Z39.48–1992.

CONTENTS

ILLUSTRATIONS

ACKNOWLEDGMENTS

Declaration prints and broadsides are the basis of this book. When I started on it in 2019, I realized that I would need to survey the holdings of four major institutional collections: the American Antiquarian Society (AAS), the Massachusetts Historical Society (MHS), the Library of Congress, and the Albert and Shirley Small Special Collections Library at the University of Virginia. AAS stands at the head of this list because it gave me the initial impetus and supported my work every step of the way. The AAS invited me to lecture on this topic in 1988 and published my remarks in the *Proceedings*. In 2021 it awarded me a Reese Fellowship, an opportunity to begin again on a checklist of Declarations, trace changes in iconography, and weigh the cultural implications. By the time I was done I had tripled the size of the checklist. Many staff members contributed advice and assistance, among them Scott E. Casper, Vincent L. Golden, Lauren B. Hewes, Amy Tims, Kimberly Toney, Laura Wasowicz, Kevin A. Wisniewski, and Nan Wolverton.

The Library of Congress collection complements the AAS holdings and includes items I have not located elsewhere. The Prints and Photographs Division has made high-resolution digital images freely available online, an invaluable service to those who want to read the small-print particulars. Sara Duke, Barbara Orbach Natanson, Michael North, Edith A. Sandler, and Lara Szypszak expedited my research during several trips to Washington. I am also grateful for the good offices of Terry Belanger and David L. Vander Meulen while I was working in the University of Virginia Special Collections Library, well equipped and aptly situated to be a center of Declaration studies.

Another important destination is the Massachusetts Historical Society, repository of the Adams Family Papers, documents essential for understanding how publishers vied for government backing and political prestige. No attempt to describe their dealings could be complete without access to John Adams's correspondence and John Quincy Adams's diary, now available online. I learned to use those sources while on a Malcolm and Mildred Freiberg Fellowship at MHS, which also offers an excellent collection of Declarations. I am greatly indebted to Peter Drummey and Kanisorn Wongsrichanalai for help with the fellowship logistics and background information about the Adams family.

Access to institutional collections was complicated by the pandemic. Nonetheless, the collection supervisors accommodated my appointment requests and welcomed me to recently reopened reading rooms. If a visit was not possible, they provided descriptions and photographs. For courtesies and contributions of all kinds, I should thank John A. Buchtel, Kevin Cason, Karie Diethorn, Farar Elliott, Paul Erickson, Margaret Glover, Lisa Kathleen Graddy, James N. Green, David Haberstich, Russell Hill, Zach Kautzman, Dong Eun Kim, John Lancaster, David A. Langbart, Robinson McClellan, Eric Motley, Jeff Neale, Erika Piola, Barbara Rathburn, Josette Schluter, Patricia R. Smith, Sandra Trenholm, Kyle R. Triplett, Mary Warnement, Sarah J. Weatherwax, and David R. Whitesell. Likewise I should acknowledge those who helped me obtain illustrations and clear the permissions: Terese M. Austin, Netisha Currie, Charles Doran, Nathan Fiske, Kelsie Jankowski, Leslie Matthaei, Jay Moschella, Mary Nelson, Marilyn Palmeri, AnnaLee Pauls, Emily Smith, Eva Soos, and Hoang Tran.

Noteworthy Declarations can also be found in private collections. The collectors Daniel Hamelberg, George E. Norcross III, David M. Rubenstein, Mark D. Tomasko, and Michael Zinman kindly allowed me to have photocopies of their holdings and see choice items in person. Members of the antiquarian book trade referred me to collectors, reported on past transactions, and alerted me to upcoming sales. Two booksellers in this list have crossed over to the curatorial side, but I owe them a word of thanks as well: Mazy Boroujerdi, John J. Garcia, Kurt Gippert, Donald A. Heald, Spencer Hunt, Seth Kaller, Selby Kiffer, Bella McKelvey, Bruce McKittrick, Alex Obercian, Tam O'Neill, Christina Papadopoulou, Gilman Parsons, Kurt A. Sanftleben, and Darren Winston.

During the writing process I revised several chapters in the light of comments and suggestions I received from Joseph J. Felcone, David J. Gary, Andrea L. Immel, Rick Stattler, and Ted Widmer. The graphic arts experts Amy Lubick, Julie L. Mellby, and Andrew Raftery prompted me to reconsider my account of printmaking techniques. The readers enlisted by the Penn State University Press deserve credit for substantial improvements. I should also recognize the editorial insights of Molly Hardy, David L. Vander Meulen, and Michael Winship, whose advice on other Declaration projects I have taken to heart and applied to this one.

Contributions of David J. Supino and a publication grant from the American Historical Print Collectors Society helped to underwrite the production costs. A travel grant from the American Philosophical Society made it possible for me to study its Declaration holdings and its archival records of early acquisitions.

To complete my account of debts incurred, I should reckon those due to the Penn State University Press. The director, Patrick Alexander, and the series editor, James L. W. West III, encouraged me to persevere with the writing of this

book and the compilation of the checklist. Their colleagues Brian Beer, Maddie Caso, Jennifer Norton, and Alex Ramos oversaw the preparation and production of this volume, including full-page illustrations large enough to show the quality of the facsimiles and the intricacy of the artwork. My thanks to all parties concerned with *The Declaration in Script and Print* for making the most of its pictorial content and supporting my attempts to describe the business basis of printmaking ventures.

FIGURE 2 *Declaration of Independence. In Congress, July 4th, 1776.*
The Unanimous Declaration of the Thirteen United States of America.
Baltimore: Printers' Car, 1828 (no. 21). Courtesy, American Antiquarian
Society.

A Moving Document

The Declaration of Independence is the founding document of the United States. Americans have learned to cherish it and read it in different ways, depending on their political principles, their interpretation of the past, and their aspirations for the future. It is the birthright of the nation, a political testament, a social compact signed by patriots who justified a revolution. They stated their reasons in writing, in an engrossed parchment expressing their commitment and convictions. They also announced their decision in printed form, the epochal broadside dated July 4, 1776. The drama of that moment captured the public imagination, which is why we celebrate independence on the Fourth. During the nineteenth century, the national holiday could be a spectacle far more impressive than the customary concert in the bandstand, speeches in the afternoon, and fireworks at night. If the timing was right, it could galvanize an entire city and fill the streets with devotees of this iconic text.

More than fifty thousand people turned out for the Grand Civic Procession in Baltimore on July 4, 1828. The parade organizers had chosen that auspicious day for the groundbreaking ceremony of the Baltimore & Ohio Railroad. The procession would lead to a field on the western edge of the city, where the venerable Charles Carroll, the last surviving Signer of the Declaration, would lay the First Stone of the Great Road (fig. 3). Then nearly ninety-two years of age, Carroll was one of the directors of the newly chartered company, an audacious attempt

FIGURE 3
Asher B. Durand, *Charles Carroll, of Carrollton*. Engraving after a painting by Chester Harding, *The National Portrait Gallery of Distinguished Americans*, 1834. Courtesy of Princeton University Library.

to open a trade route beyond the Alleghenies. The Erie Canal had ensured the prosperity of New York City. Just as the steamboats plied the Hudson River, so would the railway bring to Baltimore a cornucopia of commodities from the hinterland around the Ohio River. Maybe, someday, steam locomotives would expedite commerce between East and West. What better way to implement independence than to plan internal improvements and tap valuable resources for a thriving city and a growing nation?

It was a fine day for a parade. The temperature stayed in the low seventies under a partly cloudy sky. Clustered ten deep in some places, the spectators lined the route from Bond Street in the city center two miles down Baltimore Street and a quarter mile beyond the first turnpike gate to the field near Carroll's upper mills at Gwynn's Falls. Stands were built on vacant lots to accommodate the crowds. Some eager onlookers occupied roofs and windows to get a better view. The proceedings began just before eight in the morning when a detachment of the Baltimore Hussars started the cavalcade, followed by pioneers in straw hats, a troop of masons, the grand marshal, and the guest of honor, Carroll, in a landaulet drawn by four horses. Next in line was a barouche carrying the orator of the day, who would read the Declaration out loud during the inauguration ceremony.

Marylanders from all walks of life had a place in the procession. Twenty-four farmers on horseback led the way, one for each state in the union, accompanied by a seedsman dressed in homespun who sowed handfuls of grain along the line of march. Carpenters built for the occasion a Doric temple mounted on a wagon drawn by four white horses. Each profession displayed symbolic attributes. Tanners wore leather sashes, gardeners sported sprays of flowers, victuallers shouldered sharpening steels, and shipwrights launched a model sixty-four-gun frigate, fifteen feet stem to stern. By all accounts, the main attraction of the day was the ship *Union*, an even larger model, measuring twenty-seven feet long, sails set and fully rigged, bound on an overland voyage of discovery from Baltimore to Ohio. Her crew sang a rousing chorus in praise of Carroll and the railroad to the tune of "Hail to the Chief."

The *Union* was not the only spectacle on wheels. Farmers harvested wheat and rye on a flatbed truck, dairymen milked a cow, turners worked a lathe, a master painter daubed a portrait, and blacksmiths tended a furnace on a parade car escorted by the sons of Vulcan wearing aprons emblazoned with the hammer and

anvil. Artisans prepared gifts for Carroll while performing on these rolling stages. Hatters demonstrated each stage of manufacture as they fashioned a beaver hat for the Signer. Cordwainers produced en route a pair of green morocco slippers. On a stage festooned with fringe and tassels, weavers sat at a loom to make chambray cloth, which they turned over to the tailors, who used it to sew a coat for Carroll. The stonecutters brought him the First Stone, which they had carved out of marble and would convey to the spot where he would mark the beginning of the railroad. Tools in hand, menial laborers and skilled mechanics acted out their pride in their professions and congratulated their civic leaders on this courageous venture.

The Baltimore Typographical Association was the most conspicuous of the trades in the procession. About ninety masters, journeymen, and apprentices marched behind the Printers' Car, a platform sixteen feet long and nine feet wide on wheels concealed behind white cloth festooned with blue muslin. Four stout bays were needed to draw this vehicle, which carried a complete printing shop equipped with two typecases on stands and a Columbian printing press (fig. 4). Paintings of statesmen and military heroes were hung on the front and sides. Also along the sides were railings decorated with oak leaves, flowers, and inscriptions such as *The Art Preservative of All Arts* and *We Appeal to Reason*. A half hogshead of wine masqueraded as a cask of ink, another hogshead purported to be type wash, but their contents were revealed when the chief printer raised a glass of wine to toast the captain of the *Union*.

Invented in 1813, the Columbian press was a patriotic allegory in itself. A cast-iron American eagle counterweight, its talons grasping an olive branch and a cornucopia, helped raise the platen. The eagle took flight when the pressman pulled at the bar. Thus, at each impression, the Black Art took credit for the triumph of Columbia, the peace and prosperity of the nation, and the benefits of independence. The cheeks of the press displayed the caduceus emblem of the winged messenger Mercury, patron deity of the printing profession. Two apprentices in winged helmets and flesh-colored tights played the part of Mercury. Each had his own caduceus, a long pole they wielded like a grabber tool to distribute the products of the press. As the Printers' Car passed down the street, the Mercuries affixed freshly printed broadsides to the tips of the poles and leaned over the railings to extend their offerings to the ladies in the windows and the gentlemen on the sidewalks.

One of the broadsides was the Declaration of Independence (fig. 2). This was not the first or last time that the Declaration was paraded before Americans on the anniversary of its publication. Nor was this the only civic procession to include a horse-drawn printing office with a press in action. In 1788 at least two cities

feted the ratification of the Constitution by putting on parades with a vehicular Federal Printing-Press and, anticipating the *Union*, a metaphorical ship of state. The printers of New York worked off an ode to the Erie Canal during the opening festivities in 1825. Marching orders for the celebrations on July 4, 1811, in Windsor, Vermont, called for the Declaration to be printed on a press in transit, but no copy has been identified, and it is not clear whether the printers rose to the occasion. Members of the Typographical Association in Evansville, Indiana, outfitted a wagon with a gilded printing press for the July 4th holiday in 1860. They produced a broadside Declaration for the bystanders to keep as a memento of the event. To my knowledge only one copy survives (no. 65), a creditable specimen of layout and design, although two of the Signers' names were misspelled and three were listed under the wrong state due to an accident in makeup.

The Baltimore broadside suffered similar typesetting accidents, and it is almost as rare—I have found only two copies—but it is a good starting place for an account of Declaration prints and broadsides. It epitomizes the performative part in the cult of the Signers. It is an excellent example of letterpress typography with stylistic traits that can be traced back to the origins of the genre. Like others of its kind, it imitates design motifs popularized by two of the earliest and most influential prints, a calligraphic rendering issued in 1818 (no. 3) and a pictorial allegory first advertised in 1816 but not completed until 1819 (no. 6). Emulating decorative scripts, the Baltimore compositor set words in italics, italic caps, all caps, small caps, bold caps, a bold Antique typeface, and an open black letter. This typographic medley served a rhetorical purpose, a means to draw the eye and raise the voice. In the same spirit, the broadside designers tried to copy the illustrations and ornaments they had seen in the allegorical engravings. They adapted for relief printing visual conceits originally intended for intaglio technology. For sure they could not aspire to that degree of detail, but they could at least replicate the basic concepts with stock cuts and typefounders' flowers. They too gave the text the embellishments it deserved: an intricate border composed of rosettes, American eagles in corner-piece compartments, and medallion portraits of Washington on the sides. To complement the eagles in the border, they placed another one at the head of the composition, more of an illustration than an ornament, an impressive creature flying through a night sky, clutching arrows and olive branches in its talons, and clenching the E Pluribus Unum motto in its beak. Those stock cuts were readily available at that time. Typefounders charged two dollars for the eagle in the center, fifty cents each for the corner pieces on the top, and seventy-five cents each for the corner pieces at the bottom. The two-dollar block was a favorite in the trade and had already appeared in a Boston edition (no. 19). It would show up again in another Baltimore edition (no. 22), along with other designs derived from

the civic procession broadside. Just as the Printers' Car contingent looked to letterpress and engraved precedents for design ideas, their work would also be influential and take a place in the chain of transmission.

In the following I will cite other examples of derivative Declarations—artistic adaptations like this one as well as facsimiles, reprints, imitations, abridgments, and piracies. I will trace a genealogy of Declarations from the progenitors of the genre in 1816 until the end of the century. Altogether I have identified more than two hundred prints and broadsides, almost all of them members of four main families: straight letterpress reprints, calligraphic versions, allegorical interpretations, and unadorned facsimiles. By 1828 these families were already beginning to intermarry, hence the mixed ancestry of the Baltimore broadside. No doubt I have failed to detect the lineage of some editions. Some are so rare that there must be others that have disappeared entirely. I cannot claim that the appended checklist is comprehensive. Nonetheless I believe that the sample is large enough to delineate the growth of the trade and the part it played in popularizing the Declaration. The checklist explains how the prints created a cultural icon, a belief system epitomized in an image meant to be treasured and revered.

The Declaration became a mass-market commodity during the Industrial Revolution. Stereotyping, steel engraving, lithography, and other technological developments made it possible for publishers to saturate the market with cheap reprint editions. The easier it was to set up new editions, the more often they went back to press. In making my listing, I have had to sort through a multitude of variants in stereotype reprints, reworked engravings, and—to take an extreme example—a lithograph that went through at least eleven commutations and permutations during the Centennial, not counting a number of inserted advertisements. The tools of analytical bibliography have been helpful here, although my listing is by no means a full-dress bibliography. I have tried to record sufficient detail to distinguish editions, issues, and states—evidence useful for identifying the most influential prints and ranking them in order of importance. This systematic approach will, I hope, reveal how Americans visualized the Declaration and kept it in the public eye.

Artists, printers, and publishers succeeded in making money in the Declaration business. They built distribution networks, organized subscription campaigns, and sought opportunities to advertise their wares. Others learned from them and tried their hand with competing ventures, which also turned a profit. Some depended on steel engravings or stereotype plates to replenish their stock of an article always in demand. It could be a steady source of income, a sudden windfall—or the ruination of those who invested in a publication project beyond their means. Expensive publications were exposed to the ups and downs of the

American economy like other luxury goods and capital-intensive products. But many were willing to take the risk even if they had to contend with payment problems, bad debts, poor credit, and other financial tribulations. I have made a special effort to collect biographical information about Declaration publishers, winners as well as losers, but especially the leading members of the trade who first perceived its commercial potential. For many of them, the Declaration was the high point of a graphic arts career worth examining here as context for their design ideas and merchandising techniques. Among other motivations, they conceived and promoted their work with a political agenda, a matter of principle, or a means of advancement. The earliest attempts to extol the document were tinged with party politics. By some accounts, the founding document began to attract public notice during the Era of Good Feelings, when it became a symbol of peace and prosperity. In 1818, however, it came into view mainly because of a newspaper war between John Binns and a rival publisher, who picked a fight over John Adams's role as an advocate of independence.

A firebrand Republican and a sometime enemy of Adams, Binns was the first to sell the Declaration as a work of art. In March 1816 he solicited subscriptions for a large allegorical engraving adorned with patriotic emblems and facsimile signatures of the Founding Fathers (no. 6). He distributed his proposals far and wide, starting with a newspaper he published in Philadelphia and then going on to other periodicals such as *Niles' Weekly Register*, which contained more information about the project. He noted the immense size of the print, described the pictorial content, named the artists involved, predicted a delivery date, and set prices for plain and colored copies. Subscribers were assured that the artwork would reflect credit on native genius and that the accuracy of the text would be certified with "proofs of authenticity." True patriots would want to have it framed and keep it on display for constant contemplation by friends and family. His proposals mark the beginning of the Declaration business. They introduced new ways of depicting the document, broached the subject of its inspirational value, and heralded changes in its meaning during the Civil War and the Centennial.

They directly influenced the management of the Printers' Car in 1828. Those selected to ride on it that day represented different ranks in the hierarchy of the trade: masters, journeymen, and apprentices. One of the masters was Hezekiah Niles, publisher of the *Register* and a staunch supporter of Binns. Besides publishing a full-length version of the proposals, he continued to promote the project during a long and difficult gestation period, an aggravating delay that could antagonize subscribers. In the *Register* for May 22, 1819, Niles told them it was "nearly ready" and predicted that it would be worth the wait: "We have good reason to hope that, whilst it may serve to warm the heart of the patriot, or embellish the

parlours of the opulent, it will also stand as a test of excellence in the various arts at its period, and give to posterity a correct idea of their perfection at this time."

The subscribers had to wait six more months, but the print finally appeared at the end of October 1819. Niles commended it again on that occasion and noted the costs incurred by Binns in case anyone was put off by its ten-dollar purchase price. The editor of the *Register* championed the engraving, which he probably saw in proof as well as its finished state. When it came time to plan for the parade, he knew that the Declaration should take center stage and seized the opportunity to produce a letterpress version of Binns's engraving. Afterward he composed a description of the Printers' Car for a Baltimore newspaper and reprinted his piece in the *Register*. That is another reason why I make an example of the Baltimore parade: here, as elsewhere, biographical information helps explain the publication process.

Historians have noticed a quickening of interest in the Declaration during the years 1816–19 and mention the early engravings as a factor in this change of heart. But they touch on this topic only briefly and rely on a single secondary source that downplays the impact of Binns's publicity campaign. Usually they have other priorities, directing more attention to the text than the document. For them the text is more important because of its exegetical attractions. They have analyzed its authorship, composition, transmission, and reception. Some look at its origins and survey its sources. Others consider the consequences of its different interpretations, its intellectual legacy, and its significance as a statement of human rights and a vindication of popular sovereignty. Modestly, Thomas Jefferson called it "an expression of the American mind," but an entire scholarly industry has been built on its meaning, mystique, and authority. The close reading by Carl Becker and the revisionist treatment by Garry Wills have become classics in their own right, reassessed by other historians who disagreed with their findings but admired their accomplishments. Pauline Maier acknowledged their work in her comprehensive history of the Declaration, tracing its changing reputation from Jefferson to Lincoln with a colorful account of its current status in the National Archives. The labor historian Philip S. Foner edited and introduced a collection of "alternative declarations," adaptations issued by socialists, suffragists, and African Americans who paraphrased the original to assert moral and economic rights grounded on the same basic principles. Looking outward, David Armitage shows how other countries followed the American example in their own foundation documents, sometimes translating their model word for word. The political philosopher Danielle Allen draws on personal experience to probe the arguments of the Signers and question what they meant by equality and

justice. Liberal or conservative, the ideological agendas of these historians have helped kindle debates about the text.

Here, however, my task is to show how Americans learned about the document, how they visualized it, and how they came to treasure it as a relic of the Revolution. I will discuss the political theory and philosophical precepts of the text only inasmuch as they influenced its iconography. More to the point, I will explain how it became an object of veneration in prints and broadsides, in single-sheet formats commensurate with its iconic status. The Binns print was not the only one suitable for framing. The Declaration appeared in other kinds of printed matter—newspapers, books, and pamphlets—but tightly focused in this way, it gained a new graphic function capable of stirring the emotions and reaching hearts and minds.

Along with their inspirational value, many of these prints offered Americans reassuring tokens of accuracy and verisimilitude. Binns promised his subscribers that his transcription of the text would be wholly reliable, "word for word, letter for letter and point for point." Instead of transcribing the fifty-six signatures, his artists would render them in facsimile—that is, they would replicate the original handwriting as faithfully as possible in the engraving medium. He was the first to recognize the importance of the autographs and the first to make them a selling point of a patriotic print (although he was accused, wrongly in my opinion, of plagiarizing another project). Binns warned Americans that the historical record had already been corrupted forty years after the event. In the course of his research, he was appalled to learn that most printings were titled *A Declaration by the Representatives of the United States of America in Congress Assembled*, whereas the original begins *The Unanimous Declaration of the Thirteen United States of America*. Of course, we now know that there are two originals with variant titles and different functions—the John Dunlap broadside printed on July 4, 1776, and the engrossed parchment signed on August 2, 1776—but Binns, like many other Americans, misconstrued the versions in script and print even while he thought he was setting the record straight. His successors were no more successful in their struggle against human error, accidents of history, and the ravages of time. They realized that the engrossed parchment might have been destroyed when British soldiers sacked the Capitol in the War of 1812. They were distressed to see that it was in poor condition and that it was still deteriorating in ways they did not understand. While its words were fading, so were the memories of those who could testify about its origins and meaning. We shall see that Jefferson was responsible for some of the most egregious errors in the depiction of the Declaration. Carroll personified the document in the 1828 parade, but the nonagenarian was not expected to last for long.

The facsimile signatures invoked the living presence of the Founding Fathers. They were a profession of faith, a testament of courage, a roll call of honor. They were the essential ingredient in prints designed to dramatize the moment, although they were often the only part visually related to the original. The designers recast the text in decorative scripts and surrounded it with patriotic imagery such as state seals, historical vignettes, and presidential portraits. Sometimes they rearranged the signatures to fit them in these elaborate allegorical compositions. They did not think that they were distorting the viewing experience but believed they were enhancing it and fulfilling the artistic expectations of their customers. As much as one would expect their work to defeat the function of a facsimile, this style did not go out of fashion until the end of the century. Then, finally, an unadorned facsimile commissioned by John Quincy Adams (no. 11) became the standard visualization of the document and the source of reproductions published by the government, expounded in textbooks, sold as souvenirs, and printed on Independence Day in the *New York Times*.

I have already published an account of the nineteenth-century facsimiles in the *Proceedings of the American Antiquarian Society*, vol. 98 (1988). Based on a lecture I had given at the American Antiquarian Society, this article contains a short narrative introduction, a checklist describing forty-eight typical examples, and five illustrations. The checklist does not claim to be comprehensive, and the commentary acknowledges the limitations of a lecture. Thirty-five years later, I am in a better position to write about the print trade and describe its products with a larger sample in greater detail. I can identify publishers and date their publications by using online resources such as library catalogs, digitized newspapers, and auction house websites. I can compare copies with high-resolution digital photographs, some of which have revealed variants worth noting here as evidence for the publication process. Two important private collections are now easily accessible in institutional libraries. The collector Daniel Hamelberg very kindly answered my questions about his holdings, second only to those of the American Antiquarian Society in size and scope.

Hitherto unrecorded prints have occasionally surfaced in the trade. Antiquarian booksellers and auction house cataloguers sometimes give the sobriquet "not in Bidwell" to newly proffered merchandise I failed to mention in 1988. Perhaps now it will be harder to profit from my mistakes, but the rarity of these prints is indisputable. I tracked down one of the truant editions (no. 40) in Hamelberg's collection after seeing references to it in auction and booksellers' catalogues. It was printed from a stereotype block, which was probably sold to other publishers. I have not yet found other stereotype editions, but I am confident that one or more will emerge in private hands, a library, or a bookseller's catalogue.

As much as I have tried to make amends for my work in 1988, I know that this larger listing must also be incomplete and must be corrected in years to come. Its lapses and elisions will be obvious, but it is still substantive enough to show how Americans commodified the Declaration and turned it into artwork that could be bought and sold.

FIGURE 5 *In Congress, July 4, 1776. A Declaration by the Representatives of the United States of America, in General Congress Assembled.* Philadelphia: John Dunlap, 1776. The Morgan Library & Museum, New York. PML 77518. Purchased as the gift of the Robert Wood Johnson Jr. Charitable Trust, 1982. Photography by Janny Chiu.

The Evolution of the Text

In 1943 Julian Boyd produced the first version of his *Declaration of Independence: The Evolution of the Text*. It accompanied an exhibition of Jefferson manuscripts organized by the Library of Congress to commemorate the two hundredth anniversary of Jefferson's birth. A patriotic effort during the Second World War, the exhibition celebrated the egalitarian democratic principles in that document, a timely message when those ideals were in danger. The Library of Congress did not stint on the production values of this publication, an impressive folio featuring luxurious collotype facsimiles of the manuscripts, all but one reproduced in actual size.

By no coincidence, Boyd was just embarking on his monumental multivolume edition of the *Jefferson Papers*, of which the Declaration document was the most important and most difficult to explain. The Princeton University Press was to publish the Jefferson edition, an attractive proposition likely to enhance the publisher's scholarly prestige. In 1945 it offered an hors d'oeuvre, a smaller version of the Library of Congress folio with a more detailed commentary and a scaled-down set of collotype facsimiles. Then in 1999 the Library of Congress reprinted its 1943 publication with an updated text and color halftone reproductions on coated paper, a distinct improvement over the 1945 collotypes but still inferior to those issued in 1943. Each of these publications has its pluses and minuses. Each says something about the function of facsimiles: a source of inspiration, a means

of historical inquiry, and a tool of textual analysis. Each in its own way is essential for understanding the composition process leading up to the Declaration printed by Dunlap on July 4, 1776 (fig. 5).

The first attempts to trace the composition process were distressing and inconclusive. Even the Journal of Congress got it wrong. Jefferson, John Adams, and other participants misremembered the sequence of events and fell back on suppositions to cover up their confusion. Binns and other Declaration publishers insisted on absolute accuracy, but they too failed to parse the facts and put them in the proper order. Historians did not succeed in sorting out the contradictions until Mellen Chamberlain undertook a comprehensive overview of the problem in 1884. John H. Hazelton accumulated valuable information for a monograph in 1906, a reliable vade mecum to the deliberations of 1776, if marred by overzealous digressions and a disorganized profusion of evidence. Founded on the manuscripts, Boyd's step-by-step exposition of the writing process is the definitive theory of evolution. Although the story has been told many times before, it should be recapitulated here because it bears on the publication of the first facsimiles and explains why they were thought to be necessary. It can be best understood by breaking it down to a series of salient dates between January 1776 and January 1777.

An obvious starting point would be January 9, 1776, the publication date of Thomas Paine's *Common Sense*, the primer of the independence debate. This eighty-four-page, two-shilling tract can be considered the first American bestseller, the first part of which was reprinted at least twenty-one times during 1776. A masterpiece of political rhetoric, it gathered disparate ideas and focused them in a plainspoken attack on an oppressive regime. The Continental Congress had already expressed the colonists' grievances and promulgated a Declaration of the Causes and Necessity for Taking up Arms. Paine argued for more extreme measures and called for a "manifesto to be published" so that the colonies could begin to deal with foreign countries. Some colonies dispatched delegates to the Continental Congress with instructions influenced by those strictures.[1]

In accordance with the Virginia instructions, on June 7, 1776, Richard Henry Lee brought before the Continental Congress the resolution "that these United Colonies are, and of right ought to be, free and independent States, that they are absolved from all allegiance to the British Crown, and that all political connection between them and the State of Great Britain is, and ought to be, totally dissolved." The resolution was seconded by John Adams, but a decision was deferred upon the request of moderates in the Middle Colonies. Later, when Congress revised the Declaration, that text was inserted in the last paragraph even though the general sense and some of the language was in Jefferson's Rough Draft. Not

just a formality, that alteration ensured that the document would be vested with the full weight and authority of parliamentary procedure.[2]

Congress started work on the Declaration despite the delay imposed by the Middle Colonies. On June 11, 1776, it appointed a committee to draft a text explaining its actions and announcing the separation of America and Britain. The Committee of Five, as it is now known, consisted of Thomas Jefferson, John Adams, Benjamin Franklin, Roger Sherman, and Robert R. Livingston. Precisely how it operated is not clear, but by common consent Jefferson was put in charge of composing the core document, which would then be reviewed by other members of the Committee. Jefferson made a fair copy of an earlier manuscript, revised it throughout, and submitted it to Adams and Franklin, who wrote suggestions in the margins. This is what is known as the Rough Draft, although Boyd believed that it would be more accurate to call it the Committee Draft. Jefferson retained it and endorsed it as the "original Rough draught" many years later when he was trying to settle disputes about his authorship. The manuscript is now in the Jefferson Papers at the Library of Congress. As we shall see, it too plays a part in the history of facsimiles.

After conferring with his colleagues, Jefferson probably supplied another fair copy, which does not survive. The Committee of Five presented it to Congress on June 28, 1776, "when it was read, and ordered to lie on the table." This is the solemn moment immortalized in John Trumbull's painting *The Declaration of Independence, July 4, 1776*, a product of painstaking historical research, although Trumbull was wrong about the date.[3]

Congress then resumed the debate on Lee's resolution on July 1, 1776. The delegates resolved themselves into a Committee of the Whole, a parliamentary expedient allowing them to suspend the usual procedural requirements and keep their deliberations off the record. Some delegations were still opposed to the measure; Delaware was divided; New York was willing but had to wait for new instructions. As Jefferson remembered it, they were at it for nine hours, until, exhausted, they agreed to adjourn for the evening and try again in the morning.[4]

The next day, July 2, 1776, Congress again resolved itself into a Committee of the Whole and brought independence to a vote. The New Yorkers still had to abstain, but the other twelve colonies carried the day and approved the Lee resolution. In a legal sense they had now accomplished the task of separating themselves from the mother country. Writing to his wife, a jubilant John Adams predicted that July 2nd would henceforth be celebrated with anniversary festivities such as parades, gun salutes, bonfires, and illuminations. He was correct about the significance of their proceedings but did not anticipate the next step in the

political process, an event better suited for a national holiday, richer in symbolism, and easier to imagine.[5]

After adopting Lee's resolution, the delegates turned to the text submitted by the Committee of Five. They knew what to expect because it had been laid on the table since June 28th. They knew that some parts would be controversial and settled down to a sustained debate, which Jefferson claimed to have continued during a good portion of July 2nd, 3rd, and 4th. Boyd attributed to them thirty-nine alterations in the text. Jefferson was not entirely happy with their emendations, which is one reason why the Rough Draft survives. He also made manuscript copies of the Committee's recension for Lee and others so they could evaluate the revisions and judge for themselves what had been gained and lost. For some historians, this stage in the composition process provides crucial evidence for the group authorship of the Declaration. Most agree that the delegates made improvements in sense and style as well as tactful changes in rhetoric that might have riled friends and allies. The deletion of Jefferson's denunciation of the slave trade is, of course, the most famous of these editorial interventions. His motives in writing it and the reasons for removing it are still being reappraised—now, more than ever, when fundamental injustices in American society are being traced to the beginning of the nation. The delegates excised the slave-trade clause to reach a consensus, which made it possible to approve the text by a vote on July 4, 1776. To be precise, they voted on the Declaration sometime that morning (not in the evening, as Jefferson implied in his account of the debates). After getting an early start, they then had the rest of the day to ensure that it was properly printed.[6]

They took the title of the Rough Draft and added the date to make it official: *In Congress, July 4, 1776. A Declaration by the Representatives of the United States of America, in General Congress Assembled.* At this point they could not claim to be unanimous—that would come later—but they could announce that their president, John Hancock, had signed it "by Order and in Behalf of the Congress" and that their secretary, Charles Thomson, had attested to its authenticity. The duly attested manuscript may have been the June 28 fair copy, but its contents can only be conjectured because it does not survive. The Committee of Five was entrusted with the task of seeing it through the press. Jefferson and/or Thomson brought it to Dunlap's printing office on Market Street, just a few minutes' walk from the State House. Reliable and efficient, Dunlap was just beginning a lucrative career in the service of Congress and would later win the contract to print its Journals. One or more compositors set up the text and proofed it. The so-called proof copy at the Historical Society of Pennsylvania contains quotation marks that may have been vestiges of the manuscript, a compositor's misreading of a rhetorical short-hand Jefferson used to indicate pauses should he be called upon to read his work

out loud. After these mistakes were discovered, the rhetorical marks were removed and replaced with spacing material, a makeshift expedient leaving peculiar gaps in the preamble. Perhaps these are signs of haste, but otherwise the Dunlap broadside is a creditable piece of work, graced with impressive letterspaced caps in the title and a stately six-line initial in the text. The presswork was competent. There is no documentary evidence for the size of the edition, but it must have been fairly large, for twenty-six copies have been located, one discovered as recently as 2008.[7]

Congress planned for the distribution of the broadside with the expectation that it would be read in public. Copies were to be delivered to assemblies, conventions, and committees of safety as well as the commanding officers of the Continental Army. General Washington ordered his troops to stand in formation to hear what he hoped would inspire "Fidelity and Courage." The Pennsylvania Committee of Safety received its copy on July 5, 1776, and scheduled a public reading in the State House Yard for the 8th. The Independence National Historical Park has a copy that belonged to Col. John Nixon, who was the orator on that occasion, standing next to the city sheriff and other officials. Worked to a frenzy, the crowd greeted his performance with "three repeated huzzas" and then tore down the King's Arms in the State House and the Court Room. The royal insignia met a similar fate in other cities. As the news spread, local patriots organized festivities such as John Adams had predicted for the 2nd.[8]

Thomson retained a copy for the record. He had already written an account of the July 4th deliberations in the Rough Journal of Congress. Instead of transcribing the text by hand, he attached one of the broadsides with wafers in a space he had left blank for that purpose. It was a common practice of clerks at that time to fold up and "wafer in" the documents they wanted to preserve in deed books, guard books, and other compendia bound up for archival purposes. Wafers were the hinging tape of the eighteenth century.[9]

Seven days after the fact, on July 9, 1776, the New York Convention finally authorized its delegates to vote for independence. Hancock had sent the broadside to the Convention, which acknowledged it in a letter announcing that the vote had been taken just a few hours before it arrived.[10]

On July 19, 1776, Congress resolved that the Declaration should be "fairly engrossed on parchment" and that all the delegates should sign it. Those terms, "engrossed" and "parchment," conferred a special meaning on this new redaction. Parchment made it more prestigious and gave it the semblance of deeds, contracts, and other legal documents of enduring value and importance. Scribes employed an engrossing hand to write out fair copies of legislation, a tradition arising out of parliamentary practice. The meaning of that term is slightly different in America from that in England, although it still suggests the formal completion of a

document. Since the New Yorkers had now made it possible, the resolution pre-scribed a change in the title to reiterate the unity of the United States: "The Unan-imous Declaration of the 13 United States of America."[11]

Thomson may have employed his assistant Timothy Matlack to write out the engrossed parchment. Matlack made his living as a scrivener only intermittently, but he had some knowledge of calligraphy and had performed similar tasks for Thomson, most notably the manuscript commission, on June 19, 1775, of Wash-ington as commander in chief. He knew how to transpose in script some of the typographical effects in the Dunlap broadside. In place of the six-line initial *W*, he wrote *When* in a flourished black letter. He employed black letter for phrases that had been set in letterspaced caps and small caps for added emphasis at the end. The Rough Journal states that Congress checked the accuracy of his tran-scription by having it "compared at the table." Perhaps at that time two interlin-ear corrections were made, *en* to correct the spelling of *Representative* and *only* to mend the omission of that word in the sentence, "Our repeated Petitions have been answered only by repeated injury."

Following Hancock, whose name occupies the center of the sheet, the dele-gates signed it on August 2, 1776, in contingents state by state, Georgia at the top left, Connecticut at the bottom right. The document contains fifty-six signatures neatly arranged in six columns. It is important to remember, however, that the composition of Congress had changed since July 4th—some members who voted on the Declaration were not present to sign it; conversely, some of the Signers could not have been present on the Fourth. To make it even more confusing, some of the Signers could not have been present on August 2nd and must have added their names at a later date. The most obvious examples are the New Hampshire delegate Matthew Thornton and the Delaware delegate Thomas McKean. Thorn-ton did not take his seat in Congress until November 4th, which explains why he could not sign his name in the proper place but had to append it at the very end, after the Connecticut contingent. McKean may have had to wait until 1781 to add his signature, but he could insert it next to those of other Delawareans at the bottom of a column. The whereabouts of the Signers vexes historians to the present day. Some speculate that Thornton and McKean were not the only ones to have been absent on August 2nd—for example, Wills, who wished to show that the delegates did not fully appreciate the importance of their actions until after the Revolution. If, however, there were as many as eight or twelve latecom-ers, as Wills conjectures, they would have had to sign out of order and could not have conformed to the regularly spaced state-by-state six-column layout.[12]

On September 26, 1776, Congress passed a resolution authorizing Robert Aitken to print its Journals. The Declaration appears in Aitken's second volume,

published in 1777, along with other July 4th proceedings, and is accompanied with the signatures in type, including Thornton but omitting McKean. The compilers of the Journals inserted the signatures without comment, no doubt trying to be thorough but inadvertently conflating the July 4th Dunlap broadside and the August 2nd engrossed parchment. They made it even more confusing by stating explicitly that the Declaration had been "engrossed and signed" on the Fourth. Jefferson consulted the Journals to shore up his shaky memory, only to be drawn deeper into error. Later editions of the Journals contain the same misleading text embellished with decorative types imitating the engraved facsimiles.[13]

Finally, Congress decided to put the unanimous version on the record. On January 18, 1777, six months after achieving unanimity, it requisitioned "authenticated" copies of the engrossed parchment from the Baltimore printer Mary Katharine Goddard. The Goddard broadside was an official government document, validated with the congressional order that had called for it appended at the end (fig. 6). To make it even more official, Hancock and Thomson signed some or all of the broadsides—Hancock identifying himself as president of Congress, Thomson as secretary. The names of the Signers were printed in the same order as in the original, including Thornton, whose signature was moved to its proper place in the New Hampshire delegation. Signatures in script and print vouched for the authenticity of this Declaration, which was intended for distribution to each of the state governments. It took the evolution of the text one step further by publicizing the actions of the Signers and making them personally responsible for independence. There could be no doubts about its meaning and legitimacy. Hancock certified that it was "A True Copy," and Thomson attested to it in the same terms as the Dunlap Declaration, but this time they wrote out their assurances in pen and ink. We shall see how facsimile publishers emulated their certification statements in engravings, lithographs, and letterpress broadsides during the nineteenth century.[14]

This chronicle of the Declaration is intended to prevent confusion, define terms, and trace the interplay of texts in the July 4th and August 2nd documents. To this day scholars debate the importance and authority of the three official texts: the Dunlap broadside wafered into the Rough Journal of Congress, the Corrected Journal of Congress, and the engrossed parchment. They dismiss the Corrected Journal because it contains a defective manuscript transcription. Becker, godfather of Declaration studies, expressed a preference for the Rough Journal, which still contained the broadside in his day. After 1906 it was fastened to the blank space of the page by a linen backing, and after 1976 it was detached, no doubt a conservation decision: it looks a lot better now than it did in 1976. Conservators often extract folded broadsides from bound volumes for treatment,

FIGURE 6

In Congress, July 4, 1776. The Unanimous Declaration of the Thirteen United States of America. Baltimore: Mary Katharine Goddard, 1777. Manuscripts and Archives Division. New York Public Library. Astor, Lenox, Tilden Foundations.

display, and safekeeping, but segregated in this way, Congress's copy of the Declaration loses some of its original meaning and distinctive status. On the other hand, any copy of the first edition deserves special consideration in the opinion of the graphic designer Thomas Starr, who argues for the superiority of print, July 4th, over script, August 2nd, in performing the function of a declaration. Matlack privatized the text, says Starr, whereas Dunlap promulgated it in a democratic medium more conducive to its message: writing is exclusive; typography is better at expressing the will of the people.[15]

Boyd noted both sides of the debate but opted for the engrossed parchment when he had to choose a text for the Jefferson Papers. Or rather, he relied on the John Quincy Adams 1823 facsimile of the engrossed parchment (no. 11), the best possible surrogate for the original, which is now illegible. Likewise, the compilers of the United States Code consulted the facsimile along with the Dunlap broadside and Dunlap's newspaper printing. Adams's facsimile has that legal standing because it was a state-of-the-art replica accredited by Congress. It will be described in detail in chapter three, which will explain how it became a benchmark for future reproductions. But that scrupulously accurate version was neglected until the Centennial, and even then it was less influential than two types of prints that dominated the trade in Declarations: calligraphic renditions of the text in the style of the writing master Benjamin Owen Tyler (no. 3) and pictorial allegories following the precedent of Binns (no. 6). Binns and Tyler claimed that they transcribed the text with utmost accuracy and vaunted the authenticity of autographs they displayed beneath it, the only portion of those prints we would consider a facsimile. As I will show in the next chapter, they were the first to deal in the Declaration as a work of art and the first to discern a meaning and mystique in the autographs, which became a defining feature of this genre.[16]

FIGURE 7 *Declaration of Independence. In Congress. July 4th. 1776.*
The Unanimous Declaration of the Thirteen United States of America.
Philadelphia: John Binns, 1819 (no. 6). National Portrait Gallery,
Smithsonian Institution.

Heroic Engravings

The newspaperman John Binns took a proprietary interest in the Declaration of Independence. Like other Republican journalists, he made a point of printing it on or near Independence Day, a patriotic gesture but also a partisan interpretation of the text. His Philadelphia *Democratic Press* upheld that tradition to celebrate Jefferson's accomplishments and ideals, a political legacy Binns used to validate his own views, take the moral high ground, and consolidate his position in the left wing of the Republican party. He attacked his enemies and extolled his friends with a fervor typical of his day and strident enough to lend him a powerful voice in state and national affairs. He thrived on controversy, although he reassured his readers that he could reach common ground and celebrate unity on Independence Day.[1]

An adroit publicist, he knew how to advertise the Declaration. He was the first to tell Americans about the iconic value of that document, for which he designed an iconographical scheme that would define a new genre of patriotic prints (fig. 7). A renegade engraver pirated his work, others imitated it, and John Quincy Adams sought to supplant it with an official facsimile, now the one trustworthy depiction of the original. In his old age Binns looked back at his career and viewed his print as one of his least controversial achievements—even though it too made a fracas in the *Democratic Press*. He wrote about it in a garrulous and

FIGURE 8
Thomas B. Welch, *John Binns.* Engraving after a daguerreotype by Frederick De Bourg Richards, *Recollections of the Life of John Binns,* 1854. Courtesy of Princeton University Library.

unreliable autobiography, a self-serving document that has probably done more harm than good to his reputation (fig. 8). The *Dictionary of American Biography* notes his *Declaration* mainly as an example of his rancorous disposition, the *American National Biography* does not mention it, and other standard sources have more to say about his backroom political intrigues than his printing business and his printmaking ventures. Nonetheless, a short account of his politics will be useful here to explain why he undertook this publication, how he marketed it, and what he wished to communicate with its ornament and illustrations. An Irish immigrant and an ardent enemy of British imperialism, he took pride in this act of patriotism, a proof of fealty to his adopted country and a sincere expression of his personal convictions based on his radical background and Republican beliefs.

JOHN BINNS

Binns was born in Dublin in 1772. His family was fairly affluent but did not expect much of a younger son, who had the means and leisure for extensive reading but

little schooling and no inducement to learn a trade. At an early age he found his calling in radical movements inspired by the French Revolution. He joined the United Irishmen, who pressed for civil liberties, constitutional reform, and Catholic emancipation. In 1794 he went to London, where he became a prominent member of the London Corresponding Society, an organization eventually banned because of its "treasonable practices." He traveled extensively on its behalf and attracted the notice of the authorities, who arrested him more than once and put him on trial, but he was acquitted by sympathetic juries. One of his co-conspirators was convicted and sentenced to death for fomenting revolution in England and Ireland. After the right of habeas corpus was suspended in 1799, he was imprisoned for twenty-two months in Gloucester Gaol with no legal redress in sight. He was treated kindly during that time—and was even allowed to borrow books, study French, and tend a garden—but the cruelty and hypocrisy of his incarceration preyed on his mind and hardened his stance against the British government. The injustices he had suffered under that regime would impart a personal meaning to the Declaration and its indictment of arbitrary power.[2]

He immigrated to America soon after he was released in 1801. He settled in Northumberland County, Pennsylvania, where he founded the weekly *Republican Argus* in opposition to the Federalist newspaper of that county. His printing office also took on book work, most notably the memoirs of his fellow refugee Joseph Priestley, who lived in Northumberland and became a friend of the family. Passions ran high in the *Argus*, which embroiled him in a libel suit and a duel of honor. After seeing him in action, Pennsylvania Republicans decided that he deserved a larger audience and invited him to take his newspaper business to Philadelphia. Established in 1807, his *Democratic Press* was the mouthpiece of a dissident faction of the party loyal to Simon Snyder, an up-and-coming candidate for governor. Snyder won the election a year later and rewarded Binns with a say in making patronage appointments. For a while the Irish immigrant enjoyed a semblance of gentility in a five-acre country estate, where he entertained his cronies during summer weekends.[3]

Binns fell from power after Snyder retired in 1817. He turned against Snyder's successor, whom he tried to get impeached, and supported an insurgent candidate in the next election. He compromised his standing in local party politics by feuding with a rival Republican paper, a factional dispute tainted by the commercial motives of the antagonists. It is true that he was always looking out for the main chance and was deeply implicated in the spoils system, but he held fast to at least one guiding principle: his aversion to Andrew Jackson. The general was a dangerous man in his opinion, a willful and divisive figure whose ruthless tactics had

upended the equilibrium between the Federalist and the Democratic-Republican parties. In the election of 1824 Binns started out on the side of William Crawford and then endorsed John Quincy Adams as a more palatable alternative to Jackson. This act of apostasy brought down the *Democratic Press*. Adams had already made up his mind about the turncoat Republican, "an infamous man" who could be bought and sold for the price of a government contract. No recompense for his defection could be expected from that quarter, although he claimed to have mortgaged his house and spent most of the proceeds on behalf of Adams in the 1828 presidential campaign. A year later he closed down the newspaper, a discredited concern burdened by debts, spurned by both parties, and abandoned by its subscribers.[4]

Campaign tactics reached a new low during the 1828 election. Binns published the first of the coffin handbills, an attack on Jackson now famous in the history of political propaganda. He accused the candidate of murdering six men who had decamped in the belief that they had completed their militia service at the end of the Creek War. They were tried for mutinous disobedience and sentenced to death, a verdict upheld by the general and duly carried out by a firing squad a few weeks after the Battle of New Orleans. To Binns, this episode proved that Jackson was not a war hero, but rather a merciless tyrant unfit for high office in a free country. He printed a supplement to the *Democratic Press* with mock epitaphs of the six innocent victims, the texts in type-metal compartments shaped like coffins and decorated with tombstone imagery. The epitaphs were dated July 4, 1828, as if to compare the candidate's cruelties with the British atrocities decried in the Declaration, a standing rebuke and a moral counterexample that should dictate a decision at the polls. He printed thousands of copies, which reached readers well beyond the Philadelphia area in the daily, weekly, and triweekly editions of the *Democratic Press*. The coffins caught the imagination of likeminded printers, who issued similar handbills repeating his accusations and adding new ones even further from the truth. In retaliation Democratic Party pamphleteers dug up dirt on John Quincy Adams. On election night, when it became clear that they would win, jubilant Democrats assaulted Binns's printing office and brought out an open casket in which they planned to carry him about town as a public punishment for his allegations. He bolted the doors, fastened the shutters, and retreated to his living quarters in back, where his wife, daughters, and servant girls had been sleeping. He took them up to the roof for safety while the rioters tried to break into the building and pelted it with stones. The mob returned the next night to try again. After a few days in hiding, he returned home, but his newspaper was doomed, and he no longer played a role in party politics.[5]

Deep in debt, Binns sold off his printing establishment and started a new career as a Philadelphia alderman. He drew on his experience in that position to write a manual for justices of the peace, which went through at least fourteen editions. Precluded from state and national affairs, he was still in demand for local events such as a meeting of the Repeal Association on the July 5th national holiday in 1841. (July 4th fell on a Sunday that year.) Alderman Binns had a seat of honor at the meeting, organized by Irish patriots who hoped to repeal the Acts of Union and reinstate the legislative independence of their mother country. When it was his turn to speak, he stood up and read the Declaration, an obvious choice for that day but also a subtle statement of his personal agenda. By invoking that document he could express pride in being an American, as well as solidarity with the Irish people who still struggled under the British yoke. He ascribed to them the same aspirations and ideals that the Philadelphians were celebrating on that day. In his hands the Declaration was a certificate of citizenship and a manifesto of human rights equally valid in other countries. He said as much when he first solicited subscriptions for his engraved facsimile: "We are firmly persuaded, that the more our Declaration of Independence is spread out before the eyes of the world, the more it will be admired, if not imitated, by foreign nations as well as our own."[6]

Binns's enemies accused him of divided loyalties even though he was a naturalized citizen who had already proved his patriotic zeal. As much as he tried to shrug off their suspicions, they sensed sedition in his radical activities abroad, his prison record, and his continuing commitment to the Irish cause. They questioned his right to publish the Declaration, a privilege they reserved for born and bred Americans. Binns fought against nativist sentiments in the Democratic Party, which tried to exclude him and other immigrants from government jobs in Philadelphia County. In 1844 the nativists prevailed and threw him out of office, leaving him no source of income except the fees he received for writing deeds and taking depositions. Once a kingmaker in Pennsylvania politics, he was reduced to clerical work in the legal system, but in his memoirs he claimed to be contented with his lot and lived well enough to reach the age of eighty-eight when he died in 1860.[7]

As if to counter nativist objections, Binns announced that his *Declaration of Independence* would be thoroughly American in style and substance. His earliest advertisements promised that the paper, types, and ink would be manufactured in this country. Friends of domestic industry might approve of its locally sourced ingredients as well as the local talent he would employ to design and engrave a "truly national publication." Instead of hiring foreign artists—a defect in Joel Barlow's *Columbiad* (1807), an otherwise commendable fine-printing endeavor— he recruited in Philadelphia and New York skilled specialists who would take on

different parts of a large and complex composition framed with allegorical embellishments. At first, he was going to set the text in type, but his artists advised him to have the entire work engraved. No doubt they viewed letterpress as a cheap and clumsy alternative to their tried-and-true intaglio techniques. An expert in lettering banknotes, Gideon Fairman would engrave the text, which would be followed by facsimile signatures of the Founding Fathers rendered by John Vallance, a prolific and versatile illustrator especially skilled in script. Vallance's facsimiles would be based on a close examination of the originals in Washington. The painter and drawing master George Bridport had designed a border of state seals that would form a "cordon of honor" around the text and signatures. Each of the thirteen original colonies would contribute a link to this symbolic chain, which would be completed by medallion portraits of Washington, Jefferson, and Hancock engraved by William Satchwell Leney after original paintings. The portrait of Washington would be flanked by cornucopias and military trophies. Sprays of indigo, tobacco leaves, and cotton bolls at the bottom of the border would complement the cornucopias at the top. The border would be engraved by George Murray, at that time a partner with Fairman in the banknote firm Murray, Draper, Fairman & Company. Binns reeled off these names to show the magnitude of what he had in mind, a print so rich in pictorial content, so full of intricate detail that only a team of artists could manage such a monumental task. They were Americans, although all but Fairman were born abroad. As much as the publisher tried to forestall nativist criticism of his work, his opponents would attack it on the grounds that immigrants should not be allowed to meddle with an instrument of national identity.[8]

Binns's proposals mark a turning point in the history of the Declaration. Historians have shown that it went through a period of neglect before Americans began to appreciate its stirring language and symbolic significance. Usually the dates 1817 or 1818 are cited as the time when it took on a new meaning, not just a statement of political theory but also an eloquent expression of ideals cherished in a democratic society. But it would be more accurate to start a year earlier, when Binns published his proposals in the *Democratic Press*. He exhorted his subscribers to think of the Declaration as a proclamation of human rights like the Magna Carta, which was already readily available in scholarly editions and splendid facsimiles. Now he would do the same with an illustrated facsimile fulfilling the highest standards of artistic excellence and historical accuracy. "Such an edition," he predicted, "will associate the pleasurable ideas of elegance and ornament, with the history of the transaction itself, and familiarize those principles which form, or, ought to form, the very bond and cement of political society."[9]

The previous illustrated editions were negligible in comparison. Within days of the Dunlap edition, Ezekiel Russell reprinted the text in Salem, Massachusetts, with a woodcut pair of portraits. Russell may have recycled the woodcut from a previous publication, for he used it in other ventures, including almanacs, where it was captioned "The Glorious Washington and Gates," and a broadside ballad, where it portrayed generals Washington and Ward. Its meaning in the Declaration is hard to discern unless it was supposed to represent the two officials named at the end, Hancock and Thomson. Equally obscure, a London broadside edition contains a stipple portrait of Hancock. Issued without an imprint, it may have been produced surreptitiously by English sympathizers to the American cause. Both of these broadsides are rare, and neither attracted the attention of others in the print trade.[10]

Binns's advance publicity appeared in more than thirty newspapers during 1816. Beginning in the March 26, 1816, issue of his *Democratic Press*, it was picked up by other papers in April and remained in the public eye until October, a regular fixture in New England and the Mid-Atlantic states, less so in the West and South. At least three papers kept it in standing type. Assiduous readers of the *Baltimore Patriot & Evening Advertiser* would have seen it around forty times in four months. By Binns's calculations, it appeared in six Philadelphia newspapers and seventy-two elsewhere in the United States by November 6, 1818. At the end of 1819, when his *Declaration* finally came off the press, the *Alexandria Gazette* retrieved the text of his proposals and printed it in more than 180 successive issues.[11]

By dint of repetition, these newspaper notices inspired other publishers to try their hand in Declaration endeavors. I have tried to narrow down the date for the earliest edition in my checklist, an ornamental letterpress broadside (no. 1) probably printed in 1816. If I am correct about the date, then one could also conjecture that the printer had seen the proposals and decided to poach customers already primed for this kind of merchandise. Likewise, the editor of the *National Advocate* issued a similarly decorated letterpress edition (no. 2) on July 4, 1817. It had been his usual practice, he explained, to print the Declaration in his newspaper on that day, but this time he was making a special effort to express his "admiration of this impressive document." Then in 1818 Benjamin Owen Tyler launched a subscription campaign for a rival publication, which he advertised in terms suspiciously similar to the 1816 proposals. Binns accused him of plagiarism, displayed parallel passages as evidence of theft, and asked newspaper editors to reprint his rejoinder. Tyler's counterattack will be described below, but there is no doubt that Binns had the original idea and made the first announcement of a facsimile edition. The short essay he wrote on the importance of the document reached a wide

swathe of the American reading public and helped bring it to the forefront of the national consciousness.[12]

In addition to the newspaper advertisements, Binns solicited subscribers by direct mail with a cover letter printed in script type dated June 1816. He told them that the list price would be ten dollars plain, thirteen dollars colored. They would receive an accompanying pamphlet that would list their names and transcribe state papers concerning the Declaration. The plate, he noted, was already in the hands of the engraver, who had been working on it for several weeks. The project had progressed far enough that he could predict a delivery date of February 1817.[13]

As it happened, he never produced the pamphlet, and the print was delayed by production problems, personnel changes, and other distractions. In early 1817, he issued a progress report about the technical difficulties he had encountered and the measures he had taken to get the project back on track. To accommodate everything, his *Declaration* would have to be larger than he had originally specified, 38 × 26 inches instead of 36 × 24 inches. These dimensions exceeded the capacity of an ordinary rolling press, so he would construct a new one for that purpose. He discovered that some of his artists were unwilling or unable to fulfill their assignments. Thomas Sully took on the task of drawing the state seals in an attempt to harmonize the designs and ensure that they conformed to the official descriptions. Leney was replaced by the portraitist James B. Longacre. Fairman turned over the ornamental lettering to Charles H. Parker. Fairman, Parker, and Binns announced that they were collaborating on a companion print, George Washington's *Farewell Address*, an equally ambitious venture similarly subject to delays and changes in plans. Eventually Binns relinquished his part in the *Farewell Address*, and Fairman formed a new partnership, which published it in 1821. Originally it was supposed to be the same size as the *Declaration* and was to be delivered at the same time, at half the price, but it grew to be even larger, and the price was raised to six dollars, probably as much as the market would bear at that time.[14]

While waiting for the artwork to arrive, Binns sought to keep up the momentum by distributing proofs of his work in progress. The Library of Congress has a proof in an early state probably dating to November 4, 1818, when he submitted his copyright application (fig. 9). It has the title lettering and the ornamental border but lacks the portraits, the text, the facsimile signatures, the imprint, and two of the state seals. The proprietors of the *National Intelligencer* received two proofs and invited their readers to look at the most recent one in their office. Binns brought one for the inspection of Secretary of State John Quincy Adams, who allowed him to start on the facsimiles. After they were completed, Adams compared them with the originals and wrote a certification statement, which is dated April 19, 1819, in the print. It was still far from finished in July when Binns presented his latest rendition

FIGURE 9
Proof of the Binns engraving, ca. 1818 (no. 6). Prints and Photographs Division, Library of Congress, LC-DIG-pga-01012.

to Jefferson along with a cover letter recounting what parts were still missing: two of the state seals, the arms of the United States, the caption for Jefferson's portrait, and the certification statement, which had not yet been engraved. The elder statesman was grateful for this gesture and wrote a cordial letter in reply. Less genial, John Adams returned an "unfinished copy" that Binns had sent him in September and made it clear that any other importunities would be rejected. The work was finally completed in October and made available in November, a cause for celebration in several newspapers, although by that time the damage had been done. Priced at ten dollars, the long-awaited *Declaration* had to compete against less expensive engravings and cheap letterpress broadsides, a new genre of patriotic prints inadvertently abetted by its publisher's saturation advertising tactics.[15]

WILLIAM WOODRUFF

One of Murray's journeymen pirated the print a year before it was completed. William Woodruff copied the design while the plate was being proofed in

Murray's shop, filled in the missing details, and hired a Philadelphia copperplate printer to produce a smaller and cheaper derivative edition (no. 5). Murray tried to dissuade him and even tried to pay him off, but Woodruff denied that he had violated anybody's rights to the Declaration, much less those of a foreigner like Binns. Although he refused to back down, a comparison of proofs revealed that he had replicated the original layout and retained all its most important parts: the border of state seals, the medallion portraits, and the headpiece composed of cornucopias, flags, and the arms of the United States. He used different pictorial sources for the state seals and replaced the Hancock portrait with one of John Adams. Instead of the facsimile signatures, he transcribed the names in the same flourished round hand he used for the text. The Hancock signature is a partial facsimile inasmuch as it is similarly configured and occupies the same central position, but it too contains fanciful calligraphic embellishments. The imprint claims that he had secured a copyright for his work and that he published it on February 20, 1819. Binns caught wind of Woodruff's transgressions in or just before November 1818, which may be why he filed his own copyright application on the 4th of November. He lodged a complaint on the 6th of November and obtained an injunction, but the defendant's attorney had it overturned on jurisdictional grounds. Then he tried again and obtained another injunction, but that too was quashed because he was not the injured party. The judge ruled that he was only the proprietor of his work and did not qualify for copyright protection, which is "only meant to encourage genius and art." The litigation lasted until 1821, when the judge tossed out the case and ordered the plaintiff to pay the costs.[16]

Invincible in court, Woodruff was free to sell his knock-off *Declaration* as he pleased, but it was not a rewarding venture. Copies of the early impressions are rare in comparison to the other engraved Declarations of this period. He appears in a list of insolvent debtors at the end of 1819, one of many Philadelphians who defaulted during the financial panic of that year. His *Declaration* was reprinted at least twice during the 1820s. He may have tried to keep up with the competition by selling it with a companion print containing the facsimile signatures (no. 7). If so, his marketing efforts were not successful: a hundred copies were liquidated at auction, along with other odd lots, in 1822. Sometime before 1825 he moved to Cincinnati, where he continued to supply the trade with intaglio work during the 1830s. By that time the plate had fallen into other hands and was reworked with a new set of state seals and the requisite facsimile signatures, derived from Binns (fig. 10). Around 1844 a traveling agent employed by a New York firm was selling a late state of this print for fifty cents. The late states are also rare, but Woodruff's design can be seen fairly frequently in another merchandising scheme, a series of souvenir handkerchiefs (no. 10).[17]

FIGURE 10
Late state of the William
Woodruff piracy. New York:
Phelps & Ensign, 1843 (no. 5).
Courtesy, American
Antiquarian Society.

BENJAMIN OWEN TYLER

The Woodruff imbroglio was a setback for Binns, but it was not as damaging as his dispute with Tyler, a vociferous antagonist adept at personal attacks and political invective. Not so much a pirate as a plagiarist, Tyler issued proposals for an engraved *Declaration* in February 1818 and started to sell it in May 1818, long before Binns and at half the price (fig. 11). He was the first to print the signatures in facsimile and the first to embellish the text with ornamental scripts. Sure of his legal footing, he solicited subscriptions for his engraving, advertised it in newspapers, and succeeded in obtaining endorsements from the Founding Fathers John Adams and Thomas Jefferson, who graciously accepted the dedication of the print. A Washington paper printed Jefferson's acceptance letter, which was picked up by other papers in Baltimore, Boston, Philadelphia, Wilmington, and Worcester. Tyler got there first, even though Binns had better Jeffersonian credentials, and made the most of the dedication, writing it out next to the title in an epistolary

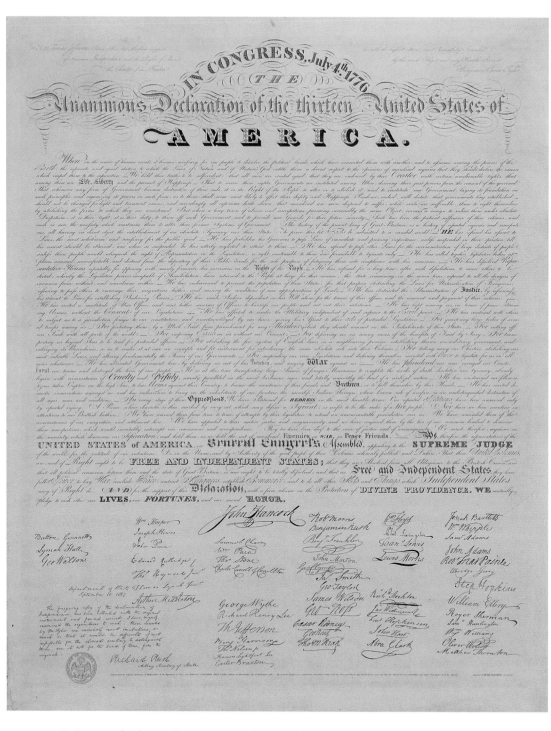

FIGURE 11 *In Congress, July 4th. 1776. The Unanimous Declaration of the Thirteen United States of America*. Washington, DC: Benjamin Owen Tyler, 1818 (no. 3). Sotheby's Books and Manuscripts Department.

hand, just the right weight of lettering for the etiquette of such occasions. He stoutly defended the originality of his prospectus in newspaper articles and a polemical pamphlet, which charged his adversary with even worse violations of intellectual property. The penman gave as good as he got in a newspaper war that proclaimed the importance of the Declaration and vindicated his cut-price calligraphic interpretation of the text.[18]

Tyler exploited his newfound fame to make his way in political circles, where he sought employment and financial support for other printmaking endeavors. He is the best documented of the nineteenth-century Declaration publishers because he courted publicity and wrote about his work to public figures whose papers have been preserved. He hovered on the fringes of the American elite, a name fading in and out of the collected correspondence of Thomas Jefferson, Andrew Jackson, John Adams, John Quincy Adams, Dolley Madison, John Marshall, and Henry Clay. Ultimately, he failed to get a government sinecure and spent his last days indebted and deserted, brought down by bad luck, poor health, and misplaced ambitions. Nonetheless, his ingratiating tactics deserve an explanation here as a means of understanding the Declaration business in his day. He helped establish it and showed that it could be profitable while setting standards for the quality of facsimile reproduction, which he authenticated in ways that became standard practice during the nineteenth century.

Tyler started out as a writing master. Born in 1789, he was the eldest son in a family of farmers who made a modest living at various locations in the Connecticut Valley region of Massachusetts and Vermont. Looking back at his hardscrabble upbringing, he once called himself "a poor Green Mountain wood chopper Boy." He left the family farm around 1813 and set himself up as a professor of penmanship in Bennington, Vermont, where he offered a three-week course of instruction priced at three dollars. He then moved to New York and founded what he called a Writing Academy, where thirty ladies and a number of gentlemen studied mercantile hands and ornamental scripts. Visitors to the academy could view specimens of his pupils' work, his collection of European and American writing manuals, and copies of his first printmaking venture, *Eulogium Sacred to the Memory of the Illustrious George Washington* (1815).[19]

The schoolmaster designed the *Eulogium* to display his calligraphic skills, advertise his teaching program, and make money on the side. He claimed to have sold thousands of copies at two dollars each and was still selling them in the 1830s, marked down to a dollar. The engraving was expertly executed by Peter Maverick, a prominent member of the trade highly esteemed for his book illustrations and banknote lettering. A portrait of Washington is at the center of the composition, surrounded

by eagles, angels, and cherubs rendered with pen flourishes in the style of George Bickham's *Universal Penman* (1733–41). The title forms an oval around the portrait, framed by elegiac verses in various scripts punctuated with masonic symbols. Tyler was not an original thinker—the verse is mainly taken from an anonymous *Elegy, in Remembrance of James Lawrence, Esquire* (1813)—but he got off to a good start in the printmaking business with the guidance of Maverick. Aptly timed to play on a surge of patriotic sentiment after the War of 1812, the *Eulogium* could be useful for someone seeking political patronage and national recognition.[20]

In 1816 Tyler served as a writing instructor at the United States Military Academy at West Point but lost his job soon after he was appointed. The reasons for his departure are not entirely clear, but he might have been too closely associated with the Superintendent Alden Partridge, who was dismissed in disgrace. Undeterred, Tyler retained the goodwill of high-ranking officials and resolved to try his luck in Washington, where he ran another writing school and published *A Complete System of Small and Running Hand*. He offered an accelerated course in penmanship by which his pupils could learn a "handsome hand" in forty-eight hours. At this point, however, he lost interest in the teaching profession and began to look around for a more congenial occupation. He took a flier in Washington real estate, which he purchased by buying deeds of delinquent taxpayers. In 1820 he was selling lottery tickets at a Pennsylvania Avenue establishment famous in its day, the Grand National Temple of Fortune. Never shy about self-promotion, he made sure that his name appeared prominently in his handbills and newspaper advertisements, some of which promised jackpots as large as one hundred thousand dollars. "Ben Tyler's Lottery" became a proverbial expression signifying the main chance. He did so well with his lottery schemes that he organized branch offices in New York, Albany, Baltimore, and Montreal. Just as suddenly as he started, he quit that line of work around 1828 and never mentioned it again—why I cannot tell, but it is possible that he had fallen out with his partners or had been implicated in a financial misadventure.[21]

He also carried on his printmaking business in Washington, where he found a ready market for the *Eulogium* and the means to take on other patriotic subjects. Soon after he arrived, he obtained permission to view the engrossed Declaration of Independence. He gained the confidence of the Acting Secretary of State Richard Rush, who allowed him to make facsimile reproductions of the signatures and a calligraphic rendition of the text. Once again, he hired Maverick to engrave his work, but this time he had a much more ambitious print in mind. He claimed to have paid somewhere between fifteen hundred and two thousand dollars to cover the production costs, and he proposed to sell it at five dollars—or seven dollars if a subscriber wanted to buy a luxury copy printed on silk or parchment. Like

the *Eulogium*, the *Declaration* displayed his skills in penmanship, the text in a uniform round hand with the "emphatical words" highlighted in ornamental scripts. Key concepts such as "Life," "Liberty," and "Justice" were rendered in black letter. The last paragraph reached a crescendo with "LIVES" in a bold slab serif Antique, "FORTUNES" in shaded and shadowed engraver's italics, and "HONOR" in open backslant contra italics.[22]

He claimed to have received orders for more than three thousand copies. More credible sales figures can be extrapolated from his order book, which contains the names of more than 1,200 subscribers, including celebrities such as Thomas Jefferson, James Madison, John Quincy Adams, John C. Calhoun, and Henry Clay. Those names are on the first page, all the better to impress potential customers. He carried on a sales campaign that brought him south to Richmond and north to Bangor, with stopovers in New York, New Haven, and Boston. While in Boston he made a side trip to Worcester, where Isaiah Thomas bought a copy on parchment for the fledgling American Antiquarian Society. The printsellers Sanderson & Ward ordered a hundred copies for distribution in Baltimore. His brother Ephraim Tyler took a hundred copies, perhaps acting as his agent in Vermont. Maverick may have done the printing as well as the engraving, his shop serving as an entrepôt for new impressions; he could produce and dispatch bulk consignments as needed, which would explain why he forwarded forty copies to his print trade colleague Asher Durand. In 1834 Tyler announced that he had a few "proof impressions" available at the discount price of three dollars. That too is hard to believe because he had more than a hundred copies on hand in 1833, which he offered to sell with the *Eulogium* in a package deal at two dollars a pair. By 1851 he was out of stock, and the plate was no longer available or serviceable, but he hoped to make a lithographic reprint if he could raise $250 to pay the printer.[23]

No wonder Binns complained about this attempt to preempt the Declaration market. By all rights he deserved some consideration for having created it, at first with his proposals, then with his progress reports and advertisements. He upheld the ethical obligations prescribed by the custom of the trade, which protects the prior claims of anyone who first publishes a prospectus. He asked newspaper editors to sympathize with his plight and help circulate his plea for justice. Let the public be the judge, replied Tyler: he had not made any grand promises, he did not boast about his expenditures, and he did not copy the prospectus except to recite the catchphrases of that genre. Nor did he have any enmity in mind when he planned this project; on the contrary, he offered his facsimile signatures to help expedite the other publication. Nonetheless, he was duty bound to show that his opponent had stolen the idea of an illustrated Declaration.[24]

WILLIAM P. GARDNER

The calligrapher had the documents to prove it, courtesy of William P. Gardner, a government clerk in the Post Office and Treasury Department. Gardner turned over to Tyler correspondence about a Declaration he had planned to publish with allegorical designs by John James Barralet. The engraver George Murray was to manage the technical part of the project. Barralet was well qualified for this line of work, having already devised an elaborate allegory for an *Apotheosis of Washington*, a popular print first published in 1802. In 1810 he made for Gardner and Murray a preliminary drawing with ideas for their "emblematical" Declaration: he proposed to put personifications of Liberty and Tyranny above medallion portraits of Hancock, Jefferson, and John Adams. They could insert below his work the text of the document, rendered either in letterpress or intaglio. The drawing does not survive, but contemporary accounts of it agree about the Liberty and Tyranny motifs. Other details are difficult to verify but may have included portraits of Signers, a figure of Minerva, a Native American, and a refuse heap of crowns and scepters. Gardner sent the drawing for the approval of Jefferson, who commended the project but declined to offer artistic advice. He did have opinions about the portraits and suggested that Hancock's should be foremost in the design, with Adams's also in a conspicuous position—for he was the "ablest advocate" of the Declaration, "the pillar of it's support on the floor of Congress." After receiving these comments, Gardner forwarded them to Murray but then ceased to communicate with his partner, who assumed that he had lost interest in their venture. Gardner did nothing about it until Tyler enlisted him in the dispute with Binns.[25]

Suddenly he realized the publicity value of his correspondence. He allowed Tyler to publish the Jefferson letter and published it himself in a local newspaper. Its gracious tribute to Adams became famous and is still quoted by historians. Cynical or forgetful, Binns appropriated it in his reminiscences as if he had been the recipient of that letter. Other letters incriminated Murray in a scheme to take Barralet's design and adapt it for the purposes of another client. That Binns's print also contained "emblematical" illustrations and three medallion portraits was bad enough, but the substitution of Washington to Adams was even worse. Tyler harped on it as evidence of partisan spite such as one could only expect from an Irish immigrant. Gardner twice wrote to Adams about that affront and concluded his testimony with a crescendo of nativist reproaches: "Ingratitude! Fell monster! This is not thy native soil—take, oh! Take thy flight for ever from the American shores!"[26]

Murray was able to disprove many of their accusations. All the artists associated with his project signed an affidavit on his behalf: Bridport, Sully, Fairman, Vallance, and even the papermaker Thomas Amies. It was not true that he had

switched allegiances from Gardner to Binns, who had already commissioned Bridport to take a different approach, not so much an allegory as a statement of historical fact. One could see obvious differences between Bridport's design and Barralet's sketch, which was still in the engraver's possession. He had even suggested that his two clients might collaborate on a printmaking project. But Binns did not want to deviate from his original idea, predicated on absolute accuracy. That was why he proposed to render the signatures in facsimile, a concept Gardner claimed for himself although Murray did not recollect any discussions along that line and could not find any mention of it in his records. Likewise the documents Gardner gave to Tyler confirm that facsimiles were not part of his publication plans. Of all his allegations, that one was the easiest to refute, but it reveals what Binns had accomplished with his proposals. The handwriting of the Founding Fathers had become a desirable ingredient in prints of the Declaration.[27]

Gardner and Tyler both hoped for career advancement as a result of this dispute. In a long letter to John Adams, Gardner explained how he had been wronged and deplored the missing portrait, an outright insult but soon to be forgotten, however, when those "Calumniations shall have decended to the Silent Tomb of Oblivion." He gave a full account of the affair while also commenting on his lifetime of government service and noting that he was currently unemployed. Likewise Tyler enlisted John Adams in his cause and sought to curry favor with John Quincy Adams, a powerful ally who could help defend him against Binns and promote his publications. The younger Adams saw the manuscript of his *Declaration* and compared its facsimile signatures with the original. Tyler told him about the plagiarism controversy and Gardner's part in that affair. Adams subscribed for a copy, which was framed for him and delivered in person by the publisher, who obtained his permission to send another one to his father. John Adams was impressed by the calligrapher's accomplishments and intrigued to learn that they might have a family connection. Perhaps one of his cousins had married Tyler's grandfather. "It would give me pleasure to know that any relation of mine possessed so much ingenuity and such a perfect Mastership of the Pen." Tyler confirmed that they were related and recalled that his grandmother had told him that she had "the honor of rocking in the cradle the President of the United States."[28]

POLITICAL AMBITIONS

The cousin twice removed hoped that his family ties and printmaking projects might lead to a patronage appointment or some other kind of political largesse.

He commissioned the miniaturist Joseph Wood to make a portrait of John Quincy Adams in the course of the 1824 presidential campaign and may have had it engraved. The portrait is now in the Boston Athenaeum, but I have yet to find a copy of the print, which was advertised along with portraits of Henry Clay, William H. Crawford, John Adams, Andrew Jackson, Martin Van Buren, John C. Calhoun, and DeWitt Clinton. Those portraits became part of his stock-in-trade, but they have been equally hard to find, except for a stipple engraving of John Adams and a three-quarter view of Clay, both in the Prints and Photographs Division at the Library of Congress (figs. 12 and 13). The print dealer made a tour of southern states in 1827 and sent a report to the president about his conversations with leading citizens in view of the upcoming election. The governors of Virginia, North Carolina, and South Carolina had spoken to him at length at dinner parties and other social occasions. He tallied the friends and foes of the administration and implied that more information was in the offing if a position could be found for him. "I know the politics of the country as well as any man,"

he declared, "on acct. of my extensive acquaintance & my prints." John Quincy Adams listened to him for a while and even loaned him money but lost patience with his problems and stopped communicating with him around 1843.[29]

Tyler also tried to attach himself to Clay. The Library of Congress print depicting Clay is after an oil painting by Charles Bird King now in the National Gallery of Art. The painting celebrates one of his foreign policy achievements, a resolution in the House of Representatives on behalf of South American independence. Seated at a desk, he holds in one hand a scroll with the text of the resolution and gestures toward it with the other. The composition is the same in the print version, but Tyler wrote out the text in ornamental scripts and inserted beneath the portrait a Spanish translation in a calligraphic cursive. It too was engraved by Maverick, who helped sell it at his shop in New York. The retail price was five dollars, although travelers to South America could buy it in bulk if they cared to inquire at the lottery office. Among other attempts to ingratiate himself, Tyler sold Clay lottery tickets, one of which won a prize, and helped organize a

testimonial dinner for the up-and-coming politician. He even named his eldest son after him. Just as he would with John Quincy Adams, he sent reports about public opinion and stated his qualifications to be a trusted adviser. His printselling ventures had given him opportunities to meet influential people and gauge the inclinations of prospective voters: "I have traveled thro' the country so much selling my Declaration of Independence that I presume no man of my age in the U.S. has a more extensive acquaintance than myself." Despite these repeated inducements, he received no encouragement from Clay, who rejected his application for a job in the State Department.[30]

The would-be political operative turned to other printmaking projects but could only complete a few of them. His Declaration subscription book contains manuscript proposals for a "Naval Monument" with portraits and battle scenes on a sheet 16 × 22 inches to be issued with a companion print celebrating the American army, priced at three dollars each or five dollars for the pair. He appears to have collected a few subscriptions but then to have abandoned the project. He planned to publish portraits of the presidents along with other high-ranking politicians, each with an inspirational letter transcribed in facsimile. There would be thirteen portraits altogether, configured to represent the original thirteen states. In January 1834 he had already started on a letter Jefferson had sent to his namesake, Thomas Jefferson Grotjan, and sent a proof to Chief Justice Marshall, who was to write similar sentiments in a space of the same dimensions. The portraits and the facsimile letters would be on a plate 22 × 28 inches, which was already in the hands of the engraver. If he could get enough subscriptions, he would undertake a companion print with another set of thirteen portrait-letters, including eminent American women in "a brilliant Star" above an array of politicians. Then, if that went well, he would transcribe the twenty-six letters in his round hand and publish them in a copybook for use in writing academies. Grotjan's father persuaded Jackson to write a letter like Jefferson's but no one else could be persuaded to participate in the project. Tyler gave up on the groups of thirteen and salvaged what he could of the Jefferson and Jackson letters, which he published in a smaller format without the portraits.[31]

ARTISTIC FAILURES

Tyler made one last foray in the political arena during the 1840 presidential campaign. Although his man Clay was defeated in the Whigs' convention, he embraced their cause and started on a newly reconceived "splendid national print"

celebrating the candidates William Henry Harrison and John Tyler. Mixing metaphors, he paraphrased George Berkeley's prophetic verse to give it the title *Westward the March of Empire Takes Its Flight* (fig. 14). He designed an elaborate structure of lithograph illustrations to frame the letterpress text, a biographical overview of the candidates. A massive headpiece is composed of the American eagle, the title in a banderole, allegories of Liberty and Justice, and portraits of two senators who supported the Whig ticket. At either side of the text, two columns display the names of military heroes along with battle scenes commemorating the heroic actions at Tippecanoe and Lake Erie; above it are portraits of the candidates and below a view of the Harrison homestead wreathed with symbols of rural prosperity. *Westward the March of Empire* is the farewell performance of Tyler the writing master, who supplied facsimile signatures beneath the candidates' portraits and wrote the names on the columns. His lettering betrays a sad decline of his powers in his later years, although he may have opted for a more subdued style to save space for that roll of honor.

By that time Tyler no longer had the financial resources to cover his production costs. Subscribers were to pay the three-dollar retail price in advance, but he raised less than $150, a third of his estimated outlay on that venture. Production problems exacerbated the situation. At first he intended to write out the biographies in a calligraphic hand, but his lithographer lacked the skill to replicate it properly, so he tried to emulate that effect with script types. That expedient also failed because the printer was not able to transfer a proof impression of the text to the lithographic stone. Cutting his losses, Tyler paid for the illustrations, bought the stone from the printer, and took it to another establishment highly praised for its work with the copperplate writing style. Here, too, things went wrong, and he entrusted his print to a third lithographer, who executed only the pictorial part. The main text had to be printed letterpress at a job shop. He ran out of money while he was haggling with the printers and could not even pay for the paper. Exasperated by this turn of events, he asked for a loan from New York Lieutenant Governor Luther Bradish and complained about the Whigs who had spurned his subscription campaign. He swore his loyalty to the party, but he had been offered a thousand dollars for his design by another printmaker who had defected to the other side. "To save my family" he too might turn against the Whigs and contrive to recoup his investment in *Westward the March of Empire* by swapping out the campaign biographies and making it a vehicle for Van Buren. "I know my power Gov.," he averred, "I do know that it is in my power to do more for the cause of Harrison than any man living and I do know that it is in my power to do them more injury." In addition to the three-dollar version of the print, Tyler

FIGURE 14

Westward the March of Empire Takes Its Flight. Lithograph with letterpress, published by Benjamin Owen Tyler, 1840. Prints and Photographs Division, Library of Congress, LC-DIG-pga-00119.

was preparing a wood-engraved version that would be stereotyped and sold at twenty-five or fifty cents apiece. He would hire more than a hundred agents to hawk it nationwide, all the more to sway the popular vote in the election. As far as I can tell, he never followed through with those plans, but he did produce a cut-rate lithograph with a similar letterpress text and almost the same layout though somewhat smaller. Its title is *Harrison, Union, Liberty, and Independence*, likewise emblazoned in a banderole and placed at the top of the design along with an American eagle. This text is framed by columns, which also display battle scenes, but they are not decorated with names of military heroes, and they are not surmounted by portraits of the senators. He told the lieutenant governor that if funding was not forthcoming, he would have to abandon the larger print and would proceed with this one as much as he wanted to retain those features. As it happened, he produced both prints and was able to bring a hundred copies to Washington, but he still needed money to pay for paper, only twenty dollars, for which he pledged Bradish "my word an[d] honor" and promised him five colored copies to cinch the deal.[32]

Westward the March of Empire was not widely distributed and did not earn the gratitude of potential patrons. The closest Tyler got to a place in the new administration was a portrait commission from First Lady Julia Tyler, who hired him to make a print with a greater display of décolletage than in the official painting. Neither the painting nor the print has survived, but she mentioned them in a letter noting that the president had rebuffed the notion of "any *400th* cousin" relationship with the printmaker. No doubt many others kept their distance if only to be spared an awkward acquaintance with someone who was always short of cash. To be fair it should be said that he had suffered a series of tragedies, setbacks, and disasters. He lost five children, the eldest age eight, and nearly lost his life in accidents that put him in the hospital for months at a time. He was incapacitated by vision problems, a case of pneumonia, a broken knee, and injuries incurred in a house fire, which destroyed almost all of his personal property. After a younger brother broke his leg, Tyler cared for him and his family of nine until he could go back to his farm. The lottery business collapsed, the prints fell out of favor, and other commercial speculations ran aground, although the restless entrepreneur went back and forth to try his luck in Washington, New York, Albany, and Vermont. He never succeeded in settling down in any of those places. He confessed to Dolley Madison that he once had a drinking problem, but he had dried out and had been preparing a lecture on temperance, which he proposed to deliver before the president and congress. As an additional inducement, he would persuade her son John Payne Todd to sign the total abstinence pledge. His

tribulations left him with only one steady source of income, a varnishing business in partnership with his wife. They developed special formulas for finishing paintings and weatherproofing the iron railings of public buildings. Even in that occupation he found a pretext to publicize his *Declaration*, perhaps no longer an article of commerce but an object of admiration and a talisman of bygone glory. In 1847, on the last day of the fair of the American Institute, he brought to the managers' room a copy of his print varnished with a mixture newly invented by his wife. He succeeded in getting an account of it in a newspaper, but the reporter remarked that the varnisher had fallen upon hard times and now depended on that menial trade to make his living.[33]

Tyler held on to the Declaration even as he disappeared from view. A long trail of advertisements and announcements came to an end in 1853 with a six-line squib about a lecture he intended to give in Bennington, Vermont. Whether he was then a resident of that town or just passing through is not known, but it is curious that he was back where he began as a writing master. He picked a patriotic topic, the anniversary of the Battle of Bennington, and stated his qualifications to address the public, albeit an audience in a village square: he was the "well known publisher of the first correct copy of the Declaration of Independence." More an admonition than an advertisement, the last newspaper notice I have found recounts his uncanny skill in imitating autographs only to remark how low he had fallen, a victim of intemperance. At one o'clock on a Saturday morning in 1855, he was picked up off a street in Boston, booked as a vagabond, and fined for public drunkenness, not the first time he had appeared before the police court of that city.[34]

His *Declaration* fell into other hands after he died, indigent, in 1858. A year later a Delavan Wentworth was seeking subscriptions for an "exact copy" of his work, which would be mounted on rollers and backed on cloth, ready for display as "an ever present reproof to all disunionists." I have found no evidence that Wentworth actually published this reproduction. But I do know of a series of lithographs issued circa 1859–63 by the New York publisher Horace Thayer, who made composite prints out of Tyler's ornamental text, Trumbull's *Declaration*, the thirteen state seals, and a key to Trumbull's painting (no. 63). Only the ornamental fillips were original, a decorative border and an allegorical vignette of the American eagle attacking the British lion. With Tyler safely out of the way, Thayer took out a copyright on his publication, although he retained the 1817 certification statement and the 1818 imprint to explain the calligraphic treatment of the document. The copyright could have applied only to the border and the vignette, imagery Tyler had castigated in his riposte to Binns.[35]

Tyler did not age as well as Binns, but he was just as belligerent and just as ruthless in his choice of weapons. He defended his *Declaration* by calling a surprise witness to testify against the Irishman and implicate him in plagiarisms even worse than his and compounded by a deliberate perversion of American history. The omission of the John Adams portrait was unforgivable, but what else could be expected of a foreign-born firebrand? Tyler's insinuations helped knock down the competition, promote his product, and gain the support of John Quincy Adams, who then went on to take a leading role in the Declaration business.

EPILOGUE

Adverse publicity compromised the sale of Binns's *Declaration*. Four years after its publication, the chastened printmaker complained that subscribers had reneged on their promises, and his agents had failed to settle their accounts. The worst offenders were in the South, where he had expected to make a handsome profit. Beset by bad debts, he never recouped his investment, which he estimated at nine thousand dollars. He received no official encouragement except in the state of Texas—not for want of trying in other states and on Capitol Hill. One of his friends introduced a bill in the Senate for the purchase of two hundred copies at nine dollars each. After being read three times it was referred to a committee, which had no objections, but a senator had it tabled without further debate. The Pennsylvania House of Representatives considered a proposition to buy two copies at ten dollars each. Sensing trouble, Binns's allies tried to divert attention by adding two copies of the Farewell Address and two copies of Trumbull's *Declaration*. Altogether the six prints would cost sixty dollars. With or without the extra prints, the measure was sidelined despite the protestations of a legislator who swore that he would vote for the Declaration even "if *Satan* himself had set the types."[36]

Binns obtained some public recognition even if he did not get a government contract. A framed copy of his print was hung above a seat of honor occupied by Carroll during the 1820 Independence Day festivities in Baltimore. Both houses of Congress were to receive copies, each displayed prominently in front of the presiding officer, and frames were to be made in Philadelphia for that purpose. What became of the Senate copy is unclear, but the copy in the House still survives in its designated place. This I can say on the authority of Samuel F. B. Morse's painting *The House of Representatives* (1822–23), where it can be seen on the south side of the room near the Speaker's rostrum (fig. 15). It is in a magnificent black

FIGURE 15
Samuel F. B. Morse, *The House of Representatives*, 1822, probably reworked
1823. Oil on canvas, 86 7/8 × 130 5/8 inches. Corcoran Collection (Museum
Purchase, Gallery Fund), 2014.79.27. Courtesy National Gallery of Art,
Washington.

FIGURE 16
Photograph of the Binns engraving (no. 6) in the National Statuary Hall.
Courtesy of the Office of the Clerk, U.S. House of Representatives.

and gilt carved wood frame with an American eagle on top, fasces supported by owls on the sides, and crossed feather pens at the bottom. At least once a garrulous congressman made it a rhetorical prop during a debate. After the House moved to new quarters in 1857, the space was converted to an art gallery now known as National Statuary Hall. The print was retained precisely as it was, although the frame must have been restored or reconstructed (fig. 16). For symmetry's sake a reproduction in a matching frame was hung on the other side of the chamber. Visitors to the Capitol can see them behind the statues and may wonder what they are doing there, but they will not find an explanation in the guidebooks.[37]

FIGURE 17 *In Congress, July 4, 1776. The Unanimous Declaration of the
Thirteen United States of America.* Washington, DC: Engraved by William J.
Stone for the Department of State, 1823 (no. 11). Courtesy of David M.
Rubenstein.

Official Facsimiles

Secretary of State John Quincy Adams redefined the function of a facsimile. He believed that the American people deserved something better than the Binns and Tyler interpretations of the text—a state-of-the-art, scrupulously accurate reproduction untainted by demeaning publicity and arbitrary artistic interventions (fig. 17). He took responsibility for the document, a prize possession of his department, a historical artifact in parlous condition but not too fragile to be handled. He once read from it out loud while giving a speech at Independence Day celebrations. As for Binns, he had many reasons to resent the work of the newspaperman, even though he had certified its veracity. He would have disliked it even more after hearing about the plans to display that print in Congress. The newspaper announcement about the copies donated to the House and Senate would have seemed at best a publicity stunt, at worst a ploy for patronage. Just a few days later, he asked Tyler to make another Declaration, an "exact fac simile" intended to be the document of record, a surrogate in case an accident should happen to the original. Tyler demanded $150 for the job, too much in Adams's opinion. He put aside his plans for the moment but kept them in mind and eventually came to terms with an equally skilled facsimilist whose work he knew and trusted.[1]

William J. Stone (1798–1865) learned the engraving trade in Maverick's shop not long before Tyler took his business there (fig. 18). He would have been trained in banknote lettering, a staple product of that shop but also a skill that could help

FIGURE 18
Hiram Powers, *William J. Stone*, 1837. Plaster. Smithsonian American Art Museum, Museum purchase in memory of Ralph Cross Johnson, 1968.155.85.

him to replicate a manuscript. In 1815 he moved to Washington where he took on commissions for "all kinds" of intaglio work, which could be printed on a rolling press he had on premises. By the 1840s he was printing lithographs as well. He supplied the House and Senate with maps, charts, and geological surveys, such a lucrative business that he had to defend it against accusations of profiteering. Adams hired him to make passports for the State Department and parchment certificates for the Patent Office. After Tyler priced himself out of consideration, Stone was an obvious candidate for the production of the official facsimile. Precisely how and when he received that commission is not known, nor are the reproduction methods he might have used. Facsimilists of this period relied on tracing techniques as well as the wet-ink transfer process, a graphic arts shortcut possibly based on eighteenth-century letter-copying machines: the original was dampened and run through a press with a transfer sheet that would take up some of the ink in a mirror image, which could then be transferred to the copperplate. Stone may have had some kind of template to start with, but he had to fill in the details with the same exacting handwork he had to master in the banknote business. It took him three years to finish the plate. In October 1822 Adams saw a proof of the signatures, which he approved, although the text was far from complete in his

opinion. Finally, in April 1823, the plate was ready to go to press, and in May the State Department authorized Stone to print two hundred copies on vellum (the same number that the Senate was to buy from Binns). An appropriate notional date was chosen for the imprint: "Engraved by W. I. Stone, for the Dept. of State, by order of J. Q. Adams Sect. of State, July 4th. 1823." Short and inconspicuous, Adams's credit line was less obtrusive than the orotund endorsements in previous facsimiles, but its significance was obvious, and it set him up as the savior of the Declaration, which was already on the verge of illegibility.[2]

Proud of his achievement, the Secretary regarded his stock of facsimiles as government property and declined at least one request for a personal copy. He put it at the disposition of Congress and received detailed instructions on how it should be distributed:

> Two copies to each of the surviving signers of the Declaration of Independence;
> two copies to the President of the United States;
> two copies to the Vice President of the United States;
> two copies to the late President, Mr. Madison;
> two copies to the Marquis de Lafayette;
> twenty copies for the two houses of Congress;
> twelve copies for the different departments of the government;
> two copies for the President's House;
> two copies for the Supreme Court room;
> one copy to each of the governors of the states; and
> one to each branch of the legislatures of the states;
> one copy to each of the governors of the territories of the United States; and
> one copy to the legislative council of each territory;
> and the remaining copies to the different universities and colleges of the United States, as the President of the United States may direct.[3]

The Secretary printed a cover letter and the text of the congressional resolution to accompany the copies he sent to the designated recipients. The Signers merited a personal letter with a longer explanation suitable for the solemnity of the occasion. He congratulated them on "this Document, unparalleled in the annals of mankind," the original of which was preserved in his department. It was his honor to present them with two copies of his state-of-the-art facsimile nearly a half century after their heroic profession of faith. The copies he gave to John Adams and Carroll (fig. 19) have survived, but the fate of Jefferson's is unknown. Altogether just about fifty are recorded in the latest census, some in state archives and

FIGURE 19 One of Charles Carroll's two copies (no. 11), detail,
transcription of his presentation inscription to John MacTavish. Collection
of Alessandra and Alexander Norcross. Image courtesy of Freeman's.

government offices as stipulated in the distribution list, but most have gone through
the trade. One of Lafayette's was sold at auction and is now in the Albert and
Shirley Small Special Collections Library, University of Virginia. As of this writ-
ing at least fifteen are in private hands, although some of them have been prom-
ised to institutions. Instead of conferring with the president, the Secretary may
have given the governors the task of selecting the universities and colleges. The
governor of Connecticut received his along with a cover letter instructing him to
take one for himself, two for the legislatures, and two for the colleges of his choice.
Extrapolating from that, one could calculate that Adams had around two dozen
to dole out as he pleased. Three copies are recorded with his inscriptions, two of
them addressed to Maryland politicians. Possibly he hoped to gain their allegiance
in the upcoming election, a conjecture repeated most recently when one of those
copies came up for sale. Perhaps he thought that Maryland would be a swing state,
which it was, but I doubt that he was exploiting the Declaration for that purpose.
If he was using it as part of his campaign, he would have inscribed more copies to
potential supporters, and more of them would have come to light by now. Also,
he would have been more likely to have sent out those Maryland copies at the
same time, but the inscriptions are in different styles. If, however, a politician
solicited a copy and seemed to be a likely ally, Adams would have looked upon
that request more favorably than the others he received.[4]

Stone deposited the plate in the State Department after he finished the two
hundred copies on vellum. The purchase order mentioned the possibility of

making more copies, but there is no record of any additional printings requisitioned by the department. In 2018 a cataloguer at the Christie's auction house compiled a census of six proof copies on paper, an enticing idea if they really are proofs in the strict sense of the term—that is, if they were pulled before the vellum printing. Until their priority can be established, however, one could just as easily surmise that they were made on a later occasion. Secretary of State Daniel Webster owned a paper copy, which he obtained as a member of Congress when John Quincy Adams was distributing the vellum copies. He claimed to have been "entitled" to it, although no one else in Congress seems to have enjoyed that privilege. In 1841 he gave it to the American Philosophical Society, a personal donation after determining that the Society could not have a State Department copy. Unfortunately, he did not reveal what the department had in stock, if anything, nor was he being entirely fair to the Philadelphians, who should have received a vellum copy the first time around. Adams designated one for them in his instructions to the governor of Pennsylvania, but unaccountably it failed to arrive. The plate remained in the department until it was transferred to the National Archives in 1965. Its history before that date is obscure, although it is sometimes mentioned in the department's records. Variants in the surviving copies indicate that it went back to press more than once during the nineteenth century.[5]

The imprint indicated the official standing of the State Department facsimile. A scrupulously honest John Quincy Adams may have been obligated to remove the imprint in a copy he took for himself and kept at his home in Quincy, Massachusetts. I make that conjecture on the basis of a copy that had been found in the Old House at the Adams National Historical Park. It has no marks of provenance and there is no documentation about its origins, but the imprint had been scraped off the parchment, as if Adams did not want his copy to be identified as government property. Additional evidence for his ownership may be construed from the condition of the parchment, either damaged along the left side or intentionally untrimmed because the margin was too narrow on that side. If the printers rejected it, Adams could have taken it for himself after ensuring that it could not be considered part of the authorized edition.

Adams's State Department successors were less concerned about the integrity of the edition. They allowed Stone to print a few copies in the 1820s or 1830s with a new imprint: *W. J. Stone Sc. Washn.* Traces of those italics are still perceptible on the plate. Washington Hood, a lieutenant in the Corps of Topographical Engineers, gave a copy to the Massachusetts Historical Society in 1838. Hood could have obtained it directly from Stone, who printed one or more of his maps, or could have commissioned it on his own. Perhaps it is no coincidence that the lieutenant's 1838 map of Oregon has Stone's imprint rendered in exactly the same style of italic

lettering. I have yet to find documentation about this printing of the facsimile, which may have been made without any formal State Department directive.[6]

Stone used a much larger imprint in all caps—W. J. STONE SC. WASHN.—for an ambitious publication project sanctioned by the government. In 1833, by an act of Congress, the State Department ordered fifteen hundred copies of Peter Force's monumental *American Archives* (1837–53), a documentary history of the nation from the discovery of Columbus to the ratification of the Constitution. Force ran out of funding before he could complete the twenty volumes he had planned, but he did produce nine volumes covering the Revolutionary period. Stone printed for him a restrike of the facsimile on thin imitation parchment, which was inserted as a folding illustration in the first volume of the fifth series (1848) next to the Continental Congress proceedings of August 2, 1776. The State Department would have given them permission to use the plate without too much interference, having already agreed to sponsor the publication.[7]

Some of the copies on imitation parchment were not folded. Either Force or the State Department could have had a cache of extra copies that were never bound in the Declaration volume. If that volume was stored in sheets, and only bound when needed, someone might have come upon the facsimiles while liquidating excess inventory and realized that they had some value on their own. Force and his partners sold the *American Archives* by subscription to supplement their income from the government. The demand for these expensive folio volumes dwindled toward the end, leaving them in a financial predicament that became increasingly urgent after they lost the support of Congress. In 1833, however, when Force embarked on this project, he requisitioned four thousand facsimiles from Stone, an optimistic figure, many more than he needed in 1848 to fulfill the government's order and the few remaining subscriptions. He would have been glad to sell separately any extra unfolded facsimiles he had on hand.[8]

There are still some unanswered questions about the Force facsimile. The quality of the reproduction is excellent, much higher than one would expect in an edition of four thousand copies. Ordinarily one would expect a copperplate to be good for a print run of maybe eight hundred to a thousand copies and that scratches, signs of wear, and other imperfections would appear in a larger edition (fig. 20). To preserve the plate, engravers sometimes resorted to alternative mass-production technologies: transfer lithography and intaglio electrotyping. Stone, for example, had gone into the lithographic printmaking business at an early date and relied on that cheap and efficient reproductive medium to make maps and charts toward the end of his career. The technique of transferring a print or drawing to the lithographic stone was common knowledge. But at first glance one can tell that the Force print is an engraving, not a lithograph, because it shows a plate

FIGURE 20
William J. Stone copperplate engraving of the Declaration of Independence,
1823 (plate shown in reverse). Plates and Facsimiles of the Declaration of
Independence, 1823–1951; General Records of the Department of State,
1763–2002, Record Group 59; National Archives (National Archives
Identifier 1656605).

mark and a rich depth of tone rather than the characteristic flat aspect of the pla-nographic process. The plate mark, however, is substantially smaller than that of the 1823 vellum edition, which raises the question whether a second plate was made by some kind of intaglio transfer process. The second plate could have been used for the production run, thus sparing the precious original. Stone had invented "complicated machines" to expedite his engraving operations and perhaps used one of them for that purpose. But why would he have put his imprint on the orig-inal plate rather than the duplicate, and how can one explain the superb quality of the Force edition? Surely some details would have been lost or altered during the transfer from one plate to the other. Forensic specialists have suggested that shrinkage may be the reason for the differently sized plate marks.[9]

Engravers employed the electrotyping process to make duplicate copies of copperplates. By 1851 the United States Coast Survey had perfected a method of making extra plates for printing maps, the main ingredient of Stone's engrav-ing business. Given a protective coating, the original plate was suspended in a cop-per sulfate solution along with a blank sheet of copper, both connected to a battery. The electric current deposited a thin layer of copper on the original to make a matrix, which was then detached and used to make the printing plate in a second electrolytic operation. Electrotypers refer to the matrix as an "alto" plate, the printing plate as a "basso" plate. The basso plate could go back to press repeatedly and bear the brunt of large editions without endangering the original. Although the Coast Survey process was well known in Washington, there is no evidence that it was used by the State Department for printing the Declaration until the end of the century. Electrotypers ran the risk of damaging the original when they had to pry it apart from the matrix. This improved process was supposed to be less hazardous, but perhaps that was not enough to convince the custodians of the plate. Apparently they preferred to print from it directly, although only on special occasions. The American Antiquarian Society has a copy on luxury hand-made paper with a watermark date of 1850, evidence that they were producing presentation copies after that date. In 1893 they distributed copies on paper to historical societies, perhaps surplus stock from a previous printing. Soon after, however, they began to think in terms of mass production. In 1894 and 1895 they obtained alto and basso electrotype plates from the United States Coast and Geo-detic Survey, which assured them that the original would not have to be used again. The basso printing plate seems to have gone back to press repeatedly. When the Bureau of Engraving and Printing inspected it in 1951, it was found to be worn and barely serviceable, perhaps capable of producing another hundred impressions.[10]

John Quincy Adams and his successors strictly controlled the distribution of the official facsimile. They were content with limited editions, just enough to reach its designated constituency: political luminaries, government bodies, historical societies, and institutions of higher education. Further research is required to ascertain what additional printings they made and on what occasions, but it is clear that they kept some copies in stock. In 1883 the Third Assistant Secretary gave one to the Superintendent of Public Buildings no questions asked. Only after the turn of the century was it made available to the public at a price anyone could afford. In the meantime printmakers like Binns and Tyler built a market for decorated facsimiles certified by government officials. The certificates satisfied the public's desire for authenticity and diverted its attention from more accurate reproductions of the document.[11]

FIGURE 21

Thomas Jefferson and John Trumbull, *First Idea of Declaration of Independence, Paris, Sept. 1786*, 1786. Graphite (Trumbull), pen and brown ink (Jefferson), 6 15/16 × 9 1/16 inches. Yale University Art Gallery, gift of Mr. Ernest A. Bigelow, 1926.8.1-.2.

🎵 Group Portraits

Better connected than his competitors, the history painter John Trumbull won a lucrative government commission and enlisted high-placed friends in his printmaking endeavors. In 1817 Congress agreed to pay him thirty-two thousand dollars for four paintings to be displayed in the Capitol Rotunda, of which the first and foremost would be a life-size *Declaration of Independence*. The enterprising artist cashed in on the fame of his *Declaration* by taking it on tour and selling a print version priced at twenty dollars, twice the price of Binns's *Declaration* and four times the price of Tyler's. Trumbull had a vexed relationship with Binns and Tyler, whose facsimiles undersold his print but also primed the market for his subject. Their advertisements evoked the drama of the document and the heroism of those who signed it, thus indirectly making his pictorial reenactment increasingly desirable.

They extolled the accuracy of their work in terms Trumbull adopted to profess similar concerns about authenticity. As a history painter he too tried to be a facsimilist but failed to meet the standards he set for himself and had to cope with worrisome mistakes in the concept of the *Declaration* and many of its details. His attempts to correct his errors compounded his confusion, and he was never entirely confident about his portraits of Founding Fathers, even though he had made many of them from life. Finally, he took a cue from his competitors and published a key to the print identifying the portraits with facsimile signatures, by then a mainstay in the trade. The iconographic borrowings went both ways: the portraits

and the key were subsumed in a later generation of prints that contained text and imagery derived from the Binns and Tyler facsimiles along with presidential portraits, allegorical motifs, and historical vignettes. Packaged in this way, the Trumbull picture was relegated to the role of an illustration, but its popularity was assured, and eventually it gained an iconic status of its own.

JOHN TRUMBULL'S PAINTINGS

Trumbull was superbly qualified to take on the Rotunda commission. His father was the governor of Connecticut, a wealthy merchant who ensured that his sons enjoyed all the career advantages of wealth and privilege. One brother was the commissary general of the Continental Army; another represented Connecticut in the House and the Senate before going on to be governor of the state for eleven consecutive terms. Following them and his father, Trumbull went to Harvard, where he excelled in the classics and studied painting on the side. He was the first college-educated artist in America. At loose ends after graduation, he joined the Continental Army and became, briefly, the second aide-de-camp of General Washington. He would never forget that honor, which is perpetuated by his tombstone, inscribed "the Patriot-Artist, and the Friend of Washington." His military service ended in a dispute about his promotion to the rank of colonel, although he continued to use the title. He returned home and tried his hand at painting portraits. Still uncertain about his future, he settled in Boston and joined in some trading ventures but then left America for London, where he resumed his art studies under the tutelage of Benjamin West. Between 1780 and 1815 the colonel went back and forth between England and America, not entirely convinced that he could make a living out of the painting profession. He set himself up as a portraitist in New York for a few years, but his true calling was to be a history painter in the grand manner like his mentor, who encouraged him and set a stirring example.[1]

Early on he realized that his most promising subject would be the American Revolution. He witnessed a battle at the beginning and resolved trading disputes at the end. In 1776 he saw the action at Bunker Hill, albeit at a distance from an outpost in Roxbury. He was John Jay's secretary during the treaty negotiations of 1794 and served on a commission that judged the claims of merchants whose cargoes had been confiscated. He was personally acquainted with the leaders of the Revolution, including Jefferson, whom he saw frequently while visiting Paris in 1786. They became close friends, and at one point Jefferson invited him to be his secretary.

Trumbull sketched out his earliest ideas for *The Declaration of Independence* during that Paris interlude (fig. 21). Until then his papers are silent on that topic,

but he could perceive its potential after interviewing the one person who knew more about it than anybody else. Here was the main author of the Declaration only too glad to describe its origins and suggest an incident that might have the makings of a compelling visual composition. They chose a scene that expressed the full force and gravity of the situation, the moment when it was submitted to Congress and read to all those present on that fateful day. Trumbull's informant even drew a floor plan showing the location of the doors, windows, and dais in the Assembly Room of Independence Hall. On that basis he could be confident of his mise-en-scène, featuring Hancock, president of Congress, seated at a table on the right and the Committee of Five standing in the center foreground. Jefferson would present to Hancock the document he had drafted in consultation with the Committee. Forming a semicircle in the background, an array of congressmen would look on at this solemn event, the exact placement of their portraits to be determined. The artist blocked out the canvas in early 1787 after returning to his studio in London. Providentially, John Adams was on a diplomatic mission to London at that time and could sit for his portrait, which was painted directly on the canvas. A return trip to Paris provided an opportunity to take the same approach with Jefferson, the focal point of the painting.

Thirty years later Trumbull could claim that he had painted thirty-six portraits from life. He produced many of them during tours of the eastern seaboard in the early 1790s, some painted directly on the canvas like those of Adams and Jefferson. He copied nine from contemporary pictures and reconstructed two from memory, although one was mainly based on a verbal description. As an assurance of authenticity, "no merely ideal head was admitted" if a reliable source could not be found. Thinking ahead, he collected portraits for a dozen history paintings, but this one ranked higher than the others and was one of four he could report to be "considerably advanced." It was put aside, however, while he pursued other projects in England and America. He got married, sought treatment for his eyesight, exhibited at the Royal Academy, and fretted about his future while detained in England during the War of 1812. Back in New York he became increasingly involved in the American Academy of the Fine Arts, which purchased four of his paintings but could not raise the money. He had to settle for an annuity and suffered other setbacks in the portrait business. "In times like the present," he lamented, "there is little demand for works of ornament or taste." The household expenses of his patrician lifestyle drove him deeper into debt.[2]

Finally, in January 1817, he brought out the *Declaration* painting and made it the centerpiece of a carefully staged patronage campaign. He went to Washington and offered his services to Congress, which was then planning to build the Rotunda section of the Capitol. Surely history paintings should be part of that

plan. They would be a means of embellishment, a source of inspiration, and a record of heroic achievements by which Americans gained the right to legislate on those premises. As a sample of what he had in mind, he displayed the still-unfinished *Declaration of Independence* in the hall of the House of Representatives. He enlisted the support of Senator James Barbour, who agreed that the Rotunda deserved a decorative scheme on a grand scale commensurate with the building. Just to be sure, Barbour asked Jefferson about the applicant's artistic credentials—and received by return of mail a testimonial ranking him higher than West, second only to David. Meanwhile, the senator introduced a resolution proposing to commission a painting of the Declaration, a larger version of the sample exhibited in the House. The project gathered momentum and grew to include four scenes of the American Revolution. Some naysayers questioned the government's role in the patronage of the arts, but all agreed on the artist's experience and skill. His friends prevailed on the basis of a cost-benefit analysis weighing the moral value of his work against its market price, a modest sum compared to the other interior decorations they had ordered. Furthermore, Americans were running out of time and needed to act now while the Revolution was still in living memory. Congress appropriated thirty-two thousand dollars for the four paintings: eight thousand dollars cash in advance, followed by payments of six thousand dollars upon the delivery of each painting. In consultation with President Madison, the colonel decided on two civil subjects and two military subjects: *The Declaration of Independence, July 4, 1776*; *The Resignation of General Washington, December 23, 1783*; *The Surrender of General Burgoyne at Saratoga, October 16, 1777*; and *The Surrender of Lord Cornwallis at Yorktown, October 19, 1781*. Madison wanted life-size figures, which prescribed the size of the canvas, 12 × 18 feet. The original painting measured 21 × 31 inches, large enough to be a trustworthy prototype for the Rotunda version, which Trumbull chalked out in September 1817 and finished a year later (fig. 22).[3]

Still chafing at his debts, he thought of other ways to monetize the Rotunda magnum opus. He realized that it was just the right size for a one-piece public exhibition, which might turn a ready profit and provide valuable publicity. Americans would see in this prestigious commission the great honor he had received by a vote of Congress, a vote of confidence that appointed him the painter of the nation. With the president's permission, he organized a series of exhibitions in New York, Boston, Philadelphia, and Baltimore, and he charged entrance fees that would accrue to his "legitimate advantage." The tour began on October 5, 1818, in New York at the Academy of the Fine Arts, which gave him the exhibition space for free and the right to collect twenty-five cents admission. (He was in a good bargaining position because he was the president of the Academy, which had fallen

FIGURE 22 John Trumbull, *The Declaration of Independence, July 4, 1776*,
1818. Oil on canvas, 144 × 216 inches. Rotunda of the U.S. Capitol. Photo:
Wikimedia Commons.

in arrears with his annuity.) In Boston he found a suitable venue at Faneuil Hall,
the meeting place of patriots during the Revolution. He did even better in Phila-
delphia, where the painting was displayed in Independence Hall, some say in the
same room where the document was signed, others in a room across the hall. By the
time he was done in Baltimore, around twenty-one thousand people had seen the
painting, and the gate receipts amounted to $4,215. The money he made came to
the attention of his adversaries in Congress who objected to his traffic in govern-
ment property and tried to obstruct the payment for the painting.[4]

The triumphant tour of the *Declaration* marks the high point of Trumbull's
artistic career. Making the most of it, he offered exhibition visitors the opportu-
nity to buy a print version almost as grand as the painting in the effort, time, and
money it required. Some financial risk was involved, but he knew what he was
doing. He could calculate the price parameters and devise a marketing strategy
on the basis of previous experience with historical prints, *The Battle at Bunker's
Hill, near Boston, June 17th. 1775* and *The Death of General Montgomery in the*

Attack of Quebec Decr. 1775. Published in 1798, they were to be the first of four-teen historical subjects, but he abandoned his plans for the series after having to cope with production delays, high costs, and slow sales. One plate cost a thousand pounds, the other a thousand guineas, expenditures dictated by the size of the prints, 20 × 30 inches. He priced them at three guineas each, half paid in advance, and started to collect subscriptions in 1790. The advance payments were to pro-vide a means of paying the engravers and forecasting the size of the edition. George Washington stood at the top of the list, other notables supported the project, and the artist's agents promoted it both in England and America. For those who balked at the expense, he published a half-size version of the prints at ten dollars a pair, also to be paid half in advance. Americans could buy a pair of the full-size version for $37.33 as late as 1807. His prints, large and small, opened up an aftermarket for his paintings and constituted a significant share of his personal assets. They were deemed valuable enough to be stored in the Bank of the United States when he left for England in 1808. He employed the same business model to sell his print of the *Declaration,* that too measuring 20 × 30 inches and demanding similar commitments from the subscribers.[5]

TRUMBULL'S ENGRAVED *DECLARATION*

Trumbull planted the names of celebrities in his subscription book starting at the top—the four living presidents of the United States. Tyler tried a similar tactic in his subscription book. But long before Tyler, Trumbull had been counting on the publicity value of big names when he asked Washington to be the lead spon-sor of *Battle at Bunker's Hill* and *Quebec.* He expected this show of support to set an example and excite a spirit of emulation in the upper echelons of American society. In letters to Adams, Jefferson, Madison, and Monroe, he explained that he had turned to them as a first step in a campaign targeted at both houses of Congress and the executive branch. With their support he could be confident in the success of his project, which would be even more expensive than his previous ventures. He intended to hire the English engraver James Heath (1757–1834), who would charge fifteen hundred guineas, or seven thousand dollars, in consideration of the size of the plate and the number of the portraits. Altogether he expected his investment in the print would be more than his income from the painting. So he had no choice but to price it at twenty dollars and ask his subscribers to pay ten dollars down, a surety and a source of working capital. His printed proposals first appeared in February 1818 and were revised as the occasion demanded. A four-page version served as a handout during the exhibition tour, configured in such

FIGURE 23
Proposals by John Trumbull, for Publishing by Subscription, a Print from the Original Picture Now Painting by Him . . . Representing the Declaration of Independence, 1818. Courtesy of Swann Auction Galleries.

a way that it could be folded into a pocket-size flyer (fig. 23). The two inner pages describe the print and stipulate the subscription terms. One of the outer pages contains a cover title, the other a key to the portraits in a numbered list naming each one of them from left to right. Visitors to the exhibition would want to have the flyer for reference while they viewed the painting and have it in hand while they thought about purchasing the print. Potential subscribers could contact the colonel or his agent, Theodore Dwight Jr., who would sign receipts for the money they received in advance.[6]

While canvassing for subscriptions Trumbull reconsidered his decision to hire Heath. The English artist was an associate of the Royal Academy, historical engraver to the king, and progenitor of a printmaking dynasty, a proven professional whose services had been in demand by painters such as West and Copley. But he was too expensive and too obviously implicated in the English establishment. Binns and Tyler had already announced their intention to employ American artists in their patriotic endeavors. What would it look like if he entrusted the Declaration to a foreigner who received royal patronage and made portraits of George III? Besides, he would have to send the prototype painting to England and would not be able to supervise the engraving in person. Rather than run those risks, Trumbull resolved that his print should be "altogether an American production" and looked for local talent in the thriving graphic arts industry of New York City. He found just what he needed in the shop of Tyler's engraver, Peter Maverick.[7]

Pupil and then partner of Maverick, Asher Brown Durand (1796–1886) mastered the art of reproductive engraving and then went on to be one of the leading painters of his generation (figs. 24 and 25). He is now best known for his Hudson River School landscapes such as *Kindred Spirits* (1849) and *In the Woods* (1855). At the beginning of his career he depended on the banknote business like

FIGURE 24
John Trumbull, *Asher B. Durand*, 1826. Oil on wood panel, 25 1/16 × 20 5/8 inches. New-York Historical Society. Purchase, Louis Durr Fund, 1895.13. Photography © New-York Historical Society.

Maverick, Stone, and others in his profession. He and his brother invented a geometrical lathe for making counterfeit-proof paper currency. Trumbull admired the skills of banknote engravers but was not sure about their proficiency in portraiture. Durand, however, had some experience in that genre and would work for a fraction of the fee Heath had requested. True, he was only twenty-four years old, but he got the job because he was a cheap, convenient, and politically acceptable alternative to the Englishman. Trumbull offered him three thousand dollars to be paid in quarterly installments of two hundred dollars, the balance upon the completion of the plate. They agreed on those terms and signed a contract on March 7, 1820.[8]

A few days later Maverick heard about the good fortune of his partner. He flew into a rage and accused Durand of perfidy and ingratitude, all the more aggravating because business had been bad and would get worse when the rumor spread that he had been spurned. He should have had that honor as the senior member of the firm. Their partnership agreement gave him the right of first refusal. "I have had suspicion of your double dealing," he complained, "but it was never reduced to a certainty until now, while you have always professed a friendship you have by every means in your power endeavoured to injure me and my business, and

FIGURE 25
Asher B. Durand, *John Trumbull*. Engraving after Samuel Lovett Waldo and William Jewett, *The National Portrait Gallery of Distinguished Americans*, 1835. Courtesy of Princeton University Library.

undermine my *reputation*." In reply to those reproaches Durand defended his conduct and claimed that he had taken on that job not to cause embarrassment but to avoid it. "The painting of Trumbull would have been injurious to you as well as me," he observed, implying that both members of the firm would suffer if the less talented of the two failed to overcome his limitations. Both parties understood what was at stake in that prestigious commission. Coming from Trumbull, a connoisseur of prints, it acknowledged the progress that had been made in the engraving trade, now capable of competing with imported goods on an equal footing. It expressed confidence in a promising newcomer, the local product, and native ingenuity.[9]

Maverick and Durand went their separate ways, one subsisting on the staple products of the trade, the other rising to the top of his profession and going on to be the nation's leading landscape painter. The *Declaration* engraving provided valuable publicity for the up-and-coming artist (fig. 26). Taking a cue from Binns, Trumbull issued progress reports to reassure his subscribers that their orders would be fulfilled promptly, indeed sooner than if the print had been engraved abroad. He invited them to see it in its etched state, which already looked like it would "do honour to the country." They could view it in the bookstore of his New

FIGURE 26 Asher B. Durand, *The Declaration of Independence of the United States of America. July 4th. 1776*, 1823. Engraving after a painting by John Trumbull, finished proof, etched state v, 20 × 30 1/8 inches. Courtesy of the Pennsylvania Academy of the Fine Arts, Philadelphia. John S. Phillips Collection, 1876.9.192a.

York agent, Andrew T. Goodrich, who would accept additional subscriptions. By then, December 1820, the advance payment was no longer required, although the best impressions would go to those who had made the ten-dollar deposit. Goodrich placed "a third proof of the plate" on display in 1821. Durand's name figured prominently in the newspaper advertisements on those occasions.[10]

Trumbull started to distribute the subscribers' copies in September 1823, just in time to dig himself out of debt. His friends realized he was in trouble and pleaded with the public to buy the twenty-dollar *Declaration*. "At an advanced period of life"—he was then sixty-seven years old—"he relies for the remuneration of his labour and services upon the liberality of that country, its government, and its citizens." The government was paying for the paintings in the Rotunda. Now the citizens should do their part in the colonel's hour of need. He owed more than thirty thousand dollars to his banker, who had started to foreclose a

mortgage on his property. He had pledged the prototype painting and the Durand copperplate as sureties for his loans. Perilously close to bankruptcy, he sold off some of his land, liquidated part of his art collection, and offered the proceeds from the print to the banker, in theory a profitable proposition. Around 1824 he drew up a balance sheet of his printmaking receipts and expenses. On one side, he had spent a total of $3,757.92 to pay Durand, buy supplies, and produce 953 copies, a maximum number of impressions before the copperplate started to show signs of wear. He did not stint on the cost of paper, seventy-five dollars a ream from the renowned Brandywine Paper Mill in Wilmington, Delaware, and five cents each for sheets of India paper, often preferred by print connoisseurs for its opacity, sheen, and ink receptivity. His unit cost could be calculated at just under four dollars, a fifth of the retail price. On the other side, his receipts amounted to $3,838. Some copies he sold himself at the full price, others he consigned to agents at a discount, but some of his agents defaulted on their obligations. After canvassing for subscriptions for more than five years, he had succeeded in selling only about 275 prints, barely enough to break even on this venture. He was "mortified" to learn that he had failed to sell a single subscription in Washington even though Dwight had put prospectuses on the desks of congressmen and had given them the opportunity to sign the subscription book, proffered at the Secretary's table for two days straight. Elected officials could spend taxpayers' money for the paintings, but not many were willing to pay out of pocket for the print.[11]

Just as humiliating and even more worrisome were Binns's and Tyler's forays in the Declarations market, both coinciding with Trumbull's proposals, one advertised at half his price, the other even less. He vented his frustration in letters to his Federalist friends in Congress, the Pennsylvania representative Joseph Hopkinson and the Connecticut senator David Daggett. Binns's *Declaration* was as repugnant as his politics. "How is it, my dear sir," he wrote to Hopkinson, "that an Irish emigrant can obtain patronage for such a work, Gothic at best—when an old officer cannot obtain it for a work, which I will proudly say will do honor to the nation in the eyes of the civilized world?" He complained to Daggett about the quality and price of the irksome print, which might seem to be a bargain next to his, but if you costed out the portraits, you could buy his room full of Founding Fathers at 42½ cents a head. That unit price compared favorably with those of other patriotic publications, such as the sixty-six cents a head you had to pay for *Delaplaine's Repository of the Lives and Portraits of Distinguished American Characters* (1815 [1816]). Besides, Binns was offering "a mere verbal copy of the Declaration" decorated with portraits, state seals, and flags "like the Christmas specimens of children at a writing school." Those were hard words but were only the beginning of his grievances against his competitors and critics.[12]

A MONGREL PICTURE

Like Binns and Tyler, Trumbull assured the public that he would uphold the highest standards of accuracy in his depiction of the Declaration. He had to second-guess the critics, however, after he put the Rotunda painting on tour and started using his print proposals as a key to the portraits. A sharp-eyed student of Declaration history had that key in hand while viewing the painting in the American Academy of the Fine Arts. Under the name Detector, he published a newspaper review quoting the proposals and collating the portraits listed in the key. He had no opinions about the artistic merit of the work but questioned the value of the portraits purchased by Congress. Soon they would be enshrined in the Capitol, yet they were a travesty of truth, a violation of "propriety and common sense." Detector knew that some of the delegates who signed the Declaration on August 2nd were not among those who had approved it on the Fourth of July. Trumbull had mixed them up in his "mongrel" picture, which included some who had voted against independence and omitted others whose likeness could not be reconstructed. A certain amount of artistic license should be allowed of course, but these faults were intolerable in a "national painting." When it came to Boston, a critic writing as Historicus made a similar roll call of delegates present and absent during the summer of 1776. He too deplored the artist's errors and omissions, which could have been avoided if he had specified which members were missing and which ones were opposed to the Declaration. The Bostonian looked for Samuel Adams and was disappointed to find him in the background, a local hero hardly more than a face in the crowd. Samuel Adams and his fellow patriots deserved better in that ill-conceived composition devoid of character and defective in design. Historicus had a good reason to hide his identity: he was Samuel Adams Wells, a grandson of the slighted Signer.[13]

Detector and Historicus also made mistakes but not in the main thrust of their head-count critiques. George Clinton, Benjamin Rush, and George Clymer had no business being in that painting. Although he had been elected to the Second Continental Congress, Clinton missed the Declaration of Independence sessions while he was serving in the New York state militia. Rush and Clymer did not take their seats until July 20th. The forty-seven names in the subscription key did not measure up to the fifty-six names in the Declaration facsimiles. Trumbull was distressed to have been found wanting and fired back with an account of his research methods—his interview with Jefferson, his conversations with others present on that occasion, his insistence on making life portraits of the surviving Signers. Unable to rely on the Journals of Congress, he had used the Declaration signatures as a "general guide," even though he knew that some

delegates had come and gone between July 4th and August 2nd. He had arranged a face-to-face meeting with Clinton, who assured him that he had been there on the Fourth. Likewise, Thomas Willing deserved a place in the painting although he had voted against independence. Trumbull sent a copy of his rejoinder to Jefferson, who sympathized with his plight and argued that an artist should be allowed to make conjectures and invoke the powers of his imagination. Jefferson remembered what he had said in Paris about the "haggard lineaments" of a Willing unable to turn the tide of history. The painter should have carte blanche to depict his discomfiture and for that matter the ridiculous wig and stockings of the Massachusetts delegate Thomas Cushing, who also opposed independence. Still smarting under these criticisms in 1822, Trumbull circulated a new version of his print proposals that explained his decision to omit the unverifiable delegates and include those seated after the Fourth of July as well as the obdurate Willing and the pacifist John Dickinson, a true patriot even though he too voted against the Declaration.[14]

Try as he might, Trumbull could not correct fundamental flaws in the painting, misconceptions based on Jefferson's faulty memory. Ten years after the event, the statesman had already forgotten what he had witnessed and had conflated in his mind the actions of (1) the Committee of Five submitting their redaction of the text on June 28th, (2) Congress approving a revised document on July 4th, and (3) Congress signing the engrossed parchment on August 2nd. He believed he had signed it on the Fourth and was all the more confident about the date because he had written an aide-mémoire about his part in those proceedings. Compelled to concede that he had signed it on August 2nd, he maintained that Congress also signed on July 4th another version on paper, which had somehow disappeared. Trumbull took him at his word, which is why the print cites the July 4th date in the title, although it actually portrays the Committee of Five presenting their report on June 28th. The jibe at Cushing was even more misleading because the dissenter was ejected from Congress months before the debate on independence. The drawing of the Assembly Room was wrong in the configuration of the doors and windows. Years later the chastened artist painted a third version of the *Declaration* in which he corrected his rendition of the interior. That much was Jefferson's fault, but Trumbull had also forgotten important details.[15]

After working on this project for thirty years, he was still adding portraits and was beginning to lose track of them. The smaller prototype painting had forty-six portraits when it was exhibited in the hall of the House of Representatives. Major General (and future president) William Henry Harrison saw it on display and noticed that his father, Benjamin Harrison, was missing. Upon subscribing for the print, he asked the artist to insert the portrait and supplied enough

information to produce an adequate likeness. Some portraits had to be moved to accommodate the new one, which brought the total up to forty-seven. In February 1819 Virginia congressmen complained that their quota of Founding Fathers had been shortchanged by the omission of Francis Lightfoot Lee, Carter Braxton, and Thomas Nelson Jr. Trumbull replied that he would be glad to make amends but not unless the Virginians could supply reliable source material for the portraits. There was no visual information for the first two, but the congressman Hugh Nelson seems to have supplied the means to depict his father, a family resemblance and perhaps a contemporary picture. He looked like him and may have even served as a model. It was too late to insert Nelson in the Rotunda painting, which had been handed over to the government, but he could take a place in the prototype. To make room for him, Trumbull switched Richard Stockton over to a new position and shifted several others as if to prevent crowding and give everyone a clear view of the proceedings. Now at a head count of forty-eight, the prototype was no longer the same as the Rotunda painting. The key contained in the subscription proposals was still valid in the Rotunda but no longer corresponded to the print, which was based on the prototype.[16]

THE following is a list of the Portraits; the numbers opposite to the names refer to the Outline of the Heads, which is placed under the Painting as a Key.

No. 1. George Wythe, *Virginia.*

2. William Whipple, *N. Hampshire.*

3. Josiah Bartlett, *do.*

4. Thomas Lynch, Jun. *S. Carolina.*

5. Benjamin Harrison, *Virginia.*

6. Richard Henry Lee, *do.*

7. Samuel Adams, *Massachusetts.*

8. George Clinton, *New-York.*

9. William Paca, *Maryland.*

10. Samuel Chase, *do.*

11. Lewis Morris, *New-York.*

12. William Floyd, *do.*

13. Arthur Middleton, *S. Carolina.*

14. Thomas Heyward, Jun. *do.*

15. Charles Carrol, *Maryland.*

16. George Walton, *Georgia.*

17. Robert Morris, *Pennsylvania.*

18. Thomas Willing, *do.*

19. Benjamin Rush, *do.*

20. Elbridge Gerry, *Massachusetts.*

21. Robert Treat Paine, *do.*

22. Abraham Clark, *New-Jersey.*

23. Stephen Hopkins, *Rhode-Island.*

24. William Ellery, *do.*

25. George Clymer, *Pennsylvania.*

26. William Hooper, *N. Carolina.*

27. Joseph Hewes, *do.*

28. James Wilson, *Pennsylvania.*

29. Francis Hopkinson, *New-Jersey.*

30. John Adams, *Massachusetts.*

31. Roger Sherman, *Connecticut.*

32. Robert R. Livingston, *New-York.*

33. Thomas Jefferson, *Virginia.*

34. Benjamin Franklin, *Pennsylvania.*

35. Richard Stockton, *New-Jersey.*

36. Francis Lewis, *New-York.*

37. John Witherspoon, *New-Jersey.*

38. Samuel Huntington, *Connecticut.*

39. William Williams, *do.*

40. Oliver Wolcott, *do.*

41. John Hancock, *President, Mass.*

42. Charles Thompson, *Sec'ry. Penn.*

43. George Read, *Delaware.*

44. John Dickinson, *do.*

45. Edward Rutledge, *S. Carolina.*

46. Thomas M'Kean, *Pennsylvania.*

47. Philip Livingston, *New-York.*[17]

KEYS TO THE *DECLARATION*

The key was wrong anyway, a case of mistaken identities. The importunate Clinton, no. 8 in the key, is actually Stephen Hopkins, whose Rotunda portrait, no. 23, properly belongs to the Pennsylvania delegate John Dickinson, and the "John Dickinson" depicted as no. 44 is the true-to-life Clinton. The art historian Irma Jaffe discovered this mix-up when she came across a preparatory study for Hopkins at Fordham University, a drawing made in 1791 and annotated with the

FIGURE 27 Asher B. Durand, key to *The Declaration of Independence*, 1823.
Engraving after John Trumbull, 6 7/8 × 31 5/8 inches (no. 13). Courtesy of
the Pennsylvania Academy of the Fine Arts, Philadelphia. John S. Phillips
Collection, 1876.9.192b.

information needed for the coloration in the painting. The person in the drawing
has nothing in common with portrait no. 23. Trumbull's full-length oil portrait
of Clinton (also made in 1791, now in New York City Hall) does not resemble
no. 8. Congressman no. 23 has refused to remove his hat in deference to Quaker
principles, which might point to Hopkins, who was born and raised in that reli-
gion, but he was disowned in 1773. Dickinson is a better candidate because he
remained in the Society of Friends all his life. Trumbull mentioned the Quaker
hat in another preparatory study but did not name its owner, as if he was already
unclear about his cast of characters. He never noticed the mistaken identities,
having more conspicuous problems to resolve in the action of his painting. The
triple transposition is understandable given the quantity of portraits and his ten-
dency to move them back and forth, but it has significant implications. The con-
fusion in the key distorts the meaning of the painting and deprives it of a poignant
detail, a dramatic crux, a crisis of conscience in a patriot who could not

countenance armed conflict against the king. Dickinson's hat helps explain his politics. To this day, guides in print and on the web persistently misidentify him and his doppelgängers—but Jaffe's emendations have not been entirely ignored. The key currently on view in the Rotunda is correct.[18]

The key was vital for the understanding of Trumbull's *Declaration*. The numbered list in the four-page proposals corresponded to an outline drawing of the portraits that had been suspended beneath the Rotunda painting while it was on tour. That drawing has not survived, but it may have been the origin of an engraved key intended to accompany the print (fig. 27). I believe that the engraved key was an afterthought designed to make the print more comprehensible and more competitive with the Binns and Tyler facsimiles. Art historians refer to it as the Durand key, although there is no evidence that it was done on his initiative. Rather, Trumbull seems to have come up with the idea while the print was being distributed to the subscribers. This time, instead of setting the names in type, the engraver reproduced the "Signatures to the Original Act," an obvious attempt to play on the popularity of the Declaration facsimiles. Critics could not complain about the presence of George Clinton, Thomas Willing, Robert R. Livingston, Charles

Thomson, and John Dickinson because their autographs were asterisked with a caveat noting that they were not among the Signers. The engraver copied the other autographs from Tyler's *Declaration*, a source better than Binns's, less humiliating to Trumbull, and more accessible than John Quincy Adams's facsimile, even though it was being printed at that time. This key is also mistaken in the identification of Clinton, Hopkins, and Dickinson, whose portraits nos. 8, 23, and 45 should have been numbered 23, 45, and 8.[19]

The engraved key was intended to be displayed in tandem with the print the same way the outline drawing was paired with the painting. At least one copy has gone through the trade in a contemporary gilt wooden frame hung by two metal chains beneath the print, which is in a matching frame. The Pennsylvania Academy of the Fine Arts obtained the two of them together by the bequest of a prints and drawings collector who died in 1876. Jaffe gave the measurements 27 1/4 × 31 inches for the key, which must be wrong unless she was describing a copy attached to the print.[20]

Separated, the key and print take on different meanings. Jefferson had a copy of the print hung above the entrance hall fireplace at Monticello, one of two framed copies he bought from Trumbull along with the "keys & description." But there was no room for the key in that space, which was just as well because it would have detracted from the drama of that scene. By keeping it out of sight, he could explicate the *Declaration* viva voce to his guests and take it upon himself to point out the participants. When a visitor asked about his feelings on that occasion, he replied "pretty much as you may imagine with a halter around his neck to be hung—for such—doubtless would have been my fate—and that too of all who signed this instrument—had we been taken by the British." Conversely, Lafayette had a copy of the key—which was displayed above a door in his bedroom not far from the State Department facsimile, a bust of Washington, a print of the Farewell Address, the text of the Constitution, and Trumbull's *Battle at Bunker's Hill* (fig. 28). A biography of Lafayette contains an illustration of the room with a caption identifying the artwork on the walls, noting that the facsimile had been "offerte au général Lafayette par une résolution du Congrès, en mai 1824." The congressional resolution allocated to him two copies, one of which came up for sale at Christie's in 1985. A Christie's cataloguer claimed that the illustration showed both copies because the caption mentions another "Déclaration d'indépendance des États-Unis. Gravure." The second Declaration has to be the engraved key, however, because of its shape, a long thin rectangle, just the right proportions to fit between the door and the ceiling. Measuring as much as 11½ × 33¼ inches, the engraved key is the only Declaration print that could have been

FIGURE 28
Lafayette's bedroom, diagram showing the placement of Trumbull's key (item 27) and the State Department facsimile (item 28). In Jules Cloquet, *Souvenirs sur la vie privée de Général Lafayette* (Recollections of the private life of General Lafayette), 1836. Courtesy of Princeton University Library.

squeezed into that space. The outline portraits helped enliven Lafayette's iconographic scheme, which celebrated his military prowess and political accomplishments with the same agenda as the conversation pieces in the entrance hall at Monticello. Lafayette's top priority was the facsimile text, the gift of a grateful nation and a precedent for the Declaration of the Rights of Man and of the Citizen. He helped draft that other declaration in consultation with Jefferson and shares with him the honor of having written a founding document for his country, an eloquent statement of democratic ideals. For these elder statesmen, these prints were graphic reminders of how they had fought for liberty and justice.[21]

At age seventy, Trumbull might have retired after installing his paintings of the Revolution. He might have abandoned his printmaking ambitions after failing to compete in the Declaration business. But he foresaw other opportunities for government patronage based on the reputation he had built in the Rotunda. He published a pamphlet description of the paintings and, having learned his lesson, compiled a key for each of them. (The *Declaration* key had to account for forty-seven portraits, one less than in the engraving key but equally askew in the identification of Clinton, Hopkins, and Dickinson.) Once again, he explained his intentions in response to the critics and noted that the four paintings were just part of a project comprising twelve scenes of the American Revolution. Anyone who used that guide on site would notice four empty niches that could be filled with paintings in the same size and style. The copyright statement in the pamphlet is dated August 22, 1827. Pursuant to a resolution of April 6, 1827, the American Academy of the Fine Arts published Trumbull's proposals for a series of historical prints subsidized by the government. Here too he called on his

extensive experience in the service of the nation. He calculated the start-up costs of the project on the basis of his *Battle of Bunker's Hill* painting and the *Declaration* engraving. An eminent painter could be hired to record an important event in a half life-size canvas to be displayed in the White House, the painting could be copied onto a plate perhaps two-thirds the size of the *Declaration*, and the plate would be good for an edition of two thousand copies, of which a thousand could be sold at ten dollars each. The remaining one thousand copies could be used to adorn public buildings and embassies abroad. Americans could learn from art patrons in England and France the mercantilist advantages of encouraging local talent instead of sending money overseas, and it would be advisable to start while it was still possible to delve in the recent past and employ an eyewitness who could re-create it with "absolute authenticity." The implications were obvious in the Rotunda pamphlet and the print proposals but did not inspire any action. By this time Trumbull's artistic powers were in decline, and he could no longer count on his political connections. He did not give up on history painting—that he could do on his own—but he could not embark on another printmaking venture without subscription assurances and a subvention.[22]

THE ICONIC *DECLARATION*

Despite these disappointments, Trumbull could not complain that the *Declaration* print had been neglected. In 1833 it came back on the market after a "considerable sum" had been paid for the copyright. Printsellers began to offer it at half price, perhaps a discount rate for restrikes. A good impression had become prohibitively expensive—as much as twenty-five to forty dollars in a frame—because "the plate is worn out." The advertisements I have seen are not entirely accurate but one contains an intriguing account of the plate, which had been stowed away in a New York City bank vault. Perhaps Trumbull kept the plate in his control so as not to compromise his work with inferior reimpressions. He took similar safekeeping measures in 1808 when he locked up his stock of prints in the Bank of the United States. But then, late in life, he appears to have retired from the printmaking business and surrendered his *Declaration* to the highest bidder. If he did sell the copyright, the new owner did not object to a spate of cheap reproductions in the late 1830s and early 1840s. New printing technologies made it possible to produce larger editions at a lower price. A fifty-cent steel engraving (no. 38) will be discussed below. The Philadelphia lithographer John T. Bowen published a version in color the same size as the Durand original. Also the same size, a steel mezzotint by Henry S. Sadd accompanied with a key (no. 45) could be had for

two dollars. The *New-York Mirror* weekly literary journal commissioned John Francis Eugene Prud'homme to supply a small folio steel engraving for a series of frontispiece illustrations. Copies of the engraving were issued separately, as was a key with the portraits in stipple, the text in letterpress, and the signatures in facsimile (no. 44).[23]

In 1848 the engraver Waterman Lilly Ormsby took the next logical step and integrated the key in a full-size reproduction of the Durand engraving (no. 52). Until then it had been kept at a distance from the engraving so as not to detract from the dramatic impact of the scene. Ormsby's solution to that graphic problem was to deploy his numbering system in a long strip beneath the title lettering, the outline portraits in the center, and the facsimile signatures at either end. Subordinated at the bottom of the print, the portraits and signatures are so faint as to be barely perceptible unless the viewer gets close enough to read the numbers and identify the participants. Ormsby cut down the flourishes in the facsimile signatures to keep them out of sight and downsized the Hancock signature to make it blend in with the others. Nonetheless he retained a semblance of the autographs, which were then standard practice in the trade. Like Sadd and Prud'homme, he could claim to have improved on Durand's work by replicating it in steel, a more durable and cost-effective printing medium if more labor-intensive than copperplate techniques. It took him two years to finish the print, but he could sell it at five dollars and make it available in bulk. It was so cheap that it was used as a promotional giveaway for magazine subscriptions. The plate or electrotypes of the plate were reprinted several times before, during, and after the Centennial.[24]

Trumbull's *Declaration* could be seen in paintings, prints, and books. The image became a national icon while it went from one medium to the next and then back again in different formats, price points, and artistic interpretations. A succession of printmakers adapted it in response to technological changes and the demands of the marketplace. After Ormsby the next in line was Robert Metzeroth, who copied the Durand engraving or one of its derivatives to illustrate the *Declaration* in a guidebook for tourists, *The National Picture Gallery in the Rotunda of the Capitol* (1860). By that time artists were no longer quite so careful to distinguish between the Rotunda painting and the prints, which included an extra portrait and a readjusted array of congressmen. Metzeroth used a print as the basis of his illustration, even though the caption states that it was "From the Original Painting in the Rotunda of the Capitol," standard language in his day but patently false in regard to the portraits. The guidebook includes a key to the painting, and that too is based on a print, although here Metzeroth detected the discrepancies and tried to fix them. The portrait numbering conforms to an earlier Rotunda key approved by Trumbull. But Richard Stockton is facing in the wrong

direction, and the North Carolinians Joseph Hewes and William Hooper have been switched around. With a new twist, the problem of mistaken identities persists in the Metzeroth key, modernized versions of which appear in guidebooks authorized by Congress and online histories of the Declaration.[25]

The chain of transmission is equally convoluted in Charles A. Goodrich's *Lives of the Signers to the Declaration of Independence*. First published in 1829, it is the most persistent if not the earliest book appearance of Trumbull's portraits. It is difficult to count the number of editions because it was reprinted from stereotype plates, not always updating the edition statement, but it seems to have gone back to press at least ten times before 1842, when it was retitled *Lives of the Signers of the Declaration of Independence*. All the editions I have seen contain a frontispiece engraving after Trumbull by Illman & Pilbrow, possibly a steel engraving. By 1842 the plate was showing signs of wear but was still in printable condition. One of the copies came into the hands of the folk artist Edward Hicks who is thought to have copied the frontispiece in at least four paintings during the 1840s. In 1851 A. S. Barnes & Co. adopted that publishing formula for a cheap twelvemo schoolbook with the same title as the Goodrich 1842 edition, but the text came from another work by Nathaniel Dwight. Instead of an engraved frontispiece, Barnes commissioned an expeditious wood engraving, which had to be truncated to fit the twelvemo format. The artist tailored the image to the correct proportions by eliminating six congressmen at one end of the Assembly Room. The full complement of congressmen appears in the wood-engraved frontispiece for the octavo *Biographical Sketches of the Signers of the Declaration of American Independence* (1848) by Benson J. Lossing, a prolific writer on historical subjects and a partner with William Barritt in the engraving business. Lossing & Barritt signed the frontispiece but neglected to credit Trumbull. Their wood engravings of this scene appear in other Declaration publications: an article by Lossing in *Harper's New Monthly Magazine* (July 1851); a letterpress facsimile of the Rough Draft with state seals circa 1860 (no. 66); and a similar rendition of the state seals with presidential portraits from Washington to Grant circa 1876 (no. 95).[26]

Those letterpress broadsides were mass-produced imitations of engravings. They employed the same decorative motifs and design elements translated into type ornaments, wood engravings, and metal cuts. They replicated the engraved calligraphy with script types. To my knowledge, Boston engravers were the first to think of Trumbull's picture as an ancillary illustration, the first to publish prints where it was subsumed in a larger scheme featuring the Declaration text and the facsimile signatures. In 1838 the Franklin Print Company of Boston took the Binns cordon of state seals and combined it with medallion portraits of the

FIGURE 29
The Declaration of Independence, with Fac-Similies of the Signatures and Likenesses of the Signers. Boston: James Fisher, ca. 1841 (no. 38). Courtesy, American Antiquarian Society.

presidents to make an ornamental border around a reproduction of the Durand print, the text in ornamental lettering, facsimile signatures, and a key. The fac-simile signatures were numbered in accordance with the key but were designed to look like they had been inscribed beneath the document. This conceit proved to be popular enough for the plate to have been taken over by other publishers who reworked it several times to keep it up to date (fig. 29). Another Boston publisher issued a miniature *Declaration* with similar design features, including a vignette after Trumbull (no. 37, 1839 edition). The publisher inserted the vignette in the place of a Washington portrait, which had been a main attraction in a previous edition. Apparently, he had detected a change of taste in the Boston market and decided that the Founding Fathers would be more desirable than the father of the country.

A multimedia exhibition may have brought about that change in taste. In 1837 a Boston gallery presented a life-size tableau of mannequins reenacting the ratification of the Declaration, each of the fifty-six Signers dressed in period costume.

This inspiring spectacle could be seen for twenty-five cents, children half price, from eight in the morning until ten at night. The proprietors called it the Great National Exhibition, a title possibly derived from a much-used and abused advertising tag for the Great National Painting. A broadside advertisement assured the public that it was not a painting, although the set designer must have relied on Trumbull's work for some of the mise-en-scène. The Committee of Five takes center stage, Franklin to the left of Jefferson, Adams to his right, and Livingston and Sherman behind them, while Jefferson submits the Committee's text to the president of Congress. The Great National Exhibition had already traveled through Philadelphia, Baltimore, and New York. Bostonians produced a steady stream of Declaration prints and broadsides before and after it arrived in town, but surely it is no coincidence that they copied Trumbull's *Declaration* in at least six editions issued between 1838 and 1841.[27]

The Boston editions set a precedent for the use of that scene. Trumbull's *Declaration* supports a ring of presidential portraits in an 1844 lithograph by Nathaniel Currier. It illustrates Tyler's calligraphic text and facsimile signatures in lithographs circa 1859–63, some mounted on rollers as if intended for classroom viewing (no. 63). A Philadelphia printmaker had it engraved as a headpiece above a letterpress text and framed the composition with a blind-embossed border (no. 48). A New York lithographer made it a visual footnote in an immense pictorial construction featuring portraits of presidents, state seals, views of government buildings, and allegories of Liberty and Justice (fig. 30). Taking a shortcut, he copied the facsimile signatures from a key and thus depicted only forty-eight instead of the usual fifty-six. During the Centennial, adaptations could be seen in books, fairground souvenirs, keepsake calling cards, and color-printed cotton handkerchiefs (fig. 31). Full-size plate-paper photolithographic reproductions with a key were sold at ten cents to fifteen cents in quantity, twenty-five cents each, or thirty cents bundled with an electrotype facsimile of the text (no. 85). The iconic image replaced a view of Monticello on the reverse of the Bicentennial two-dollar bill, which is still in production. Like Barnes's schoolbook, the two-dollar bill omits some of the portraits to fit the others within the designated space. The Bicentennial thirteen-cent stamps reproduce the prototype painting in a strip four stamps across, a space long enough to include all of the painting's forty-eight portraits. To this day, the portraits are a staple product of the global collectibles industry. Plates, pitchers, creamers, medals, wall plaques, jigsaw puzzles, calendars, postcards, and framed giclée reproductions on canvas are just a few of the novelties currently available online.

In one version or another—the prototype, the Rotunda painting, or the Durand print—Trumbull's *Declaration of Independence* is a touchstone of

FIGURE 30
*The Presidents of the United
States and Declaration of
Independence.* New York:
Louis R. Menger, 1849 (no. 54).
Prints and Photographs
Division, Library of Congress,
LC-DIG-ppmsca-10759.

American history. It has prevailed over all other attempts to depict that event despite its omissions, inaccuracies, and artistic failings. Critics complain about the static composition, the pedantic details, and the monotonous array of portraits. Indeed, this deliberative body seems staid and expressionless in comparison to his bravura battle scenes *Battle at Bunker's Hill* and *Quebec*. Other artists envisaged more energetic proceedings, most notably Charles Édouard Armand-Dumaresq, whose *Déclaration de l'indépendance* (ca. 1873) was displayed at the Centennial. He took Trumbull's Assembly Room, turned it around, and populated it with gesticulating congressmen, some with arms upraised as if they were taking the Tennis Court Oath. His concept may have influenced Howard Chandler Christy's equally animated *Signing of the Constitution* (1940). Neither of these paintings have kindled any popular interest or critical esteem.[28]

Trumbull's approach was more successful because it expressed the spirit of the occasion, the Enlightenment ideals of order, reason, natural rights, and social equality. His *Declaration* shows democracy in action, although the action is mainly

FIGURE 31 *Declaration of Independence of the United States of America 4th.
July 1776.* Cotton handkerchief, ca. 1876 (no. 94). Collection of Shelburne
Museum, museum purchase, 1959, 1961-1.256. Photography by Andy Duback.

apparent in the heroic resolve and decorous impassivity of the participants.
He made an extraordinary effort to paint them as individuals, each with distinc-
tive features but united in their shared convictions. Like the Declaration facsim-
iles, his work was designed to be viewed up close with a scrupulous attention to
detail. Its subject and its graphic affinities with the facsimiles brought it into a
close relationship with script. He intended it to have a documentary function.
It records the creation of a text and partakes of the textual tradition by incorpo-
rating the facsimile signatures in the key. That may have been a marketing ploy
at first, but eventually the combination of key and portraits joined the canon of

Declaration iconography and became a standard ingredient in the monumental patriotic prints of the nineteenth century. Forty items in this book's checklist contain the Trumbull picture in one form or another. After allegories went out of fashion, it continued to be reproduced on its own, usually without any attempt to identify the portraits. Of the artists discussed here, Trumbull is easily the foremost in fame and reputation, but even he had to cater to public taste. He too adopted the marketing methods and sales techniques of Binns and Tyler.

FIGURE 32 *Memorial Chart. Centennial Jubilee.* Philadelphia: David Kohn,
ca. 1876 (no. 93). Library Company of Philadelphia.

The Print Trade and the Centennial

Trumbull was not the only one to copy his competitors. Opportunistic publishers seized upon the most desirable selling points of the Declaration and kept an eye out for novelties with commercial potential. They imitated the layout, illustrations, and calligraphy of previous prints. Nearly everybody borrowed decorative motifs and patriotic emblems, standard fare such as the American eagle, the Liberty Bell, and Independence Hall. Transfer lithography, stereotyping, and other duplicating technologies made it easier to appropriate imagery and replicate a text. The checklist identifies more than a hundred individuals or firms involved in the Declaration business: advertisers, artists, engravers, letterpress printers, mapmakers, newspaper proprietors, writing masters, and other members of the graphic arts industry. Some aimed at the top of the market, others at the bottom. Priced in pennies, cheap stereotype broadsides combining the Binns border and the Tyler text offered the same iconographic ingredients as expensive engravings suitable for framing. We shall see the cross-marketing methods of James D. McBride, who sold impressively authenticated actual-size lithographs and bulk quantities of giveaway keepsakes, which helped promote the larger lithographs.

McBride was the leading purveyor of Centennial facsimiles. Another publisher pirated his prints and adopted the same merchandising formula, by no means the only piracy documented in the checklist. Market entry was not expensive, bestsellers were free for the taking, and the pictorial paratext grew larger and

more complex during the Centennial. This chapter will explain how these visual traits were transmitted in succeeding generations, how facsimiles became a print-making genre, and how they could depict the document in different ways while retaining a semblance of authenticity.

THE PROGENY OF BINNS AND TYLER

The process of replication begins with Binns and Tyler. Each founded a family of prints, Binns with his allegorical approach incorporating the state seals in an emblematic border, Tyler with his rhetorical rendition in calligraphic scripts. More than 70 percent of the prints described here were derived in whole or part, directly or indirectly, from these archetypal designs. Letterpress printers constructed the cordon of honor border out of factotum frames and stock cuts of the state seals. Likewise, they simulated the calligraphic treatment with script type and a variety of decorative letter lighter and heavier in weight, typographic cues to lower or raise the voice like the dynamic markings in a music score. Engravers and lithographers employed similar expedients.

Most of all, the copyists needed a source of facsimile signatures. Printed in a limited edition, intended for official use only, the State Department facsimile was not available to members of the trade, who looked elsewhere for a serviceable master image. They found what they wanted in the government-certified Binns and Tyler engravings as well as their numerous descendants, many of which also bore authentication statements. In fact, the fifty-six names were the only components of those prints rendered in what we would consider a facsimile, Tyler's truer to the original than Binns's but both with identifiable idiosyncrasies. The writing master couldn't help but improve on the originals, regularizing the rhythm of abutting letters and unconsciously correcting the signs of carelessness and haste. The autographs in the allegorical print had to be truncated to fit in that crowded composition. Both sets of signatures remained in common use throughout the century but were reconfigured for different applications. They were parodied in a teetotaler broadside signed by workingmen who had turned against the bottle. They were crammed together in miniatures, tabulated in columns, and strewn about the page to make a pleasing pattern—but they all belong to one family or the other.[1]

These genetic relationships are easily perceptible but can be complicated because the two families frequently intermarried and exchanged motifs with other graphic mediums, mainly magazine and book illustrations. The signatures could come from one source, the design concept from another. I can trace reciprocal

influences between books and prints, but I may have missed some of the links in the chain of transmission. On one hand, the prints are so rare that some are sure to have disappeared entirely. On the other, the books are so common that it is hard to sift through the reprints and new editions. Either way, I may have skipped over one or more intermediaries in my attempts to describe the dissemination of the text and signatures. With that caveat, however, I will give two examples of book publications predicated on the popularity of the facsimiles. Returning what they had taken, they inspired greater interest in the Declaration and provided source material for new generations of facsimiles.

Both families influenced the gestation of Joseph M. Sanderson's monumental nine-volume *Biography of the Signers* (1820–27), edited in part by his brother John Sanderson. Historians credit their work with promulgating the cult of personality in Declaration history, setting the tone for other hagiographic ventures during and after the Centennial. Such was the prestige of this landmark publication that it was known as *Sanderson's Biography of the Signers* long after the Sandersons had abandoned it. But it might seem even more ambitious in consideration of its origins and sources. Most accounts fail to mention the impetus it received from prints and the financial perils its publishers faced on the verge of America's first great economic disaster, the Panic of 1819.

Joseph Sanderson got started in the Declaration business by selling the Tyler print (no. 3) and the Woodruff piracy (no. 5). He advertised them along with other art products in a Baltimore looking-glass and picture-framing establishment operated by the firm Sanderson & Ward, active circa 1818–1819. Sanderson & Ward announced that they were Tyler's agents in Baltimore and ordered at least a hundred copies from him, but, brought down by the Panic, they defaulted on their debts. After Tyler took them to court, the city marshal inventoried their assets, which amounted to only $130. Whatever was left of the hundred copies does not appear on the inventory, a one-page document describing their entire stock-in-trade as two large mirrors and three small ones. The piracy did not burnish their reputation. They admitted its dubious origins and scoffed at Binns's complaints in advertisements meant to tempt customers whose moral scruples might yield to a budget price. It cost four dollars plain or twelve dollars in a frame.[2]

Sanderson's dealings in the print market encouraged him to launch the *Biography of the Signers* on his own account. He enlisted the journalist Paul Allen to take charge of the editorial department and issued subscription proposals in December 1818. Surely, he wrote, there would be a strong demand for his publication given "the avidity so recently displayed for the possession of the Declaration of Independence." For purchasers of the prints, his work would be required reading, "since it is of very little import to become acquainted with a man's

hand-writing, without a previous knowledge of the man." Subscribers could expect to receive half volumes of about 150 pages octavo, maybe ten altogether, and could pay for them on delivery.[3]

Each installment would cost $2.50. Sanderson published it in parts so that his subscribers would not have to pay for it all at once. Also, he realized that his authors would need time to write the fifty-six biographies and that he would need a steady income to stay afloat during those troubled times. If all went well, he could expedite his return on investment, preserve his working capital, and build a revolving fund by which he took the proceeds from one part to pay for the production of the next one. The first part did not appear until November 1820, perhaps delayed by his tribulations in Baltimore. Meanwhile he moved to Philadelphia and replaced Allen with his brother as editorial director of the project. To keep the project in the public eye, he issued a handsome eight-page prospectus prefaced with four pages of facsimile signatures "Copied from Mr. J. Binns' Print" by the Philadelphia engraver John Warr Jr. This is the first appearance of the Warr signatures, which would go on to have a life of their own. Sanderson relied on them to promote his publication and included them in the first half volume, an essential ingredient cementing the connection between books and prints.[4]

The economic turmoil after 1819 drove several Philadelphia publishers out of business, Sanderson included. After publishing two volumes, he relinquished the *Biography of the Signers* to another Philadelphia publisher, Ralph W. Pomeroy. His brother left at the same time to be succeeded by other editors, who produced volumes three through nine. Pomeroy continued to recruit subscribers and avoided awkward explanations about the fate of his predecessors. To that end, he rebranded volumes one and two by reissuing the leftover sheets with new engraved title pages bearing his name and the dates 1823 or 1824. The substituted title pages have duped historians into thinking that Sanderson's work first appeared in 1823, a dating error that has obscured the formative influence of his printselling career.[5]

The Warr signatures appeared in later editions of Sanderson but also doubled back into the print trade. The engraver shared his 110 Walnut Street address in Philadelphia with the publisher Robert Desilver, who employed him in several illustration projects. Desilver inserted the signatures at the front of Joel Barlow's *The Columbiad* (1807), a window dressing for remaindered copies that had been dumped on the market in the 1820s. Many of those cut-price copies are in elaborate gilt-tooled bindings executed in his shop. A deteriorated version of the plate furnished patriotic front matter for his *Speeches, Addresses and Messages of the Several Presidents of the United States* (1825). Eleazer Huntington, a writing master in Hartford, copied Warr when he produced his calligraphic *Declaration* in the early 1820s (fig. 33). He subscribed for a copy of the Tyler print and used it as a model

FIGURE 33
In Congress July 4th. 1776. The Unanimous Declaration of the Thirteen United States of America. Hartford, CT: Eleazer Huntington, ca. 1820–24 (no. 8). Donald A. Heald Rare Books.

for his layout, but apparently Tyler's signatures were less accessible or more difficult to transfer to his engraving. Similarly, the anonymous engraver who imitated the Woodruff piracy (no. 9) supplied facsimile signatures after Warr, a competitive advantage since the autographs were lacking in the early states of the piracy. The Warr version remained in circulation as late as the Centennial, when it appeared in a splendidly printed memorial volume published by the Boston City Council. By that time it had dropped out of *Sanderson's Biography of the Signers*, which had been whittled down to a one-volume abridgment, but the earlier editions remained in circulation and helped propagate this branch of the Binns family.[6]

My second example concerns the other iconic manuscript of the Declaration, Jefferson's Rough Draft. Here too we see the interchange between books and prints as well as the proliferation of Binns and Tyler graphic motifs. The checklist in this volume contains seven reproductions of the Rough Draft, probably just a sampling of those once commonly available in the trade but now so rare as to be recorded here in only one or two copies. The first facsimile appeared as two folding plates at the end of Thomas Jefferson Randolph's *Memoir, Correspondence,*

FIGURE 34
*Declaration of Independence.
July 4th, 1776.* New York:
William R. Knapp, 1868
(no. 75). Courtesy of Swann
Auction Galleries.

and Miscellanies from the Papers of Thomas Jefferson, volume four (1829). Randolph
or his publisher commissioned it from the Philadelphia banknote engraver Charles
Toppan, who would go on to be a prominent member of the trade and the presi-
dent of the American Bank Note Company (no. 41). Toppan's work was excellent
and is still valuable because it displays details that have been obliterated over time.
It was reprinted in *Sanderson's Biography of the Signers* (1847) and probably else-
where, but slightly different versions appear in nineteenth-century publications,
whether alterations of Toppan's engraving or new redactions I cannot tell. The
variant versions circulated widely in pamphlets at the outbreak of the Civil War
and during the Centennial. One publisher claimed to have sold thirty-five thou-
sand copies and offered bulk quantities to the trade at sixteen dollars per hundred.
One of the pamphlets became a print by way of a newly invented photolitho-
graphic process (fig. 34). A New York firm bought from the inventor the rights to
use an immense copying camera and transfer-paper techniques in the production
of maps, plans, and diagrams. Its technicians extracted from the pamphlet the
text of the Rough Draft and the facsimile signatures, which were then inserted
next to other images—Trumbull's *Declaration*, the key, and, in one print, a view
of Independence Hall. That patchwork composition epitomizes the anachronisms
inherent in the Declaration genre. While purporting to represent the solemnities
of July 4th, it conflates Jefferson's writing assignment on June 11th, the Commit-
tee of Five's report on June 28th, and the signing ceremony on August 2nd.[7]

The Rough Draft has intriguing graphic features on its own. It gives a glimpse
of the creative process and the writer at work, whose interpolations and crossings-
out show the stop-and-go development of his exposition, the false starts, second
thoughts, and the sudden onset of a felicitous expression. Historians have studied

it for evidence in the authorship controversy, some believing it to be the documentary proof of Jefferson's primacy, some seeing significant revisions by his colleagues in Congress. Taken to an extreme, the controversy pits the Romantic view of the author against sociological readings of literary texts. Federalists and Republicans disagreed on who should get the credit for the text just when they began to appreciate its importance. That is one reason why the Rough Draft survives. Jefferson kept it for reference and annotated it when his contemporaries began to question his contributions. The facsimiles may have skewed the debate to some degree because most of them omit his marginal notes identifying the revisions of Franklin and Adams. I do not believe there was any interpretative agenda on the part of the printers but rather a stylistic decision to trim off the marginalia so they could run the text in columns. Nonetheless, reframed in this way, it looks like the one and only "original" Declaration and reinforces the idea that handwriting reveals the author's intentions.[8]

The facsimilists extolled the expressive power of the written word. The fifty-six signatures represented courage and commitment, each an act of patriotism, each a mark of character. Likewise, the Rough Draft communicated the convictions of the author and displayed a meaning of its own impossible to express in a typeset transcription. Jefferson's denunciation of the slave trade is the longest and most eloquent of the grievances against the king and the most memorable of the deletions imposed by Congress. The sincerity of his sentiments has been disputed, but his critics might have read more into the document instead of taking the transcriptions at face value. Jefferson used graphic devices to indict George III for that "execrable commerce" and convey a sense of outrage. The phrase "Christian king of Great Britain" acquires extra irony in the Rough Draft, where he wrote the word "<u>Christian</u>" in letterspaced roman rather than the cursive he used for the rest of the text and then underlined the word for good measure. He goes on to castigate the king in extra-large letterspaced caps for his inhumanity toward "MEN." Well versed in the conventions of eighteenth-century typography, he might have expected Dunlap's compositors to set those words in the same letterspaced caps and small caps they would use in the last paragraph. The same typographic sensibility can be seen in copies of the Rough Draft he wrote out for his friends. The plain caps and italics in modern editions are reticent in comparison and make no attempt to replicate these rhetorical signs of indignation. In the facsimiles, however, the slave trade grievance immediately draws the eye and becomes a pivotal part of the argument. It is no coincidence that there was a surge of Rough Draft reproductions in books and prints just before and during the Civil War.[9]

The least accurate and most pervasive of the reproductions occupies a two-page spread in the *Harper's Weekly* of July 3, 1858. The slave trade paragraph is at

the center of the composition, the text in three columns, and the signatures in a rectangular block wedged together to fit inside the margins. The signatures descend from Tyler by way of a folding plate in Robert Sears's *Pictorial History of the American Revolution* (1845), a popular bestseller already in its twenty-seventh thousand by 1848. Here, however, they take on a different meaning, as if the southern delegates had come to their senses and favored abolition after all. *Harper's* commentary does not divulge the origins of its Rough Draft, which might have been custom-made or copied from an intermediary print or book I have not seen. One possibility is the mammoth weekly newspaper *Brother Jonathan*, which displays the Rough Draft and the Sears signatures in a pictorial supplement for July 4, 1848.[10]

Widely circulated and easily copied, *Harper's* letterpress version became the springboard for similar reproductions. New York printers took it bodily, framed it with state seals, and appended a Trumbull wood engraving with a key to make an *Original Declaration* (no. 66), which in turn provided the signatures, the seals, and the Trumbull image for one of the Centennial Declarations (no. 95). A *Centennial Offering* turns the *Harper's* version into a lithograph illustrated with portraits, landmarks, battle scenes, the Liberty Bell, and other patriotic motifs (no. 90). The largest print in the checklist is a gargantuan enlargement of the Rough Draft with the signatures compacted in a block at the bottom (fig. 35). From Sears the signature block inherits several substantive mistakes, including the misspellings Rutlidge and Hayward. Despite those defects, despite the fact that it is at least four times removed from the original, it is still in circulation and serves as the cover illustration in the most recent edition of Wills's *Inventing America* (2018). I could cite other examples of the back-and-forth exchange between books and prints, but these two, the *Biography of the Signers* and the Rough Draft, should suffice to show the growth of this genre and its many mutations in form and content.

THE FRAMERS OF THE DECLARATION

As if destined for display, the text of the Declaration fits neatly on a single sheet of paper. The Dunlap broadside was printed on a sheet approximately 21 × 16½ inches, the standard post size of that period. Other early broadside editions were printed on paper the same size, although printers sometimes opted for a smaller format in two columns. The New York printer John Holt understood the display potential of the two-column text, which occupies an entire page in the July 11, 1776, issue of his *New-York Journal*. He told his readers that they could detach

FIGURE 35
Fac-Simile of the Original Draught of the Declaration of Independence. In General Congress Assembled 4th. July, 1776. Chicago: Kurz & Allison, 1896 (no. 109). Prints and Photographs Division, Library of Congress, LC-DIG-ppmsca-08314.

that leaf and "fix it up, in open view, in their Houses, as a mark of their approbation." Then he took the same typesetting and printed a broadside version with adjustments in the border and spacing to accommodate an endorsement by the New York Convention. Some newspaper proprietors took Holt's concept one step further and issued separate supplements designed to be viewed on their own (nos. 2, 15, 26, 64, 101, and 107), although some were so cheaply produced that they were obviously ephemeral. The *New York Times* carries on that tradition by printing a full-page reproduction of the State Department facsimile on the Fourth of July.[11]

Picture framers understood the commercial potential of the Binns, Tyler, and Trumbull Declarations. Binns's newspaper carried advertisements for picture glass large enough to cover his print. The copy he donated to the House of Representatives is still on display in a reconstructed version of the original frame, which must have been a masterpiece of ornamental wood carving (fig. 16). A looking-glass store in Albany was selling half-price copies of Trumbull's *Declaration* after the artist quit the printmaking business (p. 80). Tyler contracted

with a paint and looking-glass store in Baltimore to manage sales in that area (p. 91). He urged his customers to consider how they might display his print in a well-appointed parlor, how they could use it to show patriotic spirit as well as artistic taste and social status. Dramatizing those aspirations, he imagined a scene in which the head of the family assembles the children beneath that symbol of civic virtue and tells them "there hangs the pledge which secured your liberty and rescued you from the jaws of tyranny." A Philadelphia antiquarian obtained wood from the table on which the Declaration was signed to make the molding around his copy, one of sixteen pictures he had framed in "relic wood." The publishers of a one-foot-square steel engraving promoted it as a "cabinet picture" suitable for a more intimate setting in the study or one of the smaller rooms of the house (no. 38). On the other hand, the framer Louis R. Menger made business for himself by publishing the second-largest item in the checklist (no. 54), just one of his generously proportioned offerings in a product line featuring "French Pictures, very handsomely framed, suitable for a bar or club room."[12]

Not many of the original frames have survived. One vintage example may be on a copy of Binns's *Declaration* donated to the Library Company of Philadelphia by James Rush (1786–1869), son of the Signer Benjamin Rush. Much easier to document are the copies laid down on linen and mounted on rollers. Like maps, they could be taken out of storage and unwound on a wall when needed for reference or instruction. Some were coated with a protective varnish, now sadly cracked and discolored. The map publisher Horace Thayer seems to have varnished his publications as a matter of course (no. 63), as did Tyler in his later years. At least two of the Tyler *Declarations* were mounted on rollers.

During the 1820s, Declaration prints became common fixtures in American homes. An 1822 probate inventory lists a facsimile and a companion print, the "Signers thereto," among the household goods of a shoemaker, an ardent patriot who had served in the Revolutionary army. Both pictures were in gilt-edged frames. Travel writers remarked on the framed facsimiles they had seen while they toured town and country, not just in private spaces but also in inns, schools, and public buildings. The Hungarian political reformer Alexander Bölöni Farkas praised the natural rights basis of the Declaration and compared it to European political charters. As if to set the scene, he kept to the conventions of the travelogue genre with a prefatory account of a typical American hostel and its front-room amenities. A visitor could relax on a rocking chair, read a newspaper, peruse tourist brochures, and consult a map of the vicinity. A grand piano might be available. There would be a carpet on the floor and a tasteful array of landscapes and portraits on the walls, but, "among all these paintings and maps," Farkas was stirred to see, "in the most prominent place in the room, almost always in a beautifully gilded

glass frame with a crown of perennial flowers, a particular document—the American Declaration of Independence."[13]

Framed facsimiles have retained their symbolic significance and are still a staple product. Philip Roth's father had one hanging in the front hall of their home in Newark, New Jersey, a reward for meeting the sales targets set by his employer. As a child Roth was impressed by this family icon and came to associate the Signers with the managers of his father's firm, the powerful and beneficent Metropolitan Life Insurance Company. Employee awards like that would have cost less than a dollar at that time, not counting the frame. The Bicentennial prompted a surge of publications from the National Archives, including a poster-size facsimile priced at seventy cents. That time around the city of Philadelphia was not allowed to borrow the engrossed parchment but received instead a specially printed restrike of the State Department facsimile. As of this writing, the online National Archives Store is selling reproductions of the facsimile at three different price points: a full-size sheet of imitation parchment, the document in an antique gold finish custom frame, and a premium version with an extra expanse of ornamental molding.[14]

LETTERPRESS AND LITHOGRAPHY

Copperplate engravings soon gave way to less expensive reproduction mediums. Letterpress printers were quick to profit from Binns's and Tyler's publicity but without any attempt to emulate their decorative schemes (nos. 1, 2, and 4). In 1823 a Boston printer produced a *Sheet Almanack* selling for a dollar a dozen, the Declaration text next to a calendar inside an ornamental border containing a stock cut American eagle (no. 14). Typefounders supplied the printing trade with a wide assortment of stock cuts loosely based on the Great Seal of the United States, with and without the motto, with and without the escutcheon, in all shapes and sizes. They portrayed the national bird on its own, divested of its heraldic attributes, or in complex compositions including other symbolic imagery such as lightning bolts, a sunburst, and a subjugated globe. A well-equipped printing shop would have a drawer of these cuts for use as needed (p. 5). Compositors usually placed them in or above the title, a standard layout dating back to Binns. The juxtaposition was all the more appropriate, of course, because Congress decided to design the Great Seal, among other deliberations, on July 4, 1776.

Printers could display their typographic skills by framing the text with intricate borders composed of stock cuts, brass rule, and pieced-together type ornaments. An elaborate composition might include compartments for other texts on patriotic

FIGURE 36
*In Congress, July 4, 1776.
The Unanimous Declaration of
the Thirteen United States of
America*. Boston: Stereotyped
by the Boston Bewick
Company, published by
Prentiss Whitney, ca. 1834–36?
(no. 33). Rare Book Collection.
The New York Public Library.
Astor, Lenox, Tilden
Foundations.

topics or statistical tables like those in almanacs and gazetteers (nos. 14, 27–30, 32, 43, 46, and 49). Some prints emulate the Binns-Woodruff pictorial scheme with wood-engraved borders containing the eagle and the state seals (nos. 18 and 20).

Beginning in the 1830s Boston publishers experimented with combinations of the Binns border and the Tyler text. The earliest attempt to my knowledge is a letterpress broadside produced by the Boston Bewick Company (fig. 36). A full-service graphic arts establishment, the Boston Bewick Company could set up a text, illustrate it with wood engravings, and stereotype the results. It could produce copperplate engravings for maps and charts, music for song sheets, and fancy job printing for advertising flyers and promotional pieces. It got its name from Thomas Bewick, who had perfected the art of white-line engraving on boxwood blocks, a technique first introduced in Boston by Abel Bowen (1790–1850), a senior partner in the firm. Bowen heads a list of its employees in an advertisement describing its operations and facilities. In 1834 he and his associates obtained an act of incorporation capitalizing their business at $120,000—an ambitious undertaking that failed, however, after a disastrous fire in 1835. The senior partner organized a new firm on the same premises but forfeited what was left of the stock of wood engravings and stereotype castings to an assignee, who sold them at auction.[15]

The Bewick partners printed the Declaration in the standard format, the text and signatures surrounded by state seals in an ornamental border. They had it stereotyped, no doubt expecting it to be a steady seller but also intending it to be an advertisement, an enticing specimen of their artistic services. The state seals are in Binns's style (transmitted by way of the Woodruff piracy), although they are contained in a rectangular frame rather than an oval border. Here too they provide a symbolic honor guard around the patriotic content, each occupying a compartment inside intertwined oak-leaf and olive garlands with the national seal at the top. The typesetter copied the layout of Tyler's title inasmuch as the first words were set in an arching curve above the text. The facsimile signatures were derived from Tyler but were rearranged in a more compact composition, five columns instead of six. The typesetter simulated the writing master's round-hand lettering with script type and employed display faces to imitate the "emphatical words," rendered in black letter, a bold Antique, and two sizes of open shaded caps. Quite possibly the company's artists obtained a copy of Tyler's original 1818 edition, which he had sold to more than a hundred subscribers in Boston—prominent state officials, patriotic citizens, and members of the trade. A looking-glass and picture-framing firm took twelve copies to be kept in stock and framed on demand. If Bostonians could pay five dollars a copy in 1818, surely a publisher could persuade them to buy a cheaper version recognizably similar to the engravings. At one point the Bewick print was selling for twelve and a half cents.[16]

The company's eclectic approach and cost-cutting measures seem to have been a success. At the very least, we can construe some profitability in that broadside from the number of times it went back to press. The earliest datable edition was commissioned by the auctioneer Prentiss Whitney, who sometimes took a flier in printmaking. The Bewick firm printed some copies on its own account but also sold stereotype plates to the trade. One printing bears the name of Samuel N. Dickinson, who may have tried his hand in a Declaration venture or performed the presswork for a customer, perhaps Bowen, one of his creditors, or one of his partners after the collapse of their corporation. The New York mapmakers Humphrey Phelps and Bela S. Squire obtained a stereotype copy of the state-seals frame, replaced the national seal with a portrait of Washington, and reset the text in the same style for an adaptation issued around 1835–37 (no. 36). Phelps in another partnership, Phelps & Ensign, used a stereotype plate of the entire print to replenish his stock of Declarations around 1838–42 (no. 40).

Following the company's example, other printers experimented with script types and the state seals. A Boston stationery firm hired a local job shop to imitate the typography and illustrations of the broadside. The types and the title layout are identical, and the state seals are faithful copies, but the ornamental frame could

not be replicated. Instead, the printers relied on type ornaments and oak-leaf corner pieces to approximate that effect, an ill-fitting assemblage including portraits of Founding Fathers and scenes of the Revolution (no. 34). The stationery firm may be responsible for another broadside with the same setting of type and a similar slapdash assortment of illustrations (no. 35). Phelps produced the most elaborate and successful of the letterpress Declarations, larger than its Boston predecessors and more persistent, surviving in at least nine variants datable between 1845 and circa 1854–63 (no. 47). These reprints too were expedited by the stereotyping process, which would explain why the text and the facsimile signatures stayed the same during this period, while the imprints and the ornaments were constantly in flux. Phelps updated his imprint whenever he moved to a new address or took a partner in his business. As initially conceived, his version of the border reinforced Binns's symbolism by chaining the state seals to cartouches containing the names of generals in the Revolutionary army. Also based on Binns, a Washington portrait headpiece rested on cornucopias between personifications of Justice and Liberty, each in a roundel before a background of battle flags. A successor firm tried to refurbish the stereotyped portion by changing the border and replacing Washington's portrait with Trumbull's *Declaration*. By that time, however, letterpress versions were beginning to look coarse and mechanical in comparison to lithographs.

Copyists at heart, Declaration publishers were slow to adopt this innovative printing technology, well known in America by the 1820s. They could learn what it could do from lithographic copies of the Woodruff piracy printed in France for export to America circa 1825–35 (nos. 16 and 17). The Lyon printer Joséphine Decomberousse patented a transfer process in 1825 and used it to undercut the price of the engravings. Perhaps she tested her invention overseas, where she would not have to answer complaints about copyright evasion. Another Lyon lithographer, Horace Brunet, followed her example and succeeded in selling at least four Woodruff reproductions, some printed on silk or satin. The earliest American endeavor I have found is a lithographic adaptation of the Binns print published in 1846 (no. 50). The artist copied Binns's text, signatures, and illustrations as well as the "cordon of honor" layout but substituted portraits of presidents for the state seals.

In the 1850s and 1860s lithography came to the forefront of the Declaration business. As elsewhere in the trade, artists and publishers appreciated its technical and economic benefits—it could capture the "nicest details" at a quarter of the cost—but it excelled in this genre as a means of printing ornamental texts. Writing masters could control how their work was rendered on the stone without having to enlist an intermediary, an obvious advantage over engraving. No longer was the pen dependent on the burin. They took the same calligraphic approach,

still a demonstration of skill, but made the most of this expressive medium by introducing new visual conceits in the iconographic canon.[17]

Professor of penmanship Gilman R. Russell hired a lithographer to illustrate the Declaration with a portrait of Washington. Russell inserted the portrait in the center of the text as if the president was vowing to defend it, his left hand on his sword, his right hand raised in an oratorical gesture (fig. 37). The president takes the same stance in a later, more elaborate version, an allegory of Fame at the top, an oval portrait of Jefferson at the bottom (no. 72). The oval is set inside a laurel wreath between goose-quill pens, which signify the act of writing, Jefferson's as well as Russell's. A companion print portrays Lincoln in the midst of the Emancipation Proclamation. In a further development of that trope, William H. Pratt made a trompe l'oeil portrait of Washington by modulating the thicks and thins of letters to depict those iconic features (fig. 38). Up close one could read the document word for word, but at a distance it took on different meanings, a personification of the newly founded nation, an embodiment of civic virtue. Pratt was a writing master in Davenport, Iowa, where he launched his publishing career with several versions of his print between 1865 and the Centennial. One version was published by his lithographer, who perceived the popularity of these optical illusions. A Philadelphia firm used the same technique to produce another trompe l'oeil Washington in 1865 (no. 69). The Philadelphians issued a Lincoln companion print and similarly envisaged him inside the Emancipation Proclamation. Pratt also tried his hand at a literal Lincoln. Founder and editor of the *Penman's Art Journal* Daniel T. Ames revisited Russell's design by placing the two portraits inside the documents, combining them in a complex composition celebrating the growth and prosperity of America (fig. 39). The twin documents could be printed together or issued as a pair. Together, they gained a new significance after the Civil War and the tragic death of Lincoln. They reaffirmed the human rights expounded in the Declaration and implemented in the Emancipation Proclamation. They expressed in writing the principles underlying the creation and preservation of the United States. Printed by photolithography, Ames's massive omnium gatherum of historical vignettes was astounding in its intricacy and dazzling in its details, but everything was organized around a central theme, a tribute to the two greatest presidents, the father and the savior of the country.[18]

Ames's print was a showpiece for the Centennial. The epigraph "Westward the Course of Empire Takes Its Way" is the same as the title of Tyler's Whig Party campaign print, although this time it is quoted correctly. It harkens back to Emanuel Leutze's mural in the Capitol and other pictures inspired by Berkeley's verse, an invocation of Manifest Destiny. See how far we have come, says Ames in this patriotic diptych: the primitive beginnings of American civilization on one side

FIGURE 37
Declaration of Independence.
In Congress, July 4th. 1776,
The Unanimous Declaration of
the Thirteen United States.
of America. Manchester, NH:
William H. Fisk, 1856 (no. 59).
Prints and Photographs
Division, Library of Congress,
LC-DIG-pga-00368.

and its later accomplishments on the other. In a march of progress from left to right, the scenes alternate between the discovery of America and the arrival of the pilgrims, a rustic village and a bustling city, the Battle of Bunker Hill and the Battle of Gettysburg, a slave auction and a school for African Americans, a hand-press and a steam press, a man on horseback and the transcontinental railroad. Above all this, the title extends across a frontage view of the Main Building of the Centennial Exhibition, said to be the largest building in the world, an impressive vantage point for viewing American arts and manufactures. Like Ames, other artists celebrated the exhibition along with the anniversary. One inserted portraits of the exhibition organizers amid allegorical vignettes in a rustic wood frame with compartments for the Declaration text and the presidential proclamation authorizing the event (fig. 32). A view of the fairgrounds accompanies another trompe l'oeil design, the text set in the shape of the Liberty Bell (no. 88).[19]

Presumably these prints were sold as souvenirs, but I know of only two distributed on site (nos. 80 and 83). Fairgoers would also want to view the historical

FIGURE 38
Declaration of Independence.
Davenport, IA: William H.
Pratt, 1876 (no. 70). Prints and
Photographs Division, Library
of Congress, LC-DIG-
ppmsca-44472.

landmarks in town and make a pilgrimage to Independence Hall, birthplace of the nation. They could buy prints at any number of shops catering to tourists. A full-size facsimile could cost a dollar, some copies with the same design cost fifty cents, and a smaller version with an advertisement was free for the taking. These price points were among the many merchandising techniques devised by General James D. McBride (1842–1932), the most enterprising and successful publisher of facsimiles. Dynamic in more ways than one, he knew best how to exploit the versatility and productivity of the lithographic medium.

JAMES D. MCBRIDE

McBride dominated the Declaration business during the Centennial. Like Binns and Tyler, he solicited the support of government officials who could help promote his publication projects, but he was more adroit in his lobbying efforts and managed to stay in favor with different administrations for over forty years. He adopted

FIGURE 39 *Centennial: "Westward the Course of Empire Takes Its Way."*
New York: James Miller, 1876 (no. 92). Amon Carter Museum of American
Art, Fort Worth, Texas, 1968.253.

his predecessors' methods for selling the Declaration and developed new ones to
tap a larger market for patriotic prints. He succeeded with his Declaration ven-
tures and employed similar tactics in other printmaking schemes. Tyler also tried
his hand in spinoffs and sequels but lacked the political leverage that McBride
could apply in his dealings with presidents, cabinet members, and congressmen.

McBride could count on his military record to vouch for his patriotic creden-
tials. He enlisted as a sergeant in the 1st Ohio Volunteer Infantry at the outbreak
of the Civil War and rose to be a lieutenant colonel in the 8th United States Col-
ored Heavy Artillery. He resigned soon after the surrender of the South, breveted
a brigadier general for his "gallant and meritorious" achievements. His customers
in Congress usually referred to him with that courtesy title. He received another
army commission at the rank of second lieutenant but relinquished it in 1868,
apparently already engaged in the business of selling historical souvenirs.[20]

The impeachment of Andrew Johnson inspired his first attempt to document
a historical event. In 1868 he went to Washington and found a way to gain the
confidence of the legislators involved in those proceedings, the representatives

FIGURE 40
Fortieth Congress U.S. Second Session. Senate Chamber . . . The Vote of the Senate . . . for the Trial of Andrew Johnson, 1868. Lithograph by J. H. Bufford for James D. McBride. Library of Congress. Manuscript Division, Andrew Johnson Papers.

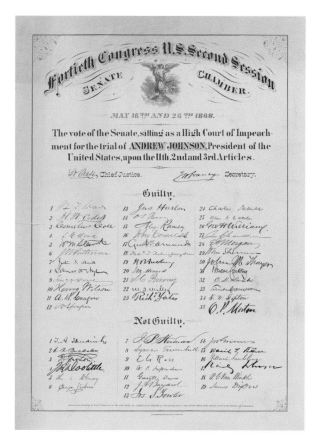

who voted on the impeachment resolution and the senators who passed judgment in the trial. They allowed him to collect their autograph signatures and arrange them in "charts," which he put up for sale along with letters attesting to their authenticity. He offered them to the president and assured him that they were worth two thousand dollars, if not more, since they could be expected to appreciate in value. What became of the charts is hard to tell, although one might be in the Gilder Lehrman Institute of American History, a vellum document signed by the Speaker of the House, the House Clerk, and the representatives who voted for impeachment. No doubt the president declined to buy the manuscripts, but McBride did succeed in repackaging them as prints, each with reproductions of the signatures, one tallying the yeas and nays in the House of Representatives, the other documenting the trial in the Senate (fig. 40). Both were printed in Boston at the John Henry Bufford lithographic establishment with the same layout, lettering, ornaments, and borders. Dated 1868 the copyright statements identify him as a resident of Mansfield, Ohio, his birthplace, where he must have returned after the war.[21]

In February 1875 McBride adapted one or both of those prints to produce the *Trial of Andrew Johnson*, a lithograph with a portrait of Johnson, the House of Representatives resolution, and facsimile signatures of the senators. He advertised it as a vindication of the former president, who had staged a political comeback in January after winning a seat in the Senate. Measuring 20 × 26 inches, it cost a dollar and bore two red seals certifying its authenticity. Orders could be addressed to the Columbian Publishing Company of New York.[22]

McBride founded this firm and an affiliate in Philadelphia, the Continental Publishing Company, to publish prints on the occasion of the Centennial. Both firms advertised their services in the same terms, "General Lithographers, Engravers & Printers on Steel, Copper, Stone and Wood," which would suggest that they were part of a fully equipped graphic arts establishment, but I have found their imprints only on lithographs made for McBride. He sent samples to newspapers, which obligingly quoted his promotional copy verbatim, along with mail-order information naming him the secretary of the Columbian Publishing Company. At one point he had three prints for sale: the *Trial of Andrew Johnson*, his *Declaration* facsimile, and Washington's commission as commander in chief of the Continental Army. These three "gems of American history" are similar in style and concept. All three display authenticating seals printed in red. Washington's commission contains the same decorative border, certification statement, and advertising component as the *Declaration* described below.[23]

The general took a similar approach in his most ambitious Centennial publication, *The Administrators of the United States Government at the Beginning of Its 2nd. Century*. It has the same decorative border and no less than three official seals accompanied with certification statements. Like the impeachment prints, it is a facsimile of autograph signatures on a document created by McBride to commemorate a moment in history. This time, however, he performed a brilliant feat of autograph collecting, almost four hundred names of the highest-ranking government officials at the time of the Centennial. They seem to have signed it in a series of ceremonies, the president and his cabinet in the Cabinet Room of the White House, the Supreme Court Justices in the Old Senate Chamber, the senators in the Vice President's Chamber, and the representatives in the Speaker's Room. McBride displayed the manuscript at the grandstand in front of Independence Hall during the festivities and then took it on tour to the Midwest and maybe elsewhere. By 1877 it was on deposit at the State Department, although its movements at this point become unclear because the original may have been confused with a facsimile. At first it had only seals for the justices, senators, and representatives, but McBride applied for permission to put the Great Seal in an empty space next to the names in the Executive Branch and succeeded in getting this

national stamp of approval. Thus encouraged, he tried to sell the manuscript to Congress for five thousand dollars, half of what it was really worth in his opinion. Congress seriously considered his offer and went so far as to appoint a committee to deliberate on its suitability, but the committee advised against a purchase at any price. Undeterred, he left it on deposit or replaced it with a facsimile in a "centennial safe," which was opened and presumably emptied during the Bicentennial. In 1938 one or the other was transferred from the State Department to the National Archives but could not be found as of June 1977. The original was sold at auction in 2012, and its present whereabouts are unknown. As for the facsimile, McBride announced in a help-wanted ad that he would need ten thousand agents to sell it and invited interested parties to write in for his circular, apparently a specimen of the print with wholesale terms and conditions.[24]

His Centennial ventures were so successful that he tried the same tactics in 1892, a repeat performance for the Chicago World's Columbian Exposition. This time he called his print *The Administration of the United States Government at the Beginning of the Four Hundredth Anniversary of the Discovery of America.* I have not yet found a copy, but congressional documents indicate that the *Administration* print contained the national seal and departmental seals in the same style as the *Administrators* print, these seals also intended to certify the facsimile signatures of government officials. Once again he sought to validate his publication by having the original or a facsimile deposited in the archives of the Executive Department. Two years later he obtained congressional approval to print the seals in his publications as if they were legal instruments that had to be endorsed by these proceedings.[25]

Like Binns and Tyler, McBride cultivated his political connections to win government contracts, but he was more insistent and successful. Although he failed to sell the *Administrators* manuscript to Congress in 1879, he tried again in 1896 by bundling the *Administrators* print with the *Administration* print, a *Declaration* facsimile, portraits of presidents, state seals, and other items to make a set of historical documents containing a good portion of his backlist. He proposed to sell 2,500 sets at five dollars each for distribution to all three branches of the federal government as well as embassies, schools, and libraries. The Secretary of State, the Secretary of the Navy, the Secretary of Agriculture, the Secretary of the Interior, and the acting attorney general commended his efforts in letters to the chair of the Senate Committee on Education and Labor. But when the appropriations bill came up for debate in the House, a representative from New York, Franklin Bartlett, pounced on this one item and delivered a diatribe he had carefully prepared in advance. The Speaker granted him extra time to express all of his concerns. Bartlett perceived no educational value in the

prints, which were so cheap in his opinion that their manufacturing cost could not have been more than a penny apiece. He ridiculed McBride's pretensions to scholarship and challenged his right to be called a general. Even worse, he read out passages in Lossing's *Biographical Sketches of the Signers* to show that the would-be general had plagiarized his sources, which were not that good to begin with. The chair of the Appropriations Committee half-heartedly defended that provision, whereupon the spending bill was voted down and sent back to the Conference Committee. Despite that defeat, McBride remained in the good graces of the government, which hired him to renew the national seal in 1903 and produce a chart of electoral votes in 1912. As before, he obtained the endorsement of the Senate Committee on Education and Labor, which authorized an edition of twenty-five thousand copies of his chart priced at a dollar each. Needless to say, it too bore an authenticating seal. He made himself welcome in Washington as late as 1919, when he enjoyed a kind of scholarly vindication during a debate on honors granted to General Pershing. One of Pershing's opponents claimed that the general's bravery on the battlefield could not be compared to the heroism of commanding officers in the Civil War. To prove his point he cited a list of officer fatalities compiled by McBride, "a careful student of Civil War history" whose research was read into the record.[26]

Off and on McBride had been in the business of making historical prints for more than forty years. Not tempted to experiment, he developed a reliable business model for the sale of his products and designed them to contain many of the same ingredients: an array of facsimile signatures, an ornamental border with patriotic emblems, and official seals certifying their authenticity. He perfected this technique in his most successful publication, a *Centennial Memorial* facsimile Declaration with each of those elements and other features that ensured wide distribution (fig. 41). To my knowledge no other facsimile has survived in greater quantities. The American Antiquarian Society has eight copies in various states, and copies frequently come up for sale at modest prices.

McBride prepared his facsimile well in advance of the Centennial. He persuaded Columbus Delano, the Secretary of the Interior, to sign a certification statement, dated January 28, 1874, and he obtained a copyright in the same year. Delano also granted permission to use the Department of Interior seal, a major selling point in the publisher's advertisements. The seal and the certification statement appear in all versions of the facsimile, although they had to be reconfigured to fit in different layouts. The certification statement implies that he was making a replica of the original—but that of course was no longer possible—so McBride used the State Department facsimile as his source document. Like Binns, he commissioned an artist to design an ornamental border with patriotic emblems: olive

FIGURE 41 *Centennial Memorial, 1776–1876. In Congress, July 4, 1776.*
The Unanimous Declaration of the Thirteen United States of America. New
York: Columbian Publishing Company, 1874? (no. 80, variant 10). Courtesy
of Swann Auction Galleries.

branches symbolizing peace, oak leaves symbolizing strength, the American eagle perched on a stonework frieze. He explicated his design in one of his advertisements, which notes that the frieze represents Plymouth Rock and that the border is composed of fagots signifying the thirteen original states. This interpretation may have been contrived after the fact, as the frieze is purely ornamental, and no meaning can be construed in the border except that the fagots look like fasces and are tied together by straps studded with stars. By that time, Binns's state seals "cordon of honor" iconography was so prevalent in prints that he may have wanted at least a semblance of that scheme in his publication. He had it printed in one or more lithographic establishments either in New York or Philadelphia or both, exactly where and when is impossible to ascertain because it appears in so many variants. His printer or printers copied the State Department facsimile with excellent results and employed imitation parchment for extra verisimilitude. It must have been in press sometime before May 1875, when it was advertised along with the *Trial of Andrew Johnson*, and it was certainly available by June 17, 1875, a date printed on envelopes used to distribute some copies in Boston.[27]

The Philadelphia Centennial Exhibition opened on May 10, 1876. McBride was already selling his facsimile by mail with the imprint of his New York outlet, the Columbian Publishing Company. In Philadelphia, however, he used the imprint of the Continental Publishing Company, and he charged a different price, a dollar, twice as much as the New York mail-order version. Did he expect fairgoers to pay a premium for the privilege of seeing it on site? Certainly he knew to make the most of the merchandising opportunities offered by the Centennial, and he was not the only one to seek his fortune where millions of visitors were expected.

A Philadelphian for the nonce, McBride played a part in the drama of that occasion. A committee of prominent citizens launched a campaign to have the engrossed parchment displayed downtown in Independence Hall instead of the Government Building on the exhibition grounds. Surely it was more appropriate to show the Declaration in the place where it was debated, adopted, and signed. The Secretary of the Interior resisted that idea, as did the Commissioner of Patents, who viewed it as government property and did not want to interfere with plans to make it a centerpiece at the fair. The Philadelphians argued in vain until General McBride paid a call on President Grant and persuaded him to intervene. The chair of the committee was pleased and puzzled by this turn of events but allowed the newcomer to join a cortege that escorted the Declaration from the train station to Independence Hall. No doubt McBride had boasting rights about his role in the affair and found ways to use it to his advantage. As mentioned above, he displayed the *Administrators* manuscript in the grandstand at

FIGURE 42 *The American Centennial Festival: Independence Hall,
Philadelphia, on the Fourth of July*, 1876. Wood engraving, 3 1/2 × 5 inches.
The Illustrated London News, July 22, 1876. Courtesy of the Free Library of
Philadelphia, Print and Picture Collection.

Independence Hall. Passersby could admire the manuscript and buy copies of the
Declaration to take away as souvenirs. The crowd around the grandstand was so
large that it drowned out Richard Henry Lee, grandson and namesake of the
Signer, when he was called upon to read out loud from the parchment during the
July 4th festivities (fig. 42).[28]

Independence Hall was McBride's base of operations. A vignette of Indepen-
dence Hall figures prominently in the lower right-hand corner of his *Declaration*
facsimile in early states on a sheet measuring approximately 20 × 15 inches. Per-
haps free samples were handed out at that location to those who might pay a dol-
lar for the premium version, available in Philadelphia at the Continental Publishing
Company. Others with the same vignette have the imprint of the Columbian
Publishing Company, which sets the price of the premium version at fifty cents,
a discount rate for those not quite so motivated by the celebrations on site. Either
imprint can be found on the premium version, printed on a sheet 32 × 24 inches

with a border in the same style but without illustrations and advertisements. That version would have been the most accessible and accurate depiction of the Declaration at the time of the Centennial.

Instead of Independence Hall, some versions contain advertisements in the lower right-hand corner. Businesses bought them in bulk for use as promotional giveaways. McBride was not the first to use the Declaration for merchandising ventures (viz. nos. 41 and 55) and by no means the last one, but he built the largest customer base of anyone in that line of business. I have seen copies with advertisements for clothing, hosiery, housewares, hardware, cabinetry, fertilizer, woolens, curtains, carpets, medicines, newspapers, liquor, railway travel, and fire insurance—a wide variety of goods and services provided by firms based in Lancaster, PA; Reading, PA; Springfield, MA; Quincy, IL; New York City and Brooklyn; Baltimore; Philadelphia; Providence; Boston; Rochester; Utica; St. Louis; and Detroit. Surely that list can be enlarged after other copies come to light. McBride went back to press on any number of occasions to make the Independence Hall specimens, the advertising handouts, and the premium versions for sale in New York and Philadelphia. At one point his artists overhauled the print from top to bottom (no. 80, variants 6–11). They rewrote the certification statement, readjusted the layout of the signatures, and retouched the heading *In Congress, July 4, 1776*, bolstering several letters to make them more legible and consistent.

This late state of the print was the source of facsimiles published by the Chicago mapmaking firm Rand, McNally & Co. (no. 82). Enterprising members of that firm appropriated McBride's *Centennial Memorial* and imitated his marketing methods as well. Their version has the same layout with the American eagle on top, an ornamental border around the text, and a view of Independence Hall. Either they did not notice the retouched heading or did not worry overmuch about the sacrifice of accuracy. They duplicated the authenticating seal but decided that they were not entitled to the certification statement, which they replaced with a caption claiming that they had made a "Guaranteed Correct Copy." They too sold copies by mail order for fifty cents without advertisements. I have not seen their premium version, but I have seen copies with advertisements for Chicago railroad companies, the main customers of the Rand, McNally firm. One of the advertisements invites Californians to attend the Centennial Exhibition by taking a cross-country train operated by the Chicago and North Western Railway. This or a similar print inspired a Declaration anecdote in the *Philadelphia Record* picked up by other papers and reprinted several times in 1902 and 1903. Declaration facsimiles had become scarce, it reported, even though they had been common back when they had carried advertisements. The *Record* claimed that it was impossible to make new facsimiles because the original had deteriorated to

the point that it could not be photographed, and the "plates" made by McBride in 1874 had been destroyed in a fire. In that predicament a Philadelphia collector proposed to pay ten dollars for a facsimile with an advertisement for a western railway.[29]

Perhaps McBride's printing materials were lost in a fire, but that did not prevent him from making one last foray in the Declaration business. In 1891 he produced a nearly full-size facsimile (no. 106) with the requisite ingredients carried over from his previous publications. He hired an artist to re-create the ornamental border he had used in the Centennial souvenirs and the *Administrators* print. He persuaded Secretary of State James G. Blaine to compose a new certification statement, which was accompanied, as always, with a departmental seal. Blaine called it "a true copy of the Original Document," although it was actually a copy of a copy, maybe more than twice removed, because it was derived from the State Department facsimile. This must have been the *Declaration* McBride brought before Congress in 1896 along with other publications in his backlist, the package deal roundly denounced by Bartlett.

Those prints may have been a boondoggle at five dollars a set, but they had also gone out of fashion. Purists would have objected to the pretentious authentication apparatus and the fustian ornamental border. Tastes had changed: Americans were beginning to prefer facsimiles unencumbered with the traditional accretions. McBride took a publishing formula dating to 1816–19 and perfected it during the Centennial with mass-produced merchandise aimed at the bottom end of the market. There is no telling how often he went back to press, but his success can be gauged by the number of variants in the checklist. If not original, he was persistent and confident enough in his formulaic approach to reintroduce the same product seventeen years later. But it was falling out of favor at a time when the Declaration trade was winding down and when facsimiles were becoming less dependent on private enterprise and less susceptible to artistic interpretation.

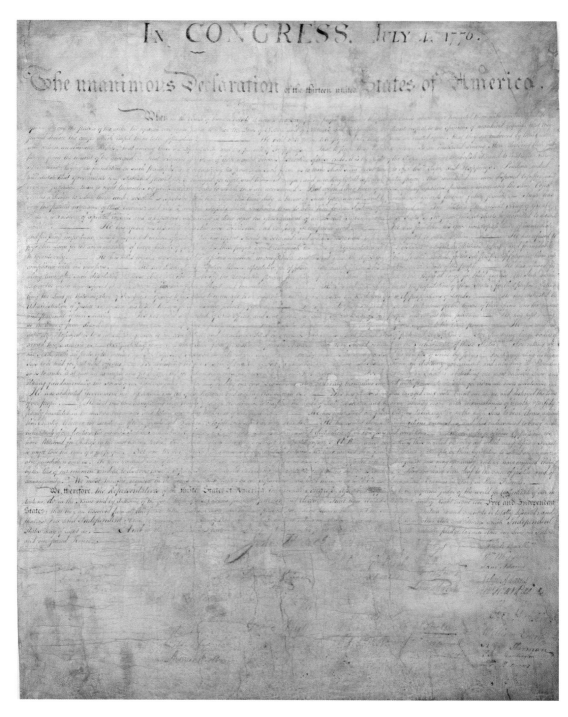

FIGURE 43 Engrossed Declaration of Independence, August 2, 1776.
Miscellaneous Papers of the Continental Congress, 1774–1789; Records of
the Continental and Confederation Congresses and the Constitutional
Convention, 1774–1789, Record Group 360; National Archives (National
Archives Identifier 1419123).

The Function of Facsimiles

Declaration facsimiles were in demand because the original could not be seen. Complaints about the condition of the engrossed parchment convinced the State Department that the light exposure and handling hazards were too great for it to remain on view. In 1894 it was taken down, locked in a safe, and kept out of sight for thirty years. Even when it could be seen, the text was hard to read, and the signatures were barely recognizable. The Binns and Tyler engravings displayed a magniloquent text above a bold array of signatures validated by certificates of authenticity. The engravings were easier to appreciate, as were their letterpress and lithograph descendants, which were similar in design, cheaper, and more accessible. The Declaration business lasted as long as it did because it provided visually satisfying surrogates for a defective original.

Conservators have cited several reasons for the deterioration of the engrossed parchment (fig. 43). During its early years it was rolled up for storage and transport along with other archival documents. Some ink would have flaked off from the curled-up writing surface because of abrasion inside the scroll and the stress of unfurling it for reading. That kind of physical damage was already apparent in 1817 when Richard Rush certified the Tyler facsimile. The ravages of time, however, do not explain why so many signatures had disappeared while the text survived comparatively unscathed. The facsimilists bear most of the blame, Binns and Tyler more than Stone because they only needed to replicate the autographs.

Tyler boasted of his "indefatigable exertions" in the State Department Office. No one seems to have supervised him, a handwriting expert better qualified than the clerks to handle precious manuscripts. Likewise Binns's engravers were allowed to work on site, although Secretary of State John Quincy Adams disapproved of them and noted the harmful effects of their copying operations.[1]

By the time Stone got started the damage had been done. He too may have employed dangerous copying techniques such as the wet-ink transfer process (p. 52), but he would have treated the text as well, and that part of the parchment seems to have been spared. Government officials worried mostly about the signatures while preparing for the Centennial Exhibition. An Interior Department spokesman lamented that they had "almost faded from sight" when he delivered the Declaration to Independence Hall. Congress appointed a commission to inquire how they might be repaired, a measure prompted in part by a newspaper campaign on their behalf. So much for the birth of the nation, the editor remarked, if all we have to show for it is an "empty cradle." A letter to the editor suggested that a skilled artisan could overwrite the missing portions like the retouching of a painting and demanded that something be done before it was too late. But the commission took its time and decided against drastic restoration techniques. Instead, the Declaration was removed from public view to protect it from light exposure and further handling.[2]

PHOTOGRAPHS

Ordinarily one would rely on photographs to assess the damage. They have provided useful evidence indicating when and where the injuries occurred, but their role in the history of the Declaration is unclear, and they arrived too late to answer the fundamental questions. The earliest attempt to use this medium created even more confusion, although it was supposed to be more reliable. What's worse, it was the source of an entire family of facsimiles tainted by textual errors throughout the document, accidentals as well as substantives.

Those unfortunate facsimiles were based on the work of Norris Peters, a photolithographer in Washington, DC. During the Civil War he was an examiner in the Patent Office, which became a loyal customer after he went into business for himself. He won lucrative government contracts by cultivating friends in high places such as Senator Roscoe Conkling and Treasury Secretary William Windom. His yachting excursions on the Potomac and his winter dinner parties were fixtures of the social season. If compelled to, he could underbid his competitors, who wondered what kind of cost-cutting measures he concealed in his top-secret

FIGURE 44
*In Congress, July 4, 1776
The Unanimous Declaration of
the Thirteen United States of
America.* Washington, DC:
The Norris Peters Co.,
ca. 1889? (no. 78). Courtesy
of Swann Auction Galleries.

manufacturing facility. They grumbled about his tactics but admired the quality of the work he performed for the Patent Office, the Coast Survey, and the Government Printing Office. A Chicago gossip columnist called him "one of the most eccentric and mysterious characters of the National Capital."[3]

Peters was the first in fifty years to make a Declaration facsimile on the basis of the original (no. 78). He was allowed to photograph it because it was displayed at that time, 1873, in the Patent Office, where he had powerful political connections. The time was right, just before the Centennial, to try a new product strategy relying on improved imaging technologies rather than ornaments and illustrations. Government officials approved of his innovative approach, a modern attempt to expunge the artistic divagations of the past. The Commissioner of Patents and the Secretary of the Interior commended Peters's work in a signed authentication statement printed at the bottom of the sheet: "The above is a photo-Lithographic fac-simile of the Original Document now on deposit in the Patent Office at Washington, D.C."

Not all of it was original, however, for not even a photograph could recover the obliterated signatures. Rather than admit defeat, the photographers used a substitute, one of the Stone engravings (no. 11). They also had to clean up the image and retouch whatever would not print properly, standard practice in their business. The Stone engraving could have helped them, but they decided on their own how to read the text. They added and removed punctuation in at least twenty places, mostly where the parchment was creased and darkened. Going from top to bottom, they omitted the periods after "1776" in the title and after "Honor" at the end. They deleted the interlinear word "only" in the phrase "answered only by repeated injury"—an overzealous erasure and more than a minor accident. That word was one of the emendations Jefferson attributed to Franklin in the Rough Draft and stands as evidence of vetting the engrossed parchment, duly "compared at the table." Someone in Peters's shop noticed that it was missing and tried to reinsert it in a later version of the print circa 1873. An interlinear word was supplied, but it was the wrong one in the wrong place, a confusion of "own" and "only." Two lines up, the phrase "fall themselves by their Hands" became "fall themselves by their own Hands." The photo editor did a better job of fixing the word "us," which had been mistakenly changed to "as" in the phrase "He has kept among us, in times of peace." Successful or not, these corrections were ignored when the firm reissued the print after Peters died (fig. 44).

Other firms reprinted the uncorrected version. Leggo Brothers, a photoengraving establishment in New York, used it to manufacture electrotype blocks for sale to newspapers. Like Rand, McNally's piracy of the McBride lithograph (no. 82), Leggo's letterpress version of the Peters lithograph was not entitled to the certification statement. The photoengravers circulated a sample (no. 84) with an advertisement dated May 3, 1876, urging their newspaper clients to think about printing a Declaration supplement on the Fourth of July. Clients who could not print it themselves could buy 250 copies or more at five cents each. Or they could buy photolithographic reproductions of Trumbull's *Declaration* in single copies at twenty-five cents, thirty cents packaged with the facsimile. I have not tried to identify the electrotypes in newspapers, which are beyond the scope of this study, but I believe that Leggo blocks may be responsible for prints issued by the John Hancock Life Insurance Company (American Antiquarian Society) and the Daughters of the American Revolution (Library of Congress). Those too are out of scope if I am correct in dating them in the twentieth century. During the Centennial, the Frank Leslie Publishing House bought one or more blocks for use in its magazines (no. 86) and its richly illustrated large folio *Historical Register of the United States Centennial Exposition*. For all its faults, the Peters photograph was the first of its kind and the only one to be used repeatedly in facsimiles.

Other early photographs confirmed the disparity between the text and sig-natures. Albert G. Gedney made one in 1883, the basis of a collotype facsimile depicting the "fading manuscript" in its entirety and at its worst, the creases in the parchment accentuated by raking light (no. 99). Beneath it Gedney placed reproductions of the Stone signatures for comparison purposes. Why he under-took this facsimile is a mystery, unless he intended it to record the current con-dition of the original. He was a lithographer in Washington and the son of a lithographer who did business with the State Department. If not as well connected as Peters, he may have been acquainted with government officials who thought that his collotype would be useful for reference purposes. He may have tried to sell it, hence his address in the imprint, but it did not circulate widely.[4]

In 1898 *The Ladies' Home Journal* received permission to photograph the manuscript for an article about the State Department's exhibition facilities. The camera operators relied on direct sunlight to elucidate details in the signatures invisible to the naked eye. Nevertheless, the halftone reproduction in the article lacks the definition and contrast in Gedney's collotype, which had been forgotten by then. The magazine claimed that its photograph was the "only authoritative one . . . made for many years." The article also included illustrations of the steel safe where the Declaration and the Constitution were stored and a display case containing a Declaration facsimile, the original Rough Draft, and other Jefferson documents. To my knowledge it was the last time outsiders were allowed to handle the document for commercial purposes. A glass-plate negative made by Levin C. Handy in 1903 seems to have been government property. Prints might have been produced on demand but not on the initiative of Handy, who was more of a free-lancer than an entrepreneur. Eventually the engrossed parchment came out of the State Department safe and passed into the custody of the Library of Congress, which then relinquished it to the National Archives. Conservators have reassessed its condition and devised ways to display it with every possible precaution for its preservation, safety, and security. No amount of political clout is likely to prevail over these protective measures. This study stops at 1900, not an arbitrary date, but a turning point in the history of the document. From then on it was beyond the reach of individuals who wished to employ it in commercial ventures.[5]

AUTOGRAPHS

Binns's and Tyler's advertising campaigns inspired a collateral interest in auto-graph collecting. Americans started on this pursuit around 1816, when Binns announced his publication project. Kindred spirits, American collectors joined

in a friendly competition to assemble complete sets of the Signers, each represented by a letter, a signed document, or a clipped signature—a hierarchy of manuscripts from large to small, the last acceptable only if nothing better was available. A top-ranking set would consist mainly of holograph letters written around the time of the Declaration, perhaps even on topics related to it. Completists usually had to settle for less evocative manuscripts to reach the requisite fifty-six. Others fell short of the goal when the rarities rose in price beyond their means. Some of the Signers were poor correspondents and left a disappointing paper trail. The most elusive was the Georgia delegate Button Gwinnett, who died in a duel shortly after he played his part in history. Among other collecting achievements, J. Pierpont Morgan owned three sets of the Signers and two Gwinnett trophies, the delegate's will and a letter to another member of Congress.[6]

The Declaration business formed the taste and guided the technique of these autograph collectors. They regarded *Sanderson's Biography of the Signers* as the standard text in their field, a guidebook and a source of background information about their manuscript holdings. Some made it a receptacle for their collections. Rather than filing them away, connoisseurs of extra-illustration could have the manuscripts mounted on leaves and inserted in a Sanderson rebound for that purpose. That way they could display them next to the relevant texts in conjunction with additional inserts such as portraits, views of historic locales, and scenes of the Revolution. An extra-illustrated Sanderson could be extended to twenty folio volumes. The pretentious bindings and the superabundance of pictorial matter eventually went out of fashion, but at the time they helped organize the autographs and contextualize them with related documents.[7]

An expert collector performed a tour de force of extra-illustration on a facsimile. In 1893 Mellen Chamberlain donated a collection of some twenty thousand items to the Boston Public Library, where he had been the head librarian. Shelved in a special room adjoining the librarian's office, more than 350 volumes contained his American and European autographs. One volume was devoted to the Signers. But he also wanted the public to see the Declaration and the other founding documents, which were framed and hung in Boston Public Library's Room for Younger Readers. He chose Force's imitation parchment restrike to represent the Declaration, the best possible facsimile, and made it even better by pasting real signatures over the engraved reproductions (fig. 45). Ordinarily clipped signatures would be least desirable in a set of the Signers. Here, however, they add an extra layer of authenticity, precisely what the facsimilists had been promising the public right from the beginning. Besides, they fit perfectly. At a distance, only the differences in paper tone make them look like a collage. They are strikingly similar to the originals and, some would say, "infinitely more pleasant to look at."[8]

silo

AUTHENTICATION

Chamberlain knew what he was doing. His research in American history resulted in several substantial monographs, including an account of John Adams's role in the Revolution. He gets the credit for resolving the confusion about the dating of independence, the vote July 2nd, the publication July 4th, and the signing ceremony August 2nd. He sorted out the day-by-day sequence of events and explained how the Journal of Congress had garbled them so that even the participants were confused. A collector of the Signers, he knew which ones were present at one time or another and why they were so intent on recording and ratifying their decisions. Their concerns are reflected in the title of his monograph, *The Authentication of the Declaration of Independence, July 4, 1776*. He understood that the delegates had been vigilant guardians of the text, which was "authenticated" when it went to press and "compared at the table" when the manuscript was signed. In the same spirit they ordered up "authenticated" copies of the Goddard broadside, documents of record for distribution throughout the United States.

In the previous chapters I have shown that certification statements were standard practice in the Declaration business. Government officials validated the facsimiles of Tyler, Binns, McBride, and Peters in the same terms and the same format, concluding with the officials' titles and their names in facsimile, an extra expression of authenticity. Tyler and McBride took those credentials one step further and included a departmental seal. Secretary of State John Quincy Adams attested to the accuracy of the Binns print with mixed emotions, his antipathy to Binns countered by his commitment to the document. Others may have been pleased to be associated with a patriotic publication or simply performed their duties by rote as if endorsing a product and doing a favor for a friend. Secretary of State John Hay wrote out the last and the longest of these statements, not described in the checklist because it is dated 1902 but worth mentioning here because it acted like an affidavit, like a deposition admissible in court. Hay couched the certification in the formulaic "To all to whom these Presents shall come" legal language prescribed for deeds and contracts. More to the point, the same language was used in state papers such as appointments, proclamations, pardons, and a national document directly dependent on the Declaration of Independence—the Articles of Confederation. The 1902 facsimile was no better than the others—it was merely a reproduction of the Stone engraving—but it was the only one to invoke the centuries-old traditions and acknowledged primacy of English common law.[9]

The Magna Carta set a precedent for American facsimiles. In 1731 a fire severely damaged the copy in the Cottonian Library, raising fears that it was no longer legible. The librarians hired a scribe to copy it on parchment and reconstruct the missing text from other sources. In case of a future catastrophe, they commissioned a facsimile from the engraver John Pine, whose work was then compared to the original and certified with the signatures of expert archivists (fig. 46). Pine decorated it with the arms of the barons who had exacted that document, a symbolic border not unlike Binns's state seals cordon of honor. Binns began his publicity campaign by comparing the Declaration to the Magna Carta, which, he noted, had been published in illustrated editions with "fac-similies of the seals and signatures." He must have known about Pine's engraving, if only by hearsay, but there is no evidence that he had actually seen a copy. Pine's son, Robert Edge Pine, printed some in the 1750s and could have brought a few to America when he emigrated in 1784. How they might have influenced Binns must be a matter of conjecture, but the parallels between the prints are striking: both have calligraphic texts, symbolic borders, and certification statements.[10]

The Framers of the Constitution adopted similar measures to give it the force of law. They signed an engrossed parchment and ordered an official edition to be printed with their names as well as another edition to be submitted for the

FIGURE 46
By Permission . . . A Correct Copy of King John's Great Charter, Taken from an Original Now Remaining in the Cottonian Library, 1733. Engraving by John Pine, 27 1/2 × 19 inches. Courtesy of Bonhams, Book & Manuscript Department.

consideration of the ratifying conventions. They asserted the legal standing of the text in the Attestation Clause, which registers its date, September 17, 1787, in the twelfth year of independence. Some have used that dating formula to interpret it in the light of the Declaration. Those arguments have been challenged, but the links between the two documents are obvious. They were signed by six of the same people. They were displayed together in Independence Hall at the Centennial and resided in the same safe at the State Department. Sometimes they were juxtaposed in prints (e.g., nos. 14, 46, and 49). To that extent, the two engrossed parchments are paired in the popular imagination (fig. 47), but the resemblance stops there. The Constitution was too technical to be a subject for artists, too specialized to justify illustrations, and too difficult to visualize on its own. Its iconographic impact was minimal, limited mainly to designs decorated with "We the People" in facsimile.[11]

FIGURE 47
Declaration of Independence, and Constitution of the United States, With a Brief Sketch of the Presidents of the United States. Boston: George Coolidge, 1844 (no. 46). Courtesy of Swann Auction Galleries.

The Declaration was better qualified to be the image of the nation. As Jefferson said, it was "an expression of the American mind," a statement of democratic ideals that seemed to call for displays of visual rhetoric as eloquent as the preamble. Binns and his followers rose to the challenge by framing the text with the state seals, by designing a symbolic entourage that made it the centerpiece of American identity. In some compositions, the state seals were fastened to an ornamental armature representing the strength and stability of the republic, a reassuring message when the body politic was threatened by factions, secession, and the Civil War. Some allegorical schemes tried to curb the divisive tendencies of the Declaration, its revolutionary message, with a ringing endorsement of national unity. Over time more and more state seals were added to the ensemble as well as presidents' portraits and Trumbull's *Declaration*. One of the most popular prints (no. 38) had all of these ingredients, all the better to affirm the spirit of unanimity. The only partisan treatment I have seen is the racist *Read and Compare!* (no. 74).

Even the unillustrated prints conveyed a political agenda. I started with an account of a parade, a demonstration of civic solidarity to honor Carroll, the last living Signer of the Declaration. After he died in 1832, Americans evoked the real

presence of the Signers in other ways, with graphic simulations such as portraits, biographies, and signatures. Autograph collectors sought to assemble complete sets of the Signers, manuscript avatars incorporated with portraits in extra-illustrated copies of *Sanderson's Biography*. But the fifty-six names could be just as convincing in a straightforward facsimile or in a print on their own (fig. 48). They signified the collective action of patriots who put aside their differences for a common cause, who subscribed to shared principles of liberty and justice. Their inspirational value was not lost on Tyler, who made them a selling point of his print in a letter to John Adams: "The very name of those Heroes, Statesman, and patriots, who achieved our Independence, will animate and nerve the arm of future generations to defend and protect those dear-bought rights, and liberties, we now enjoy."[12]

Of more than two hundred prints itemized in the checklist, nearly sixty have signatures derived from Tyler, nearly forty from Binns, and more than thirty from Stone. Other examples will come to light after the checklist is published, but these are enough to show that the facsimile signatures were a vital part of a thriving genre. They started as engravings and reappeared in lithographs and letterpress broadsides, which could be propagated in turn by stereotyping, electrotyping, and other mass-production technologies. Priced in pennies, the down-market Declarations were cheap and easily discarded. They were disposable, which is why many survive in single copies and why the checklist must be considered incomplete. Some will have escaped my notice, and some have disappeared entirely, lost editions whose existence can be inferred from the rarity and quantity of the known editions. For good reason some publishers failed to date or identify their work, which I have described here as best I can with conjectural imprints and tentative attributions. Historians have been reluctant to take on this low-yield, labor-intensive empirical research. They note in passing the contributions of Binns and Tyler but overlook the other publishers whose adaptations, imitations, and piracies saturated the market for patriotic prints; they underestimate the impact of the early engravings and the growing fervor inspired by the later versions.

Binns's and Tyler's marketing methods also deserve to be better understood. Their newspaper advertisements, subscription campaigns, celebrity endorsements, and highly publicized attacks on each other's products helped dramatize the Declaration and promote the cult of the Signers. I have included biographical information about them and their successors to tally the rewards and hazards of this business, the profit potential of steady sellers, and the pitfalls of expensive ventures. Trumbull's thwarted ambitions are a case in point. He eventually accessorized his prints with the facsimile signatures popularized by his competitors. Also worth noting are novelties such as cotton handkerchiefs, copper plaques,

FIGURE 48 *Fac Simile of the Signatures to the Declaration of Independence.*
England or America: Virtue & Co., ca. 1852–60 (no. 25). Courtesy of
Princeton University Library.

FIGURE 49 Pieced Centennial flag print quilt (including the cotton
handkerchief *Declaration of Independence*. Philadelphia?, ca. 1876? [no. 96]).
Collection of Shelburne Museum, gift of J. Watson Webb Jr. 1952-571.
Photography by Andy Duback.

and keepsake miniatures—evidence of a market large enough to encourage exper-
iments in other formats. The Declaration could be tucked in a pocket, stitched
in a quilt (fig. 49), mounted like a medallion, and passed from hand to hand like
a calling card. It could be subsumed in maps, almanacs, and advertisements. Print-
sellers kept it in stock, repeatedly ordering new editions, but it was not always sold
over the counter. Subscription agents and mail-order outlets dealt directly with
the consumer. Magazine and newspaper publishers gave copies to their subscribers.
Engravers and calligraphers used them to impress potential customers. Printers
doled them out at Independence Day parades. Produced in quantity and widely
distributed, the Declaration was a staple of the graphic arts industry and a canon-
ical genre in American visual culture.

 Framed copies were constantly in view. Binns and Tyler intended them to
have a place of honor in the home, a marketing gambit that seems to have

succeeded. Frame stores bought them on spec for sale in cities. Travel writers saw them on the walls of country inns and public buildings. Congressmen could consider the copy Binns donated to the House of Representatives, where it was prominently displayed near the Speaker's rostrum. To some a reproach, to others an inspiration, it stood straight in front of them during the fateful debates of the 1850s. No doubt many merely glanced at the state seals and hardly gave a second thought to their symbolic significance. Nor were they likely to pause for a close reading of the document, which they could see elsewhere in less stressful situations. In any case it was more a subject for adulation than analysis in the pictorial prints, an aesthetic also evident in the calligraphic versions, those too favoring form over content. The Declaration became a work of art during the nineteenth century. Only at the century's end did the embellishments fall out of fashion, but the official facsimile stayed in demand and retained its mystique, more than ever an essential image of an iconic text.

Checklist of Prints and Broadsides, 1816–1900

SCOPE

This checklist describes Declaration of Independence prints and broadsides published between 1816 and 1900. Chapters 1 and 6 touch on publications before and after those dates. In general these single-sheet Declarations were intended to be viewed on their own, as independent art objects rather than illustrations in books, magazines, and newspapers. The term "prints" usually refers to engravings and lithographs, "broadsides" to letterpress texts; I have retained that distinction, although here the two types of graphics are closely related and often exchange design motifs. I have included facsimile signatures, even without the text, because they rejoined it in later versions. The Hinton signatures (no. 25), for example, were sometimes appended to the text of the Rough Draft (nos. 101 and 105). The Trumbull key (no. 13) was reproduced in some of the pictorial prints. Some signatures reappear in other media such as plaques and handkerchiefs, which I have treated like prints because they are similar in design and were sold in the same market. The checklist is in chronological order, although variants and later editions are sometimes grouped in the same entry.

DESCRIPTIVE PROCEDURES

Each entry consists of a title transcription, imprint, date, measurements, transcriptions of headings and captions (if present), notes, locations, and references (if applicable). Titles are in italics. I have regularized capitalization, superscripts, and place names in imprints wherever an exact transcription might be misleading or obtrusive, e.g., passages in all caps. The imprint statement starts with the place of publication if that is known; if not, I have used the "sine loco" abbreviation, *s. l.* I have transcribed names of printers and publishers along with their addresses, many of which have been useful for dating purposes. Often it is possible to narrow down the dates by tracking the changes of addresses in city directories. Square brackets indicate information I have supplied from other sources such as

directories, advertisements, and reference works on the print trade. Square brackets in the original are transcribed as angle brackets. Like library catalogers, I have prefaced publication dates derived from copyright statements with a *c*, which should serve as a warning that a product might have arrived on the market a year or two later, e.g., McBride's *Centennial Memorial* (no. 80). Measurements are to the nearest quarter of an inch in order of the height and width of the largest copy found. I have followed E. McSherry Fowble's *Two Centuries of Prints in America* in using the § symbol to denote headings and captions, if any, as well as whatever artists' names might appear on a print. The notes section begins with an indication of the printing process and then contains a short account of typography, layout, illustrations, and ornament. I have provided cross-references whenever I have noticed design motifs derived from other publications. This section may also include an account of pricing and publishing practices as well as evidence about dates and attributions.

LOCATIONS

I have designated locations with the standard United States and United Kingdom MARC organization codes. I have used initials to identify private collections and organizations not in the MARC code database. This section also includes figure references for the illustrations. Location codes in italics indicate copies I have not seen in person but can describe in adequate detail on the basis of reproductions and catalog records. Copies in the book trade are cited in italics except for a few I examined on site before they were sold; those citations are in roman. Either way I am greatly indebted to auction houses and antiquarian booksellers for information about copies I have not found in institutional collections. The illustrations in their catalogues and online listings have revealed editions and variants I would not have noticed otherwise. I have recorded prices, a means of gauging rarity, condition, visual allure, and historical significance. Auction prices include the buyer's premium. Some prints have been subject to speculation, others have been undervalued in my opinion, but prices have been rising in response to renewed public interest in the Declaration. No doubt the valuations I have cited will soon go out of date, but they will still be useful for comparison purposes. They document trends in the trade over more than thirty years. Present market conditions are worth noting in the light of similar developments during the early nineteenth century, when printmakers formed the taste for facsimiles and succeeded in making them desirable to collectors.

AAN	Alessandra and Alexander Norcross, Philadelphia, PA
CLU-C	William Andrews Clark Memorial Library, University of California, Los Angeles, Los Angeles, CA
CSmH	The Huntington Library, Art Museum, and Botanical Gardens, San Marino, CA
CSt	Stanford Libraries, Stanford, CA
CtHWa	Wadsworth Atheneum Museum of Art, Hartford, CT
DeWint	Winterthur Museum, Garden, and Library, Winterthur, DE
DH	Daniel Hamelberg, Champaign, IL
DLC-MSS	Manuscript Division, Library of Congress, Washington, DC
DLC-PP	Prints and Photographs Division, Library of Congress, Washington, DC
DLC-RBSC	Rare Book and Special Collections Division, Library of Congress, Washington, DC
DMR	David M. Rubenstein, Washington, DC
DNA	National Archives and Records Administration, Washington, DC
DSI-MAH	National Museum of American History, Smithsonian Institution, Washington, DC
DSI-NPG	National Portrait Gallery, Smithsonian Institution, Washington, DC
GL	Gilder Lehrman Institute of American History, New York, NY
ICA	Art Institute of Chicago, Chicago, IL
ICN	The Newberry Library, Chicago, IL
KWiU	Wichita State University Libraries, Wichita, KS
MA	Amherst College Library, Amherst, MA
MBAt	Boston Athenaeum, Boston, MA
MBJFK	John F. Kennedy Presidential Library and Museum, Boston, MA
MDT	Mark D. Tomasko, New York, NY
MH-H	Houghton Library, Harvard University, Cambridge, MA
MHi	Massachusetts Historical Society, Boston, MA
MiU-C	William L. Clements Library, University of Michigan, Ann Arbor, MI
MoSHi	Missouri Historical Society, St. Louis, MO
MWA	American Antiquarian Society, Worcester, MA
NCC	National Constitution Center, Philadelphia, PA
NcD	David M. Rubenstein Rare Book & Manuscript Library, Duke University, Durham, NC
NhHi	New Hampshire Historical Society, Concord, NH

NHi	Patricia D. Klingenstein Library, New-York Historical Society, New York, NY
NjP	Princeton University Library, Princeton, NJ
NN	New York Public Library, New York, NY
NNSCH	Cooper Hewitt, Smithsonian Design Museum, New York, NY
PAFA	Pennsylvania Academy of the Fine Arts, Philadelphia, PA
PHi	Historical Society of Pennsylvania, Philadelphia, PA
PPAmP	American Philosophical Society Library, Philadelphia, PA
PPIn	Independence National Historical Park, Philadelphia, PA
PPL	Library Company of Philadelphia, Philadelphia, PA
PSt	Eberly Family Special Collections Library, Penn State University Libraries, University Park, PA
RPJCB	John Carter Brown Library, Providence, RI
ScCMP	Middleton Place Foundation, Charleston, SC
ScFlM	James A. Rogers Library, Francis Marion University, Florence, SC
TxFACM	Amon Carter Museum of American Art, Fort Worth, TX
Uk	British Library, London, UK
UkLU-K	King's College London, London, UK
UkLW	Wellcome Collection, London, UK
ViU	Albert and Shirley Small Special Collections Library, University of Virginia, Charlottesville, VA
VtShelM	Shelburne Museum, Shelburne, VT

REFERENCES

Standard reference works, specialist studies in articles and monographs, and other secondary sources are cited after the location codes. The full citations are in the Bibliography. Some sources are the sole authorities for my descriptions (e.g., nos. 22, 23, 56, and 74).

VARIANTS AND LATER EDITIONS

This checklist is about three times the size of my first attempt in 1988. I have redated some items and deleted others I now know to be out of scope. Rather than cross-referencing my revisions, I have renumbered the entries and tried to make them more accessible by indexing the names of artists, printers, and publishers.

The introduction explains why the checklist is larger than the 1988 version and notes that photographs have revealed many of the newfound variants and later editions. Altogether I have collected more than fifteen hundred photographs, including close-ups of imprints and decorative details that might have been altered in the course of reprinting a publication. It is possible that some alterations I have recorded are merely in-press corrections, but I believe that most can be interpreted as evidence of other printings. The Woodruff piracy and its derivatives (nos. 5, 9, 10, 16, 17, 20, and 42) show how a popular design could be copied in other media and how an engraved plate could pass into the hands of other publishers. Humphrey Phelps and his successors printed a script type Declaration at least nine times between 1845 and the Civil War (no. 47). Stereotype broadsides and steel engravings could go back to press repeatedly (nos. 33 and 38), a prime technological advantage of the industrial era. Entries with long lists of editions should help identify successful publications and reckon the longevity of the steady sellers.

1 *Declaration of Independence. In Congress, July 4, 1776.* [New York:] Daniel Fanshaw, Printer, Nos. 241 Pearl and 10 Cliff-Streets [ca. 1816]. 12 × 10 ¾ inches

NOTE: Letterpress, text in two columns within a border of type ornaments, printed on silk, no signatures. City directories locate Daniel Fanshaw at 10 Cliff Street between 1814 and 1817 (McKay, *Register*, 27). The Pearl Street and Cliff Street addresses appear in the imprints of books and pamphlets printed by him between 1815 and 1817, just before he relocated to 20 Sloat-Lane. During 1814 and 1815 he was in a partnership with William Henry Clayton and printed at least one item over his own name in 1815. But a date of 1816 seems more likely because he dissolved his partnership with Clayton toward the end of 1815 and set out on his own account with a newly reconstituted workforce (*Evening Post* [New York], November 22, 1815). The type ornaments in the border include several displayed in the D. & G. Bruce *Specimen of Printing Types* (New York, 1818). The ornaments section of that specimen is dated 1816.

ViU

2 *From the Office of the National Advocate.—July 4, 1817. Declaration of Independence, by the Representatives of the United States of America, in Congress Assembled, July 4, 1776. A Declaration.* [New York: Napthali Phillips, 1817]. 23 × 18 inches

NOTE: Letterpress, text in two columns within a border of type ornaments, with a relief cut of an American eagle, signatures in type arranged by state, misspelling several names, and omitting James Smith and George Taylor. "Not wishing to consign it for the day to a transitory duration in our columns, we respectfully transmit an extra sheet, containing a neatly printed copy of the declaration, which accompanies this day's Advocate" (*National Advocate* [New York], July 4, 1817).

DH MWA

Swann Auction Galleries, New York, November 25, 2014, lot 103, $6,500

3 *In Congress, July 4th. 1776. The Unanimous Declaration of the Thirteen United States of America.* [Washington, DC: Benjamin Owen Tyler, 1818]. 32 ½ × 27 inches

§ To Thomas Jefferson, Patron of the Arts, the firm supporter of American Independence, and the Rights of Man, this Charter of our Freedom is, with the highest esteem, most Respectfully Inscribed by his much Obliged and very Humble Servant Benjamin Owen Tyler. § Copied from the original Declaration of Independence in the Department of State, and Published by Benjamin Owen Tyler Professor of Penmanship, City of Washington 1818. The publisher designed and executed the ornamental writing, and has been particular to copy the Facsimilies exact, and has also observed the same punctuation, and copied every Capital as in the original. Engraved by Peter Maverick Newark N.J. § Department of State September 10. 1817. The foregoing copy of the declaration of Independence, has been collated with the original instrument and found correct. I have, myself, examined the signatures to each. Those executed by Mr Tyler are curiously exact imitations; so much so that it would be difficult if not impossible for the closest scrutiny to distinguish them, were it not for the hand of time, from the originals. [Signed in facsimile:] Richard Rush Acting Secretary of State [with the seal of the Secretary of State's office]

NOTE: Engraved, title and text in various ornamental scripts, facsimile signatures in six columns. I have seen copies printed on parchment (MWA MHi) and silk (NN) as well as on paper, possibly manufactured by Joshua and Thomas Gilpin on the first papermaking machine in America. Tyler claimed that he had paid $200 a ream for the paper and $600 a ream for the silk and parchment (Tyler, *Declaration*, 11).

Fig. 11 *DH* DLC-MSS DMR MHi *MiU-C* MWA NHi NN PPAmP RPJCB *ScCMP* ViU VtShelM; Nash, *American Penmanship*, no. 87; Stephens, *Mavericks*, no. 492

Printed on parchment, William Reese Company, catalogue 200 (2001), item 22, $75,000; William Reese Company, catalogue 273 (2009), item 58, and catalogue 281 (2010), item 14, $25,000; Swann Auction Galleries, New York, October 2, 2012, lot 213, $9,000; printed on silk, Swann Auction Galleries, New York, April 14, 2015, lot 110, $25,000; Sotheby's, New York, January 17, 2018, lot 75, $11,875; Skinner, Boston, November 18, 2018, lot 12, $4,613; "trimmed... insect damaged," Seth Kaller, website, January 20, 2020, $35,000; printed on silk, Sotheby's, New York, January 24, 2023, lot 1312, $35,280

4 *In Congress, July 4th. 1776. The Unanimous Declaration of the Thirteen United States of America.* [New York?, 1818]. 21 ½ × 16 inches

NOTE: Letterpress, printed on satin in two columns within a folding ribbon ornamental border, the title in shaded and fat faces, the signatures in italics. The first line of the title arches over a stock cut depicting the national seal, the flag, and other patriotic emblems. Tyler remarked in passing that a letterpress broadside printed on satin had been published "within a few weeks" of his and was selling for less than half the price (Tyler, *Declaration*, 14). The late Stephen O. Saxe examined a photograph and compared the types and ornaments with the early American type specimens in his collection. He confirmed that it could have been printed in 1818, both from evidence of the types, which are consistent with this date, and of the stock cut, which he found in an 1820 specimen of the D. & G. Bruce typefoundry.

NcD

5 *In Congress, July 4th. 1776. The Unanimous Declaration of the Thirteen United States of America.* [Philadelphia: William Woodruff, 1819]. 27 ¾ × 20 ¼ inches

§ Engraved by Wm. Woodruff § To the People of the United States this Engraving of the Declaration of Independence is most respectfully inscribed by their fellow citizen Wm. Woodruff. § Philada. Published Feby. 20th. 1819, by William Woodruff. § Copy Right secured § Printed by C. P. Harr[i]son

NOTE: Engraved, title in ornamental scripts, text in a uniform round hand, a few words emphasized in ornamental capitals, within an ornamental oak-leaf border bearing the state seals in medallions and portraits of Washington, Jefferson, and Adams. A close imitation of no. 6, with the signatures in the same script as the text. Eventually Woodruff or a later proprietor of the plate accompanied this print with a separately published facsimile of the signatures (no. 7).

ViU; Hart, *Portraits of Washington*, no. 595; Stauffer, *American Engravers*, no. 3406 state I

LATER EDITIONS AND ADAPTATIONS: ca. **1820s?** 33 ½ × 26 ¼ inches, Harrison's imprint effaced (*DH* NN; torn, damp stained, Swann Auction Galleries, New York, September 26, 2019, lot 90, $1,375; Hart, *Portraits of Washington*, no. 595a; Stauffer, *American Engravers*, no. 3406 state II; Cunningham, *Popular Images of the Presidency*, fig. 3-1). ca. **1820s?** 27 × 20 ½ inches, § Printed by E. Valentine N. York (*ScFlM*). ca. **1836–42** 30 ½ × 21 ¾ inches, Valentine's imprint effaced, Woodruff's imprint changed to § Philada. Published by O. Rogers No. 67 South 2nd. St. Philada. (PPIn UkLW). ca. **1836–42** 31 × 22 ¼ inches, with Rogers's imprint, facsimile signatures after Binns (DLC-MSS NHi). ca. **1836–42** with Rogers's imprint, the state seals redesigned and reengraved (Hart, *Portraits of Washington*, no. 596; Stauffer, *American Engravers*, no. 3407). **1843** 27 ¾ × 21 inches, with a different portrait of Washington, § Gimber Sc. Trumbull Pinxt. § Published by Phelps & Ensign 7 ½ Bowery N.Y. § Story & Atwood Engravers 151 Fulton St. N.Y. (Fig. 10 *DH* NHi NN MWA; *Christie's, New York, May 18, 2012, lot 91, $3,750*; Hart, *Portraits of Washington*, no. 117; *Boston Daily Mail*, November 4, 1843). ca. **1843** as the previous print but Washington's portrait unsigned (Hart, *Portraits of Washington*, no. 117a).

6 *Declaration of Independence. In Congress. July 4th. 1776. The Unanimous Declaration of the Thirteen United States of America.* [Philadelphia: John Binns, 1819]. 36 × 25 ½ inches

§ Originally designed by John Binns. Ornamental part drawn by Geo. Bridport. Arms of the United States, and the Thirteen States, drawn from Official Documents, by Thos. Sully. Portrait of Genl. Washington, Painted in 1795 by Stuart. Portrait of Thomas Jefferson, Painted in 1816 by Otis. Portrait of John Hancock, Painted in 1765 by Copley. Ornamental part, Arms of the United States, and the Thirteen States, engraved by Geo. Murray. The Writing designed and engraved by C. H. Parker. Portraits engraved by J. B. Longacre. Printed by James Porter. § To the People of the United States this ornamented copy of the Declaration of Independence is respectfully dedicated by their fellow citizen [signed in facsimile:] John Binns § "Department of State, 19th. April 1819. I certify, that this is a Correct copy of the original Declaration of Independence, deposited at this Department; and that I have compared all the signatures with those of the original, and have found them Exact Imitations." [signed in facsimile:] John Quincy Adams § [Copyright statement of John Binns dated November 4,

FIGURE 50
Fac Similes of the Signatures Accompanying Wm. Woodruff's Ornamental Engraving of the Declaration of Independence. Philadelphia: William Woodruff, 1819? (no. 7). William L. Clements Library, University of Michigan.

1818] § Fac-similes by Tanner, Vallance, Kearny & Co. Engraved in the office of the Secretary of State, from the Original Signatures.

NOTE: Engraved, title and text in ornamental script with the signatures in facsimile, within an ornamental border bearing state seals in medallions and stipple portraits of Washington, Jefferson, and Hancock. Subscription proposals for this print first appeared in the *Democratic Press* (Philadelphia), March 26, 1816, and were reprinted with additional information in *Niles' Weekly Register* (Baltimore), July 6, 1816.

Fig. 7 *DH* DLC-MSS DMR *DSI-NPG* MHi *MiU-C* NHi NN PPAmP PHi PPL ViU; Hart, *Portraits of Washington*, no. 594; Cunningham, *Popular Images of the Presidency*, fig. 3-2

Marc Matz & Heidi Pribell, Cambridge, MA, June 11, 1989, lot 216, $4,125; Willen's Manuscripts and Fine Prints, Beverly Hills, November 2, 1989, lot 23, est. $9,000–11,000; Freeman's, Philadelphia, November 18, 2007, lot 2742, $14,340; Bauman Rare Books, holiday catalogue (2007), item 15, $38,000; William Reese Company, bulletin 34 (2014), item 31, $14,000; Sotheby's, New York, June 19, 2015, lot 102, $6,875; Heritage Auctions, Dallas, September 14, 2020, lot 43269, $30,000; Heritage Auctions, Dallas, June 11, 2022, lot 43238, $10,313; hand colored, Heritage Auctions, Dallas, December 1, 2022, lot 47019, $40,000; Geographicus, New York Antiquarian Book Fair, April 29, 2023, $30,000

LATER EDITIONS AND ADAPTATIONS: **1872** 36 × 26 inches, letterpress reproduction of the original engraving with the name of M. G. Duignan substituted to Binns's in the dedication, § [copyright statement of M. G. Duignan dated 1872] § Engraved by the Actinic Engraving Co., No. 113 Liberty Street, New York. § Printed by Geo. W. Wheat & Co., No. 8 Spruce Street, New York. (NHi). **1876** 36 ¼ × 28 ½ inches, lithograph, § [copyright statement of H. J. Toudy and A. J. Stone dated 1876] § Photo. lith. from original, and printed from stone by H. J. Toudy & Co. (DLC-MSS). **1876** 35 × 25 ½ inches, engraving, § [copyright statement of Henry Sartain dated 1876] § Printed by Henry Sartain. § Published by Henry Sartain, Philadelphia, Pa. (DLC-MSS; *hand colored, Donald A. Heald Rare Books, catalogue [2017], item 9, $25,000; Philadelphia Print Shop, website, February 11, 2018, $25,000*; Hart, *Portraits of Washington*, no. 594a). For the plate-printing business of Henry Sartain (1833–1894), see Martinez and Talbott, *Philadelphia's Cultural Landscape*, 17–18. Binns's plate with Sartain's modifications is at PPL.

7 *Fac Similes of the Signatures Accompanying Wm. Woodruff's Ornamental Engraving of the Declaration of Independence, Faithfully Copied from the Original, in the Office of the Secretary of State.* [Philadelphia: William Woodruff, 1819?]. 11 ½ × 17 ¾ inches

§ "And for the support of this Declaration, with a firm reliance on the protection of Divine Providence, we mutually pledge to each other, our Lives, our Fortunes, and our Sacred Honor."

NOTE: Title and quotation in letterpress, engraved facsimile signatures after Tyler.

Fig. 50 *MiU-C*

8 *In Congress July 4th. 1776. The Unanimous Declaration of the Thirteen United States of America.* [Hartford, CT:] Engraved by E. Huntington [ca. 1820–24]. 27 × 21 ½ inches

NOTE: Engraved, closely imitating Tyler's title and design, although skimping on some of the ornamental hands in the text, and with facsimile signatures after Binns, transmitted through the John Warr Jr., engraving. For Eleazer Huntington, engraver and author of *The American Penman* (first published in 1824), see Groce and Wallace, *Dictionary of Artists*, 335, and Nash, *American Penmanship*, 23–24. Huntington was one of the original subscribers to Tyler's facsimile and is listed in Tyler's subscription book at ViU.

Fig. 33 CSmH *DH* MHi MWA NjP PPAmP ViU

"Handsomely framed with silk matting," William Reese Company, catalogue 254 (2007), item 58, $25,000; "handsomely framed with silk matting," Bauman Rare Books, catalogue (2007), item 13, $25,000; "expert restoration," Sotheby's, New York, January 17, 2018, lot 76, estimate $10,000–$15,000, not sold; "expert restoration," Donald A. Heald Rare Books, catalogue (March 2018), item 8, $15,000; foxed, most of imprint cropped, Swann Auction Galleries, New York, September 27, 2018, lot 279, $2,210; Swann Auction Galleries, New York, September 26, 2019, lot 89, $2,125; William Reese Company, catalogue 367 (December 2019), item 42, $17,500; "expert restoration," Donald A. Heald Rare Books, website, July 20, 2022, $15,000

9 *In Congress, July 4th. 1776. The Unanimous Declaration of the Thirteen United States of America.* [s. l., ca. 1820s?]. 31 ¼ × 22 ¼ inches

NOTE: Engraved, closely imitating the Woodruff piracy (no. 5) but with a floral border around the state seals instead of the oak-leaf border. Like no. 8, the facsimile signatures are after Binns transmitted through the John Warr Jr., engraving. The round-hand text has some similarities with the text in no. 8 but is not as well executed and resorts to flourished capitals instead of ornamental scripts in the emphasized phrases at the end. The engraver omitted the word "have" in the phrase "We have appealed" and after noticing the mistake inserted the missing word as a superscript. This print is unsigned, although it must have been a fairly ambitious project, which suggests that the publisher wanted to follow Woodruff's example without incurring legal repercussions.

DH MWA

FIGURE 51
In Congress, July 4th. 1776.
The Unanimous Declaration
of the Thirteen United States of
America. Cotton handkerchief.
Glasgow: Colin Gillespie,
ca. 1821–26 (no. 10). Courtesy
of Swann Auction Galleries.

10 *In Congress, July 4th. 1776. The Unanimous Declaration of the Thirteen United States of America.* [Glasgow: Colin Gillespie, 1821]. 33 × 31 inches

§ Published at Glasgow 1821 by Cln [?]

NOTE: Cotton handkerchief printed in red, a reproduction of the Woodruff piracy (no. 5) in a rope border ornamented with stars and anchors, sprays of laurel on the left and right with the names of Hamilton and Putnam, vignettes at the bottom left and right corners of the design depicting the Boston Tea Party and the surrender of General Burgoyne at Saratoga, facsimile signatures after Tyler.

DeWint NNSCH

Seth Kaller, New York Antiquarian Book Fair, April 21, 2022, $38,000; *Heritage Auctions, June 11, 2022, lot 43267, $21,250*

LATER EDITIONS AND ADAPTATIONS: ca. **1821–26** 32 × 28 inches, as above but with a border of cannons and anchors, some differences in the illustrations next to the border, no imprint in the copies I have seen, but contemporary advertisements attribute it to Colin Gillespie of Glasgow (Fig. 51 *DH* MWA NN VtShelM; *Jeff R. Bridgman Antiques, website, June 17, 2019, $55,000*; Swann Auction Galleries, New York, September 26, 2019, lot 91, $4,500; *Christie's, New York, June 18, 2020, lot 90, $3,000*; *Providence Patriot*, May 23, 1821).

Copies in black on white and blue on white are reproduced in Collins, *Threads of History*, nos. 23 and 58. Imported "silk" handkerchiefs with this design could be had for $1 (*Georgetown Gazette*, July 14, 1826). ca. **1826–32** 32 × 27 ¾ inches, as above but with a border of beehives in medallions along with other patriotic symbols, the title reformatted, *In Congress* in Tuscan lettering (*DH*; *Heritage Auctions, October 15, 2022, lot 43002, $1,000*). ca. **1832** 31 × 28 ¾ inches, with the beehives border, the reformatted title, and a eulogy of Charles Carroll inserted above the text (*MA*).

11 *In Congress, July 4, 1776. The Unanimous Declaration of the Thirteen United States of America*. [Washington, DC: Department of State, 1823]. 34 × 26 ¾ inches

§ Engraved by W. I. Stone, for the Dept. of State, by order of J. Q. Adams Sect. of State, July 4th. 1823.

NOTE: Engraved facsimile of the entire document in actual size, printed on parchment. John Quincy Adams reported that two hundred copies had been printed as of January 1, 1824. He sent a copy to John Adams on June 24, 1824. The original plate belonged to the State Department and probably passed into the National Archives as government property (*Annals of Congress*, 18th Cong., 1st sess., 915; *National Intelligencer* [Washington, DC], June 7, 1823; Adams, *Letters Received*, reel 465). Copies on paper (MHi MWA PPAmP) have been described as proofs, but it is not yet known when or why they were printed.

Fig. 17 *AAN* DMR DNA *DSI-MAH* GL *MBJFK MH-H* MHi NCC *ViU*; Stauffer, *American Engravers*, no. 3045

Printed on paper, Brigham Young's copy, Christie's, Los Angeles, January 31, 2002, lot 2, $171,000; parchment, Christie's, New York, May 24, 2002, lot 44, $251,500; parchment, Raynors' Historical Collectible Auctions, Burlington, NC, ca. March 2007, lot 43, $481,750; parchment, Christie's, New York, February 12, 2009, lot 8, $698,500; printed on paper, Christie's, New York, February 12, 2009, lot 9, $68,500; parchment, Heritage Auctions, Dallas, April 11, 2012, lot 34018, $597,500; parchment, Christie's, New York, December 7, 2012, lot 34, $782,500; printed on paper, Brigham Young's copy, Christie's, New York, December 5, 2017, lot 45, $432,500; printed on paper, Christie's, New York, June 14, 2018, lot 86, estimate $200,000–$300,000, not sold; parchment, Christie's, New York, December 4, 2018, lot 140, $852,500; parchment, Thomas Emory's copy, Sotheby's, New York, January 24, 2019, lot 2122, $975,000; parchment, one of Charles Carroll's two copies, Freeman's, Philadelphia, July 1, 2021, lot 1, $4,420,000

LATER EDITIONS AND ADAPTATIONS: **1820s or 1830s** 33 ½ × 28 inches, printed on wove paper, § *W. J. Stone Sc. Washn.* (MHi NHi). **1833** 29 × 25 inches, inserted as a folding plate in Peter Force's *American Archives*, 5th ser., vol. l (1848), printed in 1,500 copies on imitation parchment, sometimes called rice paper or parchment paper, § W. J. STONE SC. WASHN. (CSmH MHi MWA NjP; *National Intelligencer* [Washington, DC], November 6, 1848). Stone invoiced Force for four thousand copies of the print on imitation parchment in an entry dated July 21, 1833, when Force started on this publication project; Force paid for them in 1839. The State Department produced restrikes with the W. J. STONE SC. WASHN. imprint at various times during the nineteenth century. MWA has one on paper watermarked J WHATMAN TURKEY MILL 1850. They come up for sale frequently, and only a few representative examples are cited here: *unfolded, Christie's, New York, June 9, 2004, lot 370, $28,680; Seth Kaller, catalogue ca. October 2008, $38,000; unfolded, Christie's, New York,*

May 18, 2012, lot 90, estimate $35,000–$45,000; folded, Robert A. Siegel Auction Galleries and Seth Kaller, June 25, 2013, lot 102, estimate $15,000–$20,000; folded, Swann Auction Galleries, New York, April 27, 2017, lot 125, $21,250; folded, Swann Auction Galleries, New York, September 26, 2019, lot 92, $20,000; *folded, bound in the volume of American Archives, Shapero Rare Books, website, January 20, 2021, £22,500.* **1893** 32 × 26 ¾ inches, copies on paper distributed to historical societies by the State Department, § W. J. STONE SC. WASHN. (MHi).

12 *General Congress, July Fourth, 1776. Unanimous Declaration of Independence, Passed in the United States Congress, by the Representatives of the American People.* Boston: Printed and Published by Russell and Gardner . . . Congress Street, August 1823. 17 × 12 ½ inches

§ The Honorable John Adams, Thomas Jefferson, and Charles Carroll, are the only surviving signers of the above Declaration.

NOTE: Letterpress, text within an elaborate border of type ornaments, American eagle stock cut, names of the Signers in type. John Jay is included among the Signers, presumably because he was a delegate to the Continental Congress, but he was not present either for the vote on July 4th or the signing on August 2nd.

MHi

VARIANT: **1.** 16 ¼ × 11 ½ inches, printed on silk, same border, same setting of type, but with different text beneath the names of the Signers, § To their Excellencies John Adams and Thomas Jefferson, and the Honorable Charles Carroll, the only *surviving signers* of the Declaration of Independence, this Print is respectfully inscribed, by their most obedient fellow citizen, Francis Ingraham. August 1, 1823. (DLC-RBSC).

13 [Key to John Trumbull's *The Declaration of Independence of the United States of America.* New York: John Trumbull, 1823]. 11 ½ × 33 ¼ inches

§ The above Names, except those marked with a Star, are imitations of the several Signatures to the Original Act.

NOTE: Engraved, forty-eight signatures after Tyler in a numbered key with outline portraits identifying the figures in Asher B. Durand's 1823 engraving of Trumbull's *Declaration*, sometimes cited as the Durand Key. It would have been available before October 1, 1823, when Trumbull billed Jefferson for two copies of the engraving accompanied by "keys & description." The earliest advertisement I have found noted the "Facsimiles of the Signatures" (*Massachusetts Spy* [Worcester, MA], December 24, 1823). The PAFA copy accompanied a proof state of the engraving.

Fig. 27 CSmH NjP *PAFA* PPAmP; Stauffer, *American Engravers,* no. 679

14 *Sheet Almanack. 1824. Together with the Declaration of Independence of the United States of America.* Boston: Printed at the Office of Zion's Herald, by Moore & Prowse, over No. 19, Cornhill [1823]. 25 ¼ × 21 inches

§ A Declaration by the Representatives of the United States of America, in Congress Assembled—July 4, 1776. § The Hon. Charles Carroll, Thomas Jefferson, and John

Adams, are the only surviving signers of the Declaration. § Price 12 cents single—$1 per dozen.

NOTE: Letterpress, in a border of type ornaments including a stock cut of the American eagle, the almanac inset within the text of the Declaration, no signatures. On the verso of the PPAmP copy is *Constitution of the United States. Together with the Amendments* and an advertisement for Moore & Prowse's "Fancy Job Printing" services. The *Constitution* was priced at twenty cents a copy.

MWA PPAmP; Matyas, *Declaration*, no. 23-11

15 *Declaration of Independence. A Declaration, by the Representatives of the United States of America, in Congress Assembled, July 4, 1776.* [Baltimore?, ca. 1825?]. 19 × 11 ¾ inches

NOTE: Letterpress, the text in two columns, signatures in type misspelling four names. Probably derived from the *American and Commercial Daily Advertiser* (Baltimore), which contains three of the four misspellings in its July 4, 1825 printing of the Declaration.

MWA

16 *In Congress, July 4th. 1776. The Unanimous Declaration of the Thirteen United States of America.* [Lyon: Joséphine Decomberousse, ca. 1825?]. 28 × 21 inches

§ Lith. Decomberousse à Lyon § To the People of the United States this Engraving of the Declaration of Independence is most respectfully inscribed by their fellow citizen Wm. Woodruff.

NOTE: Lithograph, a reproduction of the Woodruff piracy (no. 5) in an early state, the signatures in a flourished round hand, rearranging the text, omitting both his and Harrison's imprints but retaining his dedication. In 1825 Decomberousse patented a process for transferring engravings on lithographic stones. She was among the first to practice this technique on a commercial scale (cf. English developments noted in Hunnisett, *Steel-Engraved Book Illustration*, 192).

DH; Bulletin of the Historical Society of Montgomery County Pennsylvania 5 (October 1946): 241; Bouquin and Parinet, *Dictionnaire*, "Decomberousse"

17 *In Congress, July 4th. 1776. The Unanimous Declaration of the Thirteen United States of America.* [Lyon: Horace Brunet, ca. 1825–35?]. 27 ¼ × 21 inches

§ Lith. de H. Brunet et Ci[e] à Lyon § To the People of the United States this Engraving of the Declaration of Independance is most respectfully inscribed Wm. Woodruff.

NOTE: Lithograph, a reproduction of the Woodruff piracy (no. 5) in an early state, the signatures in a flourished round hand, misspelling several names, Brunet's imprint inside the oak-leaf border.

NN; Bouquin and Parinet, *Dictionnaire*, "Sastre dit Brunet"

VARIANTS: 1. 27 ½ × 20 ¾ inches, Brunet's imprint inside the oak-leaf border, another transcription of the signatures, some of the same misspellings, § To the People of the

United States this Engraving of Declaration o Independence is most respectfully inscribed. Wm. Woodruff. (*DH*). **2.** 30 × 21 ¼ inches, printed on silk or satin, Brunet's imprint outside the oak-leaf border, the signatures in a different layout, some of the same misspellings, § To the People of the United States this Engraving of Declaration of Independence is most respectfully inscribed. Woodruff. (MWA PPIn). **3.** 28 ½ × 21 inches, printed on silk or satin, Brunet's imprint outside the oak-leaf border, signatures in the same layout as variant 2, some of the same misspellings, with an outer border of six-pointed stars, § To the People of the United States this Engraving of Declaration of Independence is most respectfully inscribed. Woodruff. (*DH ICA*; *Jeff R. Bridgman Antiques, website, November 18, 2019, item sold*; *Heritage Auctions, Dallas, June 11, 2022, lot 43008, $8,750*; Collins, *Threads of History*, no. 57; Cunningham, *Popular Images of the Presidency*, fig. 3-6).

18 *In Congress, July 4th, 1776. The Unanimous Declaration of the Thirteen United States of America.* Reading, PA: Published by Charles M'Williams, 1826. 22 ½ × 17 ¾ inches

§ George Getz, Printer.

NOTE: Letterpress, text in italics and signatures in type arranged by state, within a border of state seals in medallions after Binns (no. 6). However, instead of Binns's three portraits at the top, that portion of the border has been cut away to accommodate three stock-cut vignettes: agricultural implements, Liberty with a cornucopia beneath the American eagle, and emblems of shipping and commerce. The list of Signers omits two members of the Pennsylvania delegation.

NHi

VARIANT: **1.** 21 ¾ × 16 ¾ inches, *Erklärung der Unabhängigkeit, der dreyzehn Vereinten Staaten. Geschehen im Congress am 4ten July, 1776*, text in Fraktur and signatures in type arranged by state, within the same border of state seals as above and the same illustrations. Here too the list of Signers omits two members of the Pennsylvania delegation, and some names are Germanized, § Herausgegeben von Carl M'Williams, 1826. § Gedruckt bey H. B. Sage. (ViU).

19 *The Declaration of Independence, In Congress, July 4, 1776. Unanimous Declaration of Independence, of the Thirteen United States of America.* Boston: Printed and Published by Dutton & Wentworth, No. 4, Exchange Street, August, 1826. 16 ¾ × 11 ¾ inches

§ The Honorable Charles Carroll, of Carrolton, Maryland, is the only surviving signer of the above Declaration.

NOTE: Letterpress, printed on silk, signatures in type, text within an elaborate border of type ornaments based on no. 12.

DH

Heritage Auctions, Beverly Hills, September 13, 2011, lot 35094, $3,884

20 *In Congress, July 4th. 1776. The Unanimous Declaration of the Thirteen United States of America.* Carlisle, PA: Printed and Published by Moser & Peters, 1826. 24 ¼ × 18 ½ inches

NOTE: Letterpress, text and signatures in type misspelling the names of Thomas McKean and Caesar Rodney, within a wood-engraved border of state seals in medallions after Woodruff (no. 5).

PHi

21 *Declaration of Independence. In Congress, July 4th, 1776. The Unanimous Declaration of the Thirteen United States of America.* [Baltimore: Printers' Car, 1828]. 21 ¼ × 17 inches

§ Printers' Car, July 4th, 1828.... Civic Procession in honour of the commencement of the Baltimore and Ohio Rail Road.

NOTE: Letterpress, a large American eagle stock cut in the center of the title, text and signatures in type, the whole framed by type ornaments with medallion portraits of Washington on the sides and smaller American eagle stock cuts in corner-piece compartments. The American eagle stock cuts appear in the Boston Type and Stereotype Foundry *Specimen of Modern Printing Types and Stereotype Cuts* (1826). Among other errors of transcription, Button Gwinnett is misspelled Burton Gwinnett, and three of the Connecticut congressmen are listed in the Delaware delegation. Accounts of the Civic Procession are in the *Baltimore Gazette and Daily Advertiser*, July 5, 1828; *Niles' Weekly Register* (Baltimore), July 12, 1828; and Bowen, *Rambles*, 31–54. For more on civic processions, see Kaminski, *Documentary History*, 18:246, 21:1586, and "Convivial Printer" by Rollo G. Silver, who quoted the *Niles' Weekly Register* article but did not locate a copy of the broadside.

Fig. 2 MWA NjP

22 *Declaration of Independence. In Congress, July 4, 1776. The Unanimous Declaration of the Thirteen United States of America.* Baltimore: John D. Toy [ca. 1828?]. 22 × 16 inches

§ Printed and sold by John D. Toy, corner of Market Street and St. Paul's Lane, Baltimore.

NOTE: Letterpress, printed on silk, text and signatures in type, framed by type ornaments with corner pieces in the same style and layout as no. 21, the signatures in the same layout as no. 21, Button Gwinnett misspelled Burton Gwinnett. John D. Toy was active at this address from around 1822 to 1840.

DSI-MAH; Collins, *Threads of History*, no. 24

23 *Declaration of Independence. Adopted July 4, 1776.* New York: James Conner [ca. 1830]. 16 × 14 inches

§ Stereotyped by James Conner, Franklin Buildings, New York

NOTE: Letterpress, printed on silk, title text in roman and signatures in type within a border of type ornaments, a stock cut of the American eagle at the top. Conner used this imprint at least twice in 1830. The American eagle stock cut appears in an 1836 type specimen he issued in partnership with William R. Cooke.

Collins, *Threads of History*, no. 87

24 *In Congress, July 4, 1776. The Unanimous Declaration of the Thirteen United States of America.* Auburn, NY: Published by Thomas Henri Gleason, at T. M. Skinner's Printing Office [ca. 1830]. 21 ½ × 17 ¼ inches

NOTE: Letterpress, printed on silk, closely imitating Tyler's title and design, text in roman with some passages emphasized in ornamental types, signatures in type arranged by states. Skinner started his printing business in Auburn in 1816 and ceased operations around 1839–41 (Hamilton, *Country Printer*, 298). The most prominent feature of the title is the word *America*, set in a font similar or identical to the Six Lines Pica Ornamented displayed in the Baltimore Type Foundry's 1832 *Specimen of Printing Types*.

DH

Early American History Auctions, Rancho Santa Fe, CA, December 7, 2013, lot 13, $8,000; Early American History Auctions, Rancho Santa Fe, CA, October 21, 2017, lot 20, $9,000

25 *Fac-Similes of the Signatures to the Declaration of Independence July 4. 1776. From Binns' Celebrated Engraving.* [Philadelphia?, ca. 1830–32?]. 10 × 7 ¾ inches

§ [Certification statement of John Quincy Adams dated April 19, 1819, copied verbatim from the Binns edition along with John Quincy Adams's signature in facsimile]

NOTE: Engraved India paper proof, facsimile signatures only, after Binns. This print was originally an illustration for John Howard Hinton's *The History and Topography of the United States* (London: Jennings & Chaplin, etc.; Philadelphia: T. Wardle, 1830–32), issued in monthly parts and sold by Carey & Hart among others (*National Gazette and Literary Register* [Philadelphia], March 26, 1831). Variants of the print appear in later editions of Hinton's *History* as well as other monograph publications. A letterpress version appears as one of the illustrations in a National Publishing Co. broadside prospectus for James D. McCabe's *Centennial History of the United States* (MWA).

MWA NjP

VARIANTS: **1.** 14 × 10 ¾ inches, the certification statement reworked to omit the date, fine plate paper (MWA ViU). **2.** 12 × 9 ½ inches, omitting the text "from Binns' Celebrated Engraving" but including the date in the certification statement (MWA PPL). **3.** 11 ¾ × 9 ¼ inches, no imprint, letterpress? (MWA)

LATER EDITIONS AND ADAPTATIONS: ca. **1852–60** 13 ¾ × 10 inches, retitled *Fac Simile of the Signatures to the Declaration of Independence*, with the dated certification statement and an ornamental border composed of thirteen state seals, an allegory of Liberty and Justice at the top, and a view of the Capitol in a cartouche at the bottom. Like the Hinton illustration above, this print may have originally appeared as a book illustration, a plate in

FIGURE 52
*Declaration of Independence.
In Congress, July 4, 1776.
The Unanimous Declaration of
the Thirteen United States of
America.* Cotton handkerchief.
Boston: Henry Bowen,
ca. 1831–33 (no. 27). Courtesy
of Swann Auction Galleries.

the first volume of William Henry Bartlett's *History of the United States of North America*, published in parts by the George Virtue firm in London and its American affiliates. One of the advertisements states that the parts will cost twenty-five cents each and that each one will be accompanied by two steel engravings (*Schenectady Reflector*, June 4, 1852). The Virtue & Co. outlet in Boston was selling loose steel engravings as of 1860 (*Boston Evening Transcript*, June 9, 1860), but it is possible that some of the copies cited here were removed from copies of Bartlett's *History*, § Ornament by A. H. Wray. & Engd. By E. Mc.Cabe. § Engraved by J. W. Allen. (Fig. 48 NjP NN PPAmP PPIn PPL ViU). ca. **1857** 12 × 9 ½ inches, like the engraved India proof above, also printed on India paper, § Published by Wentworth & Company, Boston 86 Washington St. (MWA).

26 *Declaration of Independence. In Congress, July 4, 1776. The Unanimous Declaration of the Thirteen United States of America.* [Norfolk, VA: Shields & Ashburn, 1831]. 18 ¼ × 11 ¼ inches

§ Beacon Office, Norfolk, July 4, 1831.

NOTE: Letterpress, an American eagle stock cut at the top, the text in two columns, the signatures in type, the whole within a border of type ornaments. Possibly included in an issue of the *American Beacon* newspaper, but the border implies that it was a separate publication.

MWA

27 *Declaration of Independence. In Congress, July 4, 1776. The Unanimous Declaration of the Thirteen United States of America.* Boston: Henry Bowen's Chemical Print, 19 Water-Street [ca. 1831–33]. 19 × 19 inches

NOTE: Letterpress, printed on cotton in five columns, signatures in type, an American eagle stock cut at the top, the whole within a border of type ornaments. Includes a note on the "singular coincidence" that Presidents Adams, Jefferson, and Monroe died on the Fourth of July. The layout is derived from no. 21, and here too Button Gwinnett is misspelled Burton Gwinnett. The American eagle stock cut appears in an 1832 specimen book of the Boston Type and Stereotype Foundry. Bowen occupied the 19 Water Street premises with his brother the engraver Abel Bowen (see no. 33) between 1831 and 1833. In 1824 he printed tickets on a similar fabric to commemorate a Fourth of July celebration at Faneuil Hall (Adams, *Letters Received*, reel 465). He also used the "Chemical Print" imprint ca. 1848 in a commemorative handkerchief, *Just the Thing for a Child to Have! John Adams's Letter Written the Day After the Signing of the Declaration of Independence* (MHi MWA), which noted a "singular coincidence" in the deaths of Adams and Jefferson. "Chemical Print" has been thought to signify lithography (Eaton, *Printed Textiles*, 344), but it probably refers to the special pigments Bowen used with metal types.

Fig. 52 ViU

Swann Auction Galleries, New York, September 26, 2019, lot 93, $1,375

VARIANTS: **1.** 19 ¾ × 18 ¾ inches, § Henry Bowen's Chemical Print. 19 Water Street (NN PPL). **2.** 18 × 18 inches, § Henry Bowen's Chemical Print.—Sold by Benj. Freeman, 27 Central Street, Boston. (*DH*). **3.** 20 × 19 inches, same design, text, border, and imprint as variant 1 but set in four columns (*DeWint* DLC-RBSC ViU VtShelM; Collins, *Threads of History*, no. 85).

28 *Declaration of Independence. In Congress, July 4, 1776: The Unanimous Declaration of the Thirteen United States of America.* [New York: Humphrey Phelps and Bela S. Squire Jr., c1832]. 33 ½ × 23 inches

§ [Copyright statement of Humphry Phelps and Bela Squire dated October 1832]

NOTE: Letterpress, text, and signatures in type above a wood engraving of the Capitol, within an elaborate border of type ornaments, which encloses tables listing the reigning sovereigns of Europe, the governors of the states and territories, significant dates in the history of the United States, presidents of the United States, heights of mountains, lengths of rivers, an account of electoral votes in 1830, the national debt, and statistics about the Capitol building. Wolcott's signature is misspelled Woolcott. Framed in a portal, the text is in two columns, with some phrases emphasized in caps, small caps, bold caps, and black letter. The outer border is in a strapwork pattern.

NHi ViU

VARIANT: 1. 33 × 24 ¾ inches, as above but the outer border is in a diamond and cross pattern (*DH*).

29 *Declaration of Independence, and Geographical Chart of the U. States of America. In Congress, July 4th, 1776: The Unanimous Declaration of the Thirteen*

United States of America. Philadelphia: Published by Thomas Morrison, No. 47, South Third-Street [c1832]. 26 × 21 inches

§ [Copyright statement of Thomas Morrison dated December 8, 1832] § C. A. Elliott, Printer, S. W. Corner of Third and Chesnut-Street, Philadelphia.

NOTE: Letterpress, hand colored, with statistical information about the states, significant dates in the history of the United States, a distance chart, a table of electoral votes, etc., inside a border of type ornaments. Framed by Corinthian columns, the text is in type beneath a portrait of Washington and above three columns of facsimile signatures after Binns. In this variant the columns extend down to the foot of the facsimile signatures.

Fig. 67 *DH* ViU

Swann Auction Galleries, New York, November 25, 2014, lot 106, $1,000; University Archives, ABAA website, February 11, 2018, $7,000; Oak Knoll Books, website, February 11, 2018, $5,500; Oak Knoll Books, website, July 3, 2019, $6,500 marked down to $5,200

VARIANT: **1.** 28 ¼ × 23 ¼ inches, tabular matter rearranged and inserted under shorter versions of the columns (DLC-MSS PPAmP).

LATER EDITION: ca. **1834** Thomas Morrison's *The Philadelphia Visiter's Companion* (1834) contains an advertisement for a German-language version of this print.

30 *The National Register of Political Events*. Boston: C. L. Adams [ca. 1832]. 29 ¼ × 23 ¼ inches

§ Unanimous Declaration of Independence, 1776.

NOTE: Letterpress, a chronological list of events in American history up to June 1832 in an architectural framework composed of rules and type ornaments surmounted by an American eagle stock cut and enclosed in an outer border of type ornaments, including some of those used in no. 27. The text of the Declaration is in three columns with the signatures in type.

MWA

31 *Declaration of Independence. In Congress July 4, 1776. The Unanimous Declaration of the Thirteen United States of America*. Hartford, CT: Joseph Hurlbut [ca. 1833]. 31 × 20 ½ inches

NOTE: Letterpress, the title in display types with an American eagle stock cut, signatures in type, the text in two columns framed by type-ornament columns and a Greek key border including corner pieces and several sets of ornaments also used by Hurlbut in Victor Moreau Sheldon's *An Epitome of Universal Geography* (1833). The American eagle stock cut is a close copy of the cut in no. 27. The layout of the title is similar to that of no. 28, and here too Wolcott's signature is misspelled Woolcott.

DH

32 *In Congress July 4th, 1776. The Unanimous Declaration of Independence, of the Thirteen United States of America.* [Boston:] Boston Chemical Printing Company [ca. 1834]. 17 × 15 ¼ inches

NOTE: Letterpress, printed on cotton, stock cut of an American eagle over the title, signatures in type, the whole within a border of type ornaments same as a four lines pica border displayed in an 1832 specimen book of the Boston Type and Stereotype Foundry. Like no. 27, it includes a note on the "singular coincidence" that Presidents Adams, Jefferson, and Monroe died on the Fourth of July as well as other patriotic texts, including a list of presidents through Andrew Jackson. Here too Button Gwinnett is misspelled Burton Gwinnett. Henry Bowen, the printer of no. 27, joined with Lemuel Blake and Jonathan Dorr to incorporate the Boston Chemical Printing Company in 1834 (Mass. Gen. Laws ch. 4, 1834). It appears to be a successor firm to Henry Bowen's Chemical Print and probably used the same fabric printing technology.

DH ViU; Collins, *Threads of History*, no. 74

Skinner, Boston, November 21, 2004, lot 76, $3,290; James Arsenault Rare Books, website, June 16, 2019, $3,500

33 *In Congress, July 4, 1776. The Unanimous Declaration of the Thirteen United States of America.* [Boston:] Stereotyped by the Boston Bewick Company. Published by Prentiss Whitney, 30, Washington Street [ca. 1834–36?]. 30 × 23 ¼ inches

§ <Copy-Right secured.>

NOTE: Letterpress, text in script type with phrases emphasized in a variety of ornamental types, within an intertwining olive-vine and oak-leaf border enclosing the state seals and the national seal, facsimile signatures after Tyler. The five lines pica open black-letter display type in the title appears in an 1832 specimen book of the Boston Type and Stereotype Foundry. The Boston Bewick Company was founded in March 1834 "for the purpose of employing, improving, and extending the art of engraving, polytyping, embossing, and printing." The proprietors obtained an act of incorporation allowing them to hold assets amounting to $120,000 but failed after a fire in September 1835 (Whitmore, "Abel Bowen," 44). Two artists associated with the firm went on to publish their own editions of the Declaration (nos. 37 and 39). Abel Bowen & Co. announced that they were successors of that business, operating at the same address, 47 Court Street, and solicited orders for engraving, stereotyping, and "Fancy Job Printing" (*Columbian Centinel* [Boston], April 20, 1836). Publishing prints seems to have been a sideline of Prentiss Whitney, an auctioneer doing business at the 30 Washington Street address from 1833 to 1836. In addition to the variants below, there were at least two stereotype reprints in part (no. 36) or whole (no. 40).

Fig. 36 NN *ViU*

Book Scene, Hull, MA, website, July 31, 2022, $4,320

VARIANTS: **1.** 28 × 22 ¼ inches, § Stereotyped by the Boston Bewick Co. § Price 12 1–2 cents. § Printed by S. N. Dickinson. (*DH* MHi). **2.** 30 × 24 inches, § Stereotyped and Printed by the Boston Bewick Company. (NN).

34 *In Congress, July 4, 1776. The Unanimous Declaration of the Thirteen United States of America.* Boston: Published at Stationer's Hall [ca. 1834–36?]. 28 × 23 inches

§ <Copy-right secured.

NOTE: Letterpress, text in script type with phrases emphasized in a variety of ornamental types, facsimile signatures after Tyler, border with state seals, portraits of Hancock, Jefferson, and Franklin, and what seem to be stock cuts or recycled illustrations of the Battle of Lexington and the Boston Tea Party. The layout of the title is identical to that of no. 33, the script type is the same, and the printer has tried to copy the border with type ornaments and oak-leaf corner pieces. Likewise, the printer imitated the emphasized text in no. 33 but with stylistic differences one step further removed from Tyler's decorative scripts. Awkward design, cheap expedients, and inferior presswork also suggest the derivative nature of this catchpenny publication. David Felt sold account books and other office supplies at his Stationers' Hall establishment in New York between 1826 and 1852 (*National Advocate* [New York], December 22, 1826; *Albany Journal*, August 23, 1852). He also operated a Boston office under the same name at 82 State Street but appears to have dropped out of active management in the 1830s (*Boston Commercial Gazette*, September 25, 1826). Willard Felt ran the Boston branch between 1829 and 1833, Lemuel Gulliver between 1834 and 1835, and Thomas Groom as of 1836. Groom retained the Stationers' Hall name for a year or two and put it on his shop sign (*The Yankee: or Farmer's Almanac for … 1837* [Boston: Sold by Thomas Groom, 1836]).

DH MWA

35 *In Congress Assembled. July 4, 1776. The Unanimous Declaration of the Thirteen United States of America.* [Boston: Stationers' Hall?, ca. 1834–36?]. 27 ¾ × 22 ¾ inches

NOTE: Letterpress, text in script type with some passages emphasized in ornamental types, the same setting as no. 34, which is also the source of the facsimile signatures. Includes six state seals spaced out between ornaments and a border composed of stock cuts and recycled illustrations with a pyramid at the bottom bearing the motto "Legum Defensor." The state seals and the ornaments are the same as those used in no. 34. The NN copy is inscribed on the verso by a Charles Ellms of Scituate, most likely the publisher Charles Ellms (1805–1866) who was born in that town and probably died there. He was closely associated with the Stationers' Hall establishment, which distributed his almanac publications ca. 1832–37 (Bidwell, "Declaration of Independence Prints").

NN

36 *In Congress July 4, 1776. The Unanimous Declaration of the Thirteen United States of America.* [New York:] Published by H. Phelps, 140 Broadway, & B. S. Squire, 15 Bowery [ca. 1835–37]. 29 × 21 ½ inches

NOTE: Letterpress, title layout similar to that of no. 33, text in the same script type with phrases emphasized in a variety of ornamental types, forty-eight facsimile signatures after Tyler by way of Trumbull's key no. 13, the whole within the same stereotyped border as no. 33 but with a portrait of Washington substituted for the national seal and the state seals

FIGURE 53
*In Congress, July 4th. 1776.
The Unanimous Declaration of
the Thirteen United States of
America*. Boston: Lewis H.
Bridgham, 1836 (no. 37).
Author's collection.

in a different order. Since they are based on the key, the signatures are not complete and include the names of delegates who did not sign on August 2nd.

NHi

37 *In Congress, July 4th. 1776. The Unanimous Declaration of the Thirteen United States of America*. [Boston: Lewis H. Bridgham, c1836]. 5 ¾ × 4 ½ inches

§ [Copyright statement of L. H. Bridgham dated 1836]

NOTE: Engraved, printed on coated stock. The title is in open sans serif and black letter, the text in a minute italic hand with some phrases emphasized in roman, backslope and bold sans-serif lettering, facsimile signatures after Tyler. An intertwining vine and oak-leaf border encloses the state seals and a portrait of Washington. The border is derived from no. 33, published by the Boston Bewick Company, which had employed Lewis H. Bridgham in the molding and casting department of its stereotype foundry (*The American Magazine of Useful and Entertaining Knowledge* 1, no. 4 [December 1834]: advertisements). *Stimpson's Boston Directory* identifies him as a stereotype founder in 1835 and 1836. See Bidwell, "Sussex Declaration," for an account of Bridgham's printing career and a publishing history of this print, which was distributed widely in America and may have reached England as well.

Fig. 53 MHi MWA NN PPL; Hart, *Portraits of Washington*, no. 588

Swann Auction Galleries, New York, June 21, 2016, lot 132, $344; Rodger Friedman, catalogue, Just Ten Items (2017), item 4, $800; Swann Auction Galleries, New York, September 26, 2019, lot 94, $219

LATER EDITIONS AND ADAPTATIONS: **1839** 6 ¾ × 5 inches, *In the Continental Congress, of 1776, on the 4th. of July, The Unanimous Declaration of the Thirteen United States of America.* Same text but parts of the border reworked to accommodate the new title and to substitute a miniature reproduction of Trumbull's *Declaration* for Washington's portrait, § Published by N. Dearborn & Son—53 Washington St. Boston, & 164 Broad Way, New York, 1839. (NHi). ca. **1839?** 7 ½ × 5 ½ inches, same title and design as the Dearborn & Son version, § Published by N. Dearborn. No. 53 Washington St. Boston (PPL).

38 *The Declaration of Independence, with Fac-Similies of the Signatures and Likenesses of the Signers; the Arms of the States and of the United States, and Portraits of the Presidents.* Boston: Published by the Franklin Print Compy. 46 Court Street [c1838]. 12 ¾ × 10 ¼ inches

§ In Congress, July 4th. 1776. The Unanimous Declaration of the Thirteen United States of America. § Engraved by D. Kimberly. § The Lettering by J. B. Bolton. § [Copyright statement of Franklin Print Co. dated 1838]

NOTE: Steel engraving printed on "fine satin card," the text similar in style to the calligraphic scripts in no. 37, beneath a reproduction of Trumbull's *Declaration* and above a key with forty-eight facsimile signatures derived from no. 13, the whole within an ornamental border enclosing twenty-six state seals, the national seal, and portraits of eight presidents, all engraved in outline. The national seal is in the center of the upper border, the title and imprint in a cartouche at the bottom. The Franklin Print Co. was selling it for fifty cents in 1838 (*Boston Courier*, August 28, 1838).

MWA NN PPIn; Hart, *Portraits of Washington*, no. 589; Cunningham, *Popular Images of the Presidency*, fig. 3-10.

LATER EDITIONS AND ADAPTATIONS: **1840** 4 ¾ × 6 inches, the text, key, and facsimile signatures excerpted and reduced, one of several illustrations in *Phelps & Ensign's Travellers' Guide, and Map of the United States* (MWA). **1841** 12 ½ × 10 inches, the copyright statement redated 1841, the address changed to "No. 30 Joy's Building," in a different border although similar in style, the portraits and twenty-six state seals engraved in greater detail with a portrait of William Henry Harrison in the place of the national seal (MWA). ca. **1841** 19 × 13 ½ inches, same border and copyright statement as the redated version, § Pr. by Chas. Thomas & Co. § Published by James Fisher 71, Court St. Boston (Fig. 29 *DH* MHi MWA NHi NN; Hart, *Portraits of Washington*, no. 589a). ca. **1841** 14 ¾ × 11 inches, as the James Fisher edition but without the Thomas imprint (NHi NN; Hart, *Portraits of Washington*, no. 589b; Cunningham, *Popular Images of the Presidency*, fig. 3-11). **1845** 4 ¾ × 6 inches, the text, key, and facsimile signatures excerpted and reduced, one of several illustrations in *Ensign's Travellers' Guide, and Map of the United States* (MWA). ca. **1861–63** 13 ¾ × 11 inches, thirty-four state seals, the silhouette portraits in the key replaced by presidential portraits including Lincoln, no copyright statement, no credits to Kimberly and Bolton, § Published by Rae Smith, 71 Nassau St. New York (ViU; *Lincoln Financial Foundation Collection, Indiana State Museum*; Holzer, "'Columbia's Noblest Sons,'" 61).

FIGURE 54 *Declaration of Independence. In Congress July 4th. 1776.* Boston: George Girdler Smith, ca. 1841–45 (no. 39). Courtesy of Swann Auction Galleries.

39 *Declaration of Independence. In Congress July 4th. 1776.* Boston: Engd. & Published by Geo. G. Smith, 186 Washington, corner of Franklin St. [1838]. 12 ½ × 9 ¾ inches

NOTE: Engraved, printed on coated paper, text in a border of state seals closely imitating the Binns edition, facsimile signatures after Binns, and portraits of eight presidents up to Martin Van Buren. An advertisement for this first state of the print priced it at twenty-five cents and noted that the facsimiles were "copied from the best authorities" (*Boston Courier*, August 30, 1838). George Girdler Smith was the "agent" of the Boston Bewick Company, which published a Declaration ca. 1834–36 (no. 33; *Boston Daily Advertiser and Patriot*, September 25, 1835). He updated the plate with later presidents, had the new versions printed on his premises, and consigned them to Charles Root, who sold them in other cities as late as 1850, the price still at twenty-five cents (*Daily Transcript and Chronicle* [Providence, RI], December 19, 1845; *American and Commercial Daily Advertiser* [Baltimore], July 10, 1846; *Times-Picayune* [New Orleans], March 9, 1847; *Irish American Weekly* [New York], April 21, 1850). Root is named as the publisher in these notices and the imprints, but it is more likely that he was an itinerant agent of Smith, perhaps paid on commission. Root does not appear in Boston city directories during this period, but Smith is always listed at the 186 Washington Street address along with the plate printer Luther Stevens, who probably produced copies for Smith and Root on demand.

NN; Cunningham, *Popular Images of the Presidency*, fig. 3-8; Holden, *Catalogue*, no. 752; Stauffer, *American Engravers*, no. 2908 state I

LATER EDITIONS AND ADAPTATIONS: ca. **1841–45** 12 × 9 ½ inches, portraits of ten presidents up to John Tyler (Fig. 54 Swann Auction Galleries, New York, April 15, 2021, lot 213, $750). ca. **1845–49** 13 ½ × 10 ½ inches, portraits of eleven presidents up to James K. Polk and a view of the Capitol, § Engraved by Geo. G. Smith. § Published by Chas Root, 186, Washington, corner of Franklin St. Boston. (*DH* DLC-PP MWA NN; Hart, *Portraits of Washington*, no. 590; Stauffer, *American Engravers*, no. 2908 state II). ca. **1849–50** 13 ½ × 10 ½ inches, portraits of twelve presidents, view of the Capitol replaced by a portrait of Zachary Taylor (*DH* DLC-PP MWA NN; Hart, *Portraits of Washington*, no. 590a; Stauffer, *American Engravers*, no. 2908 state III; Cunningham, *Popular Images of the Presidency*, fig. 3-9; *Swann Auction Galleries, New York, April 27, 2017, lot 126, $500*).

40 *In Congress, July 4, 1776. The Unanimous Declaration of the Thirteen United States of America.* [New York:] Published by Phelps & Ensign, 7 ½ Bowery N.Y. [ca. 1838–42]. 28 ½ × 22 inches

NOTE: Letterpress, a stereotype reprint of no. 33.

DH

De Simone Company, catalogue 25 (1991), item 15, $975; The Brick Row Book Shop, catalogue 117 (1994), item 55, $900; Bauman Rare Books, catalogue (June 2006), item 19, $4,600; Swann Auction Galleries, New York, June 21, 2016, lot 133, $344

41 *Declaration of Independence July 4 1776.* [Philadelphia: Charles Toppan, 1840]. 2 × 3 inches

§ Engraved by C. Toppan Phila July 4 1840

FIGURE 55
*Declaration of Independence
July 4 1776.* Philadelphia:
Charles Toppan, 1840 (no. 41).
Courtesy of Independence
National Historical Park.

NOTE: Engraved card on coated stock, text in a minute script within an oval border composed of state seals, the national seal, and portraits of Washington and Jefferson in medallions. A partner in several banknote engraving firms, Charles Toppan (1796–1874) was the founding president of the American Bank Note Company, which frequently reprinted this miniature keepsake for promotional purposes (Griffiths, *Story of the American Bank Note Company*, 26, 34–36). No doubt this listing of later editions accounts for only a few of the restrikes.

Fig. 55 NN *PPL PPIn*; Hart, *Portraits of Washington*, no. 591a; Holden, *Catalogue*, no. 751

LATER EDITIONS AND ADAPTATIONS: **after 1840?** 2 ¼ × 3 ¼ inches, with a two-line border and ornamental arabesques on four sides (NN). **after 1840?** 3 × 4 inches, with a one-line border and a flower-and-arrow ornament on the left and right sides (PPL). ca. **1856?** 2 × 2 ¾ inches, the backgrounds of the portraits and state seals reworked with cross-hatching, § W. L. Germon, late of the firm of Mc.Clees & Germon, Photographers No. 168 Chestnut St. S. W. Cor. of 7th (MWA). **1864** 2 ¼ × 3 ¾ inches, with a flower-and-arrow ornament on either side, § Albany Bazaar. Feb. 1864. Sanitary Fair § Contributed by Gavit & Cowell. Alb. (*KWiU*). **1871** 8 ¼ × 5 ¼ inches, copies could be purchased for twenty cents at the Cincinnati Industrial Exposition, where it was printed "on tinted card board" by members of the American Bank Note Company. Advertisements of that firm claim that it was "the Smallest Engraving in the world" and that it cost over $5,000 to produce, § Printed at Cincinnati Industrial Exposition 1871 § American Bank Note Company § & 163 Fourth St. Cincinnati (MWA; *Cincinnati Daily Gazette*, September 21 and 23, 1871). ca. **1873?** 7 ½ × 5 ½ inches, with elaborate scrollwork and an advertisement for the New York office of the American Bank Note Company (NN; Hart, *Portraits of Washington*, no. 591; Holden, *Catalogue*, no. 751). ca. **1873–75?** 3 × 4 ¼ inches, with an advertisement for the Philadelphia office of the American Bank Note Company over the name of the manager, Alfred Pinchin. On the verso is an engraved reproduction of Trumbull's *Declaration* (DLC-PP; *North American and United States Gazette* [Philadelphia], January 13, 1875).

42 *In Congress, July 4th. 1776. The Unanimous Declaration of the Thirteen United States of America.* [s. l., ca. 1840s]. 28 × 27 ½ inches

NOTE: Handkerchief, a reproduction of the Woodruff piracy (no. 5) printed in black on yellow on silk, laurel wreaths at the top corners, American eagles at the bottom corners,

names of states rather than state seals in the oak-leaf border, facsimile signatures derived from a late state of no. 5.

NHi; Collins, *Threads of History*, no. 56; Cunningham, *Popular Images of the Presidency*, fig. 3-7

43 *Declaration of Independence. In Congress, July 4, 1776: The Unanimous Declaration of the Thirteen United States of America.* [New York: Phelps & Ensign?, c1842]. 31 × 24 inches

§ [Copyright statement of Humphry Phelps and Bele Squire dated October 1842]

NOTE: Letterpress, text and signatures in type, the same setting and layout as no. 28, but with different type ornaments in the borders and a different placement of the tables. Bela Squire left the firm Phelps & Squire around 1839. If the date in the copyright statement is correct, the successor firm Phelps & Ensign would have issued this print. Printers capable of misspelling names in a copyright statement would not have worried about tables ten years out of date.

MWA

44 *Declaration of Independence by the Representatives of the United States of America, in Congress Assembled, on the 4th of July, 1776.* [New York: Daniel Fanshaw?, ca. 1842?]. 15 ½ × 19 inches

§ Prud'homme ft. N.Y.

NOTE: Engraved key to Trumbull's *Declaration* with the portraits in stipple above the title in script type and the text in letterpress italics, some words emphasized in roman, facsimile signatures after no. 13, the whole within a decorative border. A version of the key without the decorative border accompanied a steel engraving of the Trumbull *Declaration* by John Francis Eugene Prud'homme in the *New-York Mirror*, volume 20 (November 5, 1842). Copies of the steel engraving were issued separately (MWA PPAmP) as was the key although the circumstances of the publication are not clear. The decorative border might have been added to the key in an attempt to make it an independent print, a conjecture supported by the size of the margins, which are much larger than those in the *New-York Mirror*. Volume 20 was published by Daniel Fanshaw, who may have sold on the side the twelve engraved prints he commissioned for that volume.

CtHWa MWA; Stauffer, *American Engravers*, no. 2623

45 [Key to John Trumbull's *Declaration of Independence of the United States of America*. New York: John Neale, 1843]. 7 ¾ × 20 inches

NOTE: Engraved on steel, forty-eight signatures in a numbered key with outline portraits identifying the figures in Henry S. Sadd's 1843 steel mezzotint of Trumbull's *Declaration*. Neale advertised "proof impressions" of the print with the key at $2 and implied they were printed on the same sheet of "very superior paper" 30 × 20 inches (*Evening Post* [New York], November 25, 1843). The print is fairly common and can be found in at least four institutional collections, but those copies are not accompanied by the key. I know of only two copies of the key and have seen them only in reproductions, both of which indicate that it was issued separately.

Tam O'Neill Fine Arts, "Examination & Authentication of Fine Art: The Declaration of Independence," typescript, October 7, 2011; WorthPoint website, "Rare Sadd Colored Engraving on Steel," July 25, 2022

46 *Declaration of Independence, and Constitution of the United States, With a Brief Sketch of the Presidents of the United States.* Boston: Printed by George Coolidge, No. 57 Washington Street, 1844. 27 × 21 inches

NOTE: Letterpress, four columns of text and three columns of signatures in type within a border of type ornaments. Includes short accounts of ten presidents and the text of the Constitution. Formerly foreman in the printing office of Samuel N. Dickinson, Coolidge went into business on his own at 57 Washington Street, Boston, in August 1844 (*Christian Watchman* [Boston], August 16, 1844).

Fig. 47 *DH* ViU

Swann Auction Galleries, New York, October 10, 2013, lot 169, $562; Swann Auction Galleries, New York, April 8, 2014, lot 122, $219

47 *In Congress July 4th. 1776. The Unanimous Declaration of the Thirteen United States of America.* New York: Published and For Sale by Humphrey Phelps, No. 4 Spruce-St., opposite City Hall [c1845]. 30 ¼ × 21 ¾ inches

§ Barritt. sc § Maigne, Printer, 98 Catharine-Street. § [Copyright statement of H. Phelps dated 1845]

NOTE: Letterpress, text in script type with many passages emphasized in ornamental types, "United States of America" in fat-face caps, facsimile signatures after Tyler probably transmitted through a folding plate in *The Pictorial History of the American Revolution* (New York: Published by Robert Sears [etc.], 1845), within a crudely colored border of state seals, including the names of generals in cartouches. In the style of the Binns edition, two cornucopias support a portrait of Washington at the top of the border. The Phelps and Maigne imprints are in a lower left compartment composed of type ornaments with additional type ornaments inside the compartment.

Fig. 56 Swann Auction Galleries, New York, September 26, 2019, lot 95, $281

LATER EDITIONS AND ADAPTATIONS: ca. **1845** 28 ½ × 20 ¾ inches, as above, omitting the Maigne imprint, "United States of America" in an open black letter (*DH* ViU). ca. **1845** 30 × 22 inches, as the previous entry, the type ornaments inside the compartment removed (NN). ca. **1846–47** 30 ¼ × 22 inches, as the previous entry, but imprint changed to § Published and For Sale by Humphrey Phelps, No. 144 Fulton-St., near Broadway, N. York. (NHi MWA *CSt*). ca. **1847–48** 31 × 23 inches, as the previous entry, but imprint changed to § Published and For Sale by Phelps, Ensigns & Thayer, No. 36 Ann-Street, New-York. (DLC-MSS). ca. **1847–48** 30 ¾ × 22 ¾ inches, *Die einstimmige Unabhängigkeits-Erklarung der dreizehn Vereinigten Staaten von Amerika. Im Congress, 4. juli 1776*, published by Phelps, Ensigns and Thayer with a copyright date of 1845 (*MiU-C*). ca. **1848–49** 28 ¾ × 21 inches, as the previous English edition, but imprint changed to § Published and For Sale by Ensigns & Thayer, No. 36 Ann-Street, New-York. § Rufus Blanchard, 248 Main St., Cincinnati. D. Needham, 12 Exchange St., Buffalo, N.Y. Jos. Ward, 52 Cornhill St., Boston. (NN). ca. **1848** The Ensigns & Thayer edition was also available in German (*Louisville*

FIGURE 56
*In Congress July 4th. 1776.
The Unanimous Declaration
of the Thirteen United
States of America*. New York:
Humphrey Phelps, 1845
(no. 47). Courtesy of Swann
Auction Galleries.

Daily Democrat, January 31, 1848). ca. **1854–63** 31 × 23 inches, retitled *The Declaration of Independence. 1776*, with the same setting of type, but with a different border, hand colored, a "Historical Notice" about the *Declaration*, biographical information about the Signers, additional state seals, a Lossing & Barritt wood engraving of Trumbull's *Declaration,* and a key to the painting, § Published by Ensign, Bridgman, & Fanning, 156 William Street (corner of Ann), New York. (*DH* MWA).

48 *Declaration of Independence. In Congress July 4th. 1776*. Philadelphia: Published by J. Dainty, 46 ½ Walnut Street [ca. 1845]. 9 ¼ × 6 ¾ inches

NOTE: An embossed ornamental frame enclosing letterpress text beneath an engraved title and an engraved reproduction of Trumbull's *Declaration*, no signatures. John Dainty was at the 46 ½ Walnut Street address in 1845 when he and Samuel Tiller advertised a $3 mezzotint portrait of Washington after Trumbull (Hart, *Portraits of Washington*, no. 107; *The Daily Union* [Washington, DC], September 10, 1845).

PPL

49 *National Treasure.* Boston: Printed at George Coolidge's Steam Power Print-
ing Office, No. 1 Water Street [ca. 1845–46]. 21 ½ × 28 inches

NOTE: Letterpress, text and two columns of signatures in type within a border of type
ornaments, many of the decorative features the same as those in no. 46. Includes short
accounts of eleven presidents and the text of the Constitution. George Coolidge and John
Wiley, partners in a firm of book and fancy job printers, moved from 1 ½ Water Street to
12 Water Street in April 1847 (*Christian Watchman* [Boston], June 18, 1847).

DH ViU

Swann Auction Galleries, New York, October 10, 2013, lot 169, $138

50 *Portraits of the Presidents and Declaration of Independence.* New York: Pub-
lished by J. H. Colton No. 86 Cedar St. [c1846]. 42 ½ × 31 ¼ inches

§ In Congress, July 4th. 1776. The Unanimous Declaration of the Thirteen United
States of America. § Lithography of F. Michelin, 111 Nassau St. N.Y. § [Copyright state-
ment of J. H. Colton dated 1846]

NOTE: Lithograph, the calligraphic text and the facsimile signatures after Binns, a laurel
border containing a view of the Capitol and medallion portraits of eleven presidents up to
James K. Polk. Also based on Binns are American flags, an American eagle, and cornuco-
pias around the portrait of Washington.

NN

LATER EDITION: **1849** 42 × 31 inches, the view of the Capitol replaced with a portrait of
Zachary Taylor (*ViU*).

51 *In Congress, July 4, 1776. The Unanimous Declaration of the Thirteen United
States of America.* [Philadelphia: Anastatic Office, 1846]. 30 × 25 ¼ inches

§ Anastatic fac-simile.

NOTE: A reproduction by the anastatic transfer process, probably derived from the Peter
Force restrike of the State Department facsimile (no. 11). The anastatic imprint is nearly
in the same place as Stone's imprint in the restrike. Advertisements priced this print at $2
and stated that it was printed in an edition of about two hundred copies (*Saturday Cou-
rier* [Philadelphia], June 20, 1846). For a full account of the Anastatic Office, operated by
John Jay Smith and his sons Robert Pearsall Smith and Lloyd Pearsall Smith, see Law,
"Introduction of Anastatic Printing to America," and the *Philadelphia on Stone* Biograph-
ical Dictionary website, Library Company of Philadelphia.

DLC-MSS MBAt PPIn

*Christie's, New York, June 24, 2009, lot 67, $25,000; Christie's, New York, December 3, 2010,
lot 69, $35,000; Christie's, New York, June 22, 2012, lot 220, not sold*

52 *Declaration of Independence July 4th. 1776.* New York: Published by
W. L. Ormsby 116 Fulton St. [1848]. 29 × 37 inches

§ Painted by J. Trumbull. § Engraved by W. L. Ormsby. after Durand.

NOTE: Steel engraving of Trumbull's *Declaration* above a key with outline portraits and facsimile signatures perhaps after no. 13, but the facsimiles are so freely rendered that the source is difficult to ascertain. "Just published" in February 1848, it could be purchased for $5 from Ormsby at his 116 Fulton Street address or at a lower price from magazine publishers who used it as a subscription premium. The subscription advertisements state that it was printed from a 21 × 31-inch plate on a 28 × 38-inch sheet (*New-York Evangelist*, February 10, 1848; *The Knickerbocker* 31 [June 1848]: 559).

Leland Little Auctions, Hillsborough, NC, June 14, 2013, lot 283, $1,100

LATER EDITIONS AND ADAPTATIONS: **after 1848** 29 ½ × 39 ¾ inches, the Ormsby publication statement burnished out, § Painted by J. Trumbull § Engraved by W. L. Ormsby New York (MWA). **1876** 27 ½ × 36 inches, § Painted by J. Trumbull § Engraved by W. L. Ormsby New York § Published by Cole & Co Brooklyn NY (DLC-PP; *Swann Auction Galleries, New York, December 1, 2011, lot 134, $960; Brooklyn Daily Eagle*, January 28, 1876). **after 1876** colored, Cole's publication statement burnished out (*Great-Republic.com, accessed March 14, 2021, $3,250*).

53 *Declaration of Independence in Phonography.* Philadelphia: Published by Dyer & Webster, Phonographic Rooms, 66 South 3rd. St. [ca. 1848]. 16 × 12 inches

§ Price 25 Cents

NOTE: Engraving, the text in shorthand, three columns.

MWA

54 *The Presidents of the United States and Declaration of Independence.* New York: Published by Louis R. Menger 59 Beekman St. [c1849]. 43 ½ × 33 ¼ inches

§ On stone by J. Britton. § Lith. of Wm. Endicott & Co. 59 Beekman St. N. York. § [Copyright statement of Louis R. Menger dated 1849]

NOTE: Lithograph, text in ornamental scripts imitating Tyler, a reproduction of Trumbull's *Declaration*, and forty-eight facsimile signatures after no. 13 within an oval ornamental border composed of thirty state seals. The composition includes allegorical figures of Justice and Liberty, views of the Capitol and the White House, the American eagle, miniature portraits of vice presidents, and larger medallion portraits of twelve presidents up to Zachary Taylor. The DLC copy was deposited for copyright on January 23, 1849.

Fig. 30 DLC-PP; Cunningham, *Popular Images of the Presidency*, fig. 3-14

LATER EDITION: ca. **1850** 42 × 31 ½ inches, portraits of thirteen presidents up to Millard Fillmore, § Published by Ensign, Thayer & Co. 50 Ann St. New York. (*DH*).

55 *Declaration of Independence, July 4, 1776.* [Boston: Oak Hall, 1850s–60s]. 13 ½ × 9 ¾ inches

NOTE: Letterpress, text in three columns, American eagle stock cut over the title, no signatures. The stock cut is the same as that in no. 32. In the center column a wood engraving by John Andrew advertises "Oak Hall, Cloths and Clothing. Nos. 32 & 34 North Street,

Boston, Mass." George W. Simmons founded the Oak Hall clothing store in 1842, then at the address nos. 32 & 34 Ann Street (*American Traveller* [Boston], June 17, 1842; *Boston Herald*, December 28, 1898). Wood engravings signed by John Andrew appear in Boston imprints as early as 1845. Ann Street was renamed North Street in 1852.

MHi MWA

56 *Declaration of Independence.* [New York: Emil Seitz, c1851.]

§ Designed and Executed with the Pen by C. Morton § Ackerman Lith. 379 Broadway New York § [Copyright statement of Emil Seitz dated 1851]

NOTE: Lithograph, "heightened in gold, bronze, and colors, names of Signers in fac-simile, fine lithographic Stuart bust of Washington at top." Emil Seitz and James Ackerman were prominent members of the trade, but I have not been able to identify C. Morton, nor have I been able to locate a copy of this print. There is, however, a detailed entry in the Holden sale catalogue, which describes it as a large oblong folio.

Holden, *Catalogue*, no. 3813

57 *Declaration of Independence. In Congress, at Philadelphia, July 4th, 1776.* Philadelphia: Published by I. Kohler, No. 104 North Fourth Street [c1855]. 24 ½ × 19 inches

§ T. Nesle. del. § H. Sebald. sc. 168 Chesn. Pha. § [Copyright statement of I. Kohler dated 1855]

NOTE: Letterpress, text in two columns, signatures in type, within an elaborate architectural frame. The list of signatures contains several mistakes: Chase, Clark, Rutledge, Heyward, and Thornton are misspelled; McKean is repeated; and Thomas Willing is included although he voted against the Declaration of Independence and did not sign the document. The American eagle, a portrait of Washington, and the figure of Liberty occupy the pediment of the frame. The state seals run along the frieze at the top and along the bottom edge. Franklin and Jefferson stand at each side, and a reproduction of Trumbull's *Declaration* is set within a cartouche at the bottom with symbols of peace and prosperity to the left, the implements of war to the right.

MWA

VARIANT: 1. 21 ¾ × 16 ¾ inches, *Erklärung der Unabhängigkeit der Vereinigten Staaten,* illustrations and layout as above, same mistakes in the signatures, text in Fraktur, § Herausgegen von I. Kohler, No. 104 Nord Vierte Strasse, Philadelphia. (*DH* PPL; *Swann Auction Galleries, New York, October 10, 2013, lot 173, $469*; Earnest, *Flying Leaves,* 140–41).

58 *New-York City & County Map with Vicinity Entire Brooklyn Williamsburgh Jersey City &c. in the 79th. Year of the Indepedence of the United States.* New York: Published by Chs. Magnus 12. Frankfurt Street [ca. 1855?]. 20 ¼ × 33 ½ inches

§ The unanimous Declaration of the thirteen United States of America. § Chs. Magnus lith. New York

NOTE: Hand-colored lithograph map of Manhattan and environs with a view of the New York City Hall in the lower left corner and the Declaration of Independence in the lower right corner, the whole within a vine and leaf border. The Declaration is enclosed in a circular border composed of the thirteen state seals, the title in black letter, the text in a uniform cursive script with some words emphasized, the signatures in a "gothic" sans-serif script with fourteen names misspelled. The mistakes in transcribing the names, the choice of words to be emphasized, the style of the black-letter title, and the border of state seals indicate that the design was derived directly or indirectly from no. 6. Magnus also printed it in a two-leaf brochure, leaving one leaf blank (Fig. 66 MWA PPL ViU).

NjP; McKinstry, *Charles Magnus*, 57, 166, fig. 2-4

59 *Declaration of Independence. In Congress, July 4th. 1776, The Unanimous Declaration of the Thirteen United States. of America*. Manchester, NH: Published by G. R. Russell [c1856]. 29 ¾ × 24 ¼ inches

§ The original of this was designed & executed entirely with a pen by Gilman R. Russell teacher of practical, plain & ornamental, writing and drawing § [Copyright statement of Gilman R. Russell dated 1856] § J. H. Bufford's Lith.

NOTE: Lithograph, title in ornamental scripts with some pen flourishes copied from no. 5, text in a uniform round hand enclosed in a grapevine border, no signatures, an American eagle perched on crossed pens above the title. Russell wrote the text around a crayon lithograph standing portrait of Washington. One or more of the artists in Bufford's shop may have been responsible for the portrait and the border (Tatham, "John Henry Bufford," 60–63). Styling himself "Prof. of Penmanship," Russell used the same design concept for another Declaration in 1866 (no. 72).

DH DLC-MSS ViU; Nash, *American Penmanship*, 266

Raynors' Historical Collectible Auctions, January 28, 2022, lot 98, estimate $4,000–$5,000, not sold

VARIANT: **1.** 29 ½ × 24 inches, as above, § Published by Wm. H. Fisk. Manchester, N. H (Fig. 37 *DH* DLC-PP CtHWa MBAt NHi; *Swann Auction Galleries, New York, October 10, 2013, lot 174, $438*; Swann Auction Galleries, New York, September 26, 2019, lot 96, $1,063; *Swann Auction Galleries, New York, September 29, 2022, lot 135, $938*).

60 *Declaration of Independence. In Congress, July 4th., 1776. The Unanimous Declaration of the Thirteen United States of America*. New York: Engraved and Published by J. C. Buttre, 48 Franklin St. [c1856]. 19 × 15 inches

§ Border drawn by W. Momberger. Lettering by C. Craske. § [Copyright statement of J. C. Buttre dated 1856]

NOTE: Engraved on steel, calligraphic text within a border composed of thirteen state seals, facsimile signatures after Binns transmitted through no. 39, a view of Independence Hall, and a reproduction of Trumbull's *Declaration*.

Fig. 57 NN ViU

Swann Auction Galleries, New York, September 27, 2018, lot 280, $813

FIGURE 57
*Declaration of Independence.
In Congress, July 4th., 1776.
The Unanimous Declaration of
the Thirteen United States of
America.* New York: John
Chester Buttre, 1856 (no. 60).
Courtesy of Swann Auction
Galleries.

LATER EDITION: ca. **1859** 22 × 14 ¾ inches, with the Washington Monument instead of
Independence Hall, advertised in 1859 along with Washington's Farewell Address and the
Constitution, the three "beautiful engravings on steel" printed on paper 22 × 15 inches
and priced at $1 for the set or fifty cents each (*DH* NHi; *hand colored, Christie's, New York,
May 18, 2012, lot 92, $3,500; Swann Auction Galleries, New York, April 27, 2017, lot 127, $975;
New-York Observer, December 29, 1859*).

61 *Declaration of Independence of the United States of America.* [New York: Sam-
 uel H. Black, c1859]. 8 ¼ × 7 ½ inches

§ In Congress § July 4th 1776. § [Copyright statement of S. H. Black dated 1859]

NOTE: Electrotype plaque in copper, the text in all caps above facsimile signatures after
Binns. Centered within the text is a medallion with a reproduction of Trumbull's *Decla-
ration*, derived from a medal by Charles Cushing Wright. Some of the plaques have been
electroplated with silver. Most are mounted in wooden frames.

DSI-MAH ViU

M & S Rare Books, catalogue 73 (2002), item 134, $450; Swann Auction Galleries, New York, September 26, 2019, lot 97, $688 (with no. 62); *Rulon-Miller Books, website, June 9, 2021, $500*

62 *The National Medallion*. [New York: Samuel H. Black?, ca. 1859?]. 17 × 12 ¾ inches

§ In Memoriam Majorum § A Declaration by the Representatives of the United States of America, in General Congress Assembled. § Battle Roll of the Revolution.

NOTE: Electrotype plaque in copper, the text above four medallions: a reproduction of Trumbull's *Declaration*, a portrait of Washington, a scene depicting the flight of the British from Boston, and facsimile signatures very freely rendered but probably after Binns; below the medallions a text listing battles of the American Revolution and presidents of the United States, concluding with James Buchanan, the texts and medallions enclosed in a stadium-shaped border ornamented with stars inside a two-line frame with four small medallions at the corners: the American eagle, Liberty, the American flag, and the national seal. The Trumbull reproduction is derived from a medal by Charles Cushing Wright.

Skinner, Marlborough, August 6–14, 2018, lot 1604, $277; Swann Auction Galleries, New York, September 26, 2019, lot 97, $688 (with no. 61)

63 *In Congress, July 4th. 1776. The Unanimous Declaration of the Thirteen United States of America*. New York: Published by Thayer & Colton, No. 18, Beekman, St. . . . Rufus Blanchard, Chicago, Illinois [ca. 1859?] 44 × 30 inches

§ Printed by Lang & Laing 117, Fulton St. N.Y.

NOTE: Lithograph in a grapevine border incorporating Tyler's lettering along with the state seals, Tyler's facsimile signatures, a reproduction of Trumbull's *Declaration*, and a key. Horace Thayer and G. Woolworth Colton started a mapmaking business in 1859 (*New-York Daily Tribune*, May 5, 1859).

eBay listing of Dalebooks.com, accessed June 10, 2022, $9,500

LATER EDITIONS AND ADAPTATIONS: **1860** 44 × 29 ¼ inches, as above but with the facsimile signatures reconfigured to include an allegorical vignette captioned "The First Blow for Liberty" and a copyright statement of H. Thayer dated 1860, § Printed by Lang & Laing 117 Fulton St. N.Y. § Published by Horace Thayer, No. 18 Beekman St. New York. Rufus Blanchard Chicago Illinois (ViU; *Skinner, Boston, November 18, 2018, lot 11, $861; Kuenzig Books, website, June 23, 2019, item sold*). ca. **1863** 42 ¼ × 28 inches, as the previous Thayer edition, § Printed by Lang & Cooper, 117 Fulton St. New York § Published by Horace Thayer. No. 36 Beekman St. New York (MHi photostat, seen in 1988 but uncataloged and possibly deaccessioned sometime after 2000).

64 *The Declaration of Independence, and Portraits of the Presidents*. Philadelphia: Engraved & Printed by Illman & Sons, 603 Arch St. [ca. 1859]. 25 ½ × 20 inches

NOTE: Engraved, the text in a minute script within an elaborate vine and floral border including portraits of fifteen presidents up to James Buchanan, flags, facsimile signatures

FIGURE 58 *The Declaration of Independence and Portraits of the Presidents.*
Philadelphia: Illman Brothers, ca. 1861 (no. 64). Library of Congress, Prints
and Photographs Division, LC-DIG-pga-07155.

after Binns, the American eagle in a cartouche, a vignette of the Washington family burial vault, and a reproduction of Trumbull's *Declaration*. The text and the facsimile signatures were copied from no. 39.

DH NHi NN *PHi* PPAmP PPIn; Hart, *Portraits of Washington*, no. 597

LATER EDITIONS AND ADAPTATIONS: ca. **1859** 23 × 15 ¾ inches, § Ledger Carrier's Annual Greeting to their Subscribers, 1859 [open sans-serif lettering] (*DH* MWA NHi; Hart, *Portraits of Washington,* no. 597a). ca. **1859** 21 × 16 ½ inches, § Ledger Carrier's Annual Greeting to their Subscribers, 1859 [open Tuscan lettering] (NN; Hart, *Portraits of Washington*, no. 597a). ca. **1859** 20 × 16 inches, § The Sun Carrier's Annual Greeting to their Subscribers, 1859 (ViU). ca. **1861** 22 × 18 ½ inches, portraits of sixteen presidents up to Abraham Lincoln, no imprint on recto, Illman Brothers imprint stamped on the verso of the DLC copy (Fig. 58 DLC-PP NN; Hart, *Portraits of Washington*, no. 597b).

65 *The Declaration of Independence.* [Evansville, IN]: Presented by the Evansville Typographical Association [1860]. 18 × 12 inches

NOTE: Letterpress, title in bold Antique extended and Tuscan outline, text in two columns within a border of type ornaments, signatures in type arranged by states, two misspelled, three assigned to the wrong state. A keepsake distributed at an Independence Day parade (*Evansville Daily Journal*, July 6, 1860, and July 7, 1860).

MWA

66 *Original Declaration.* New York: Published by Ensign, Bridgman, & Fanning, 156 William Street [c1860]. 36 ½ × 28 inches

§ Fac-Simile of the Original Draught by Jefferson of the Declaration of Independence In Congress 4th. July, 1776. § 1776 § Key to Declaration of Independence, § The Declaration of Independence of the United States of America July 4th, 1776. § [Copyright statement of Ensign, Bridgman & Fanning dated 1860]

NOTE: Letterpress, the text a facsimile of the Rough Draft arranged in three columns followed by facsimile signatures after Tyler transmitted through an illustration in the July 3, 1858, *Harper's Weekly*, a Lossing & Barritt wood engraving of Trumbull's *Declaration*, a key to the painting, the whole surrounded by thirty-three state seals, two territorial seals, and the national seal in medallions. The DLC copy is inscribed with the date August 14, 1860.

DLC-MSS

67 [Declaration of Independence. Albany, NY: John Edmonds Gavit, ca. 1860?]. ¾ inch diameter

NOTE: Engraved, the text in a micrographic script in a border of two concentric circles. The imprint set inside the inner circle is not entirely legible, but it includes the name of J. E. Gavit, a banknote engraver in Albany, NY. He was one of the founders of the American Bank Note Company and served as its president, 1867–74 (Griffiths, *Story of the American Bank Note Company*, 42–46). Beneath the text are facsimile signatures of John Adams, Thomas Jefferson, Roger Sherman, Philip Livingston, and Benjamin Franklin. This

FIGURE 59
[Declaration of Independence].
Albany, NY: John Edmonds
Gavit, ca. 1860? (no. 67).
Courtesy of Mark D.
Tomasko.

micrographic conceit would have obliged the engraver to make a selection of signatures. Apparently, these were chosen to represent the Committee of Five, which had been charged with the task of drafting the document. If that was the intention, however, the engraver opted for the wrong Livingston, the Signer Philip Livingston instead of his cousin once removed Robert R. Livingston, who served on the Committee but was not one of the Signers.

Fig. 59 *MDT*

Parsons Books, Nashua, NH, Anniversary Catalogue (2016), $2,000

VARIANT: **1.** 3 × 4 ½ inches, printed on cardstock inside an ornamental border along with an American eagle, cornucopias, and portraits of Washington inset in the two corner pieces at the top, § Creed & Lord's Prayer. § Declaration of Independence. § The Ten Commandments (PPL).

68 *Fac-Simile of the Original Draught by Jefferson of the Declaration of Independence in Congress 4th. July, 1776.* Boston: Published & Lithd. by L. Prang & Co. [ca. 1861–65]. 11 × 14 ¼ inches

§ <One Fourth Size>

NOTE: Tinted lithograph, the text a facsimile of the Rough Draft arranged in three columns followed by facsimile signatures after Tyler. The title, layout, and facsimile signatures were derived directly or indirectly from an illustration in the July 3, 1858, *Harper's Weekly.*

MHi Uk

69 *The Declaration of Independence*. Philadelphia: Published by the Art Publishing Association of Philadelphia, Swander Bishop & Cos. [c1865]. 24 × 19 inches

§ Stuart § Swander. '65 § Drawn with a steel pen by R. Morris Swander, and engraved (fac simile) by P. S. Duval & Son. Philada. § This Allegorical Portrait of Washington Respectfully dedicated to the Christian Commission of the United States by the Publishers. § [Copyright statement of Swander Bishop & Co. dated 1865]

NOTE: Lithograph, the text in a script expanded, compressed, and modified in various ways to form a portrait of Washington after Stuart, a vignette of Trumbull's *Declaration* above the text which is framed by facsimile signatures after Tyler, the whole within a small ornamental border. Several signatures had to be repeated to fill out the composition. The *Declaration* vignette is composed of outline figures derived from the key in no. 66. The DLC copy has a copyright stamp dated February 7, 1866.

DH DLC-MSS NHi

VARIANT: **1.** 24 × 17 ¾ inches, "Commission" altered to "Commission's" (Fig. 60 MHi PPIn ViU; Swann Auction Galleries, New York, September 29, 2022, lot 136, $500).

70 *Declaration of Independence*. [Davenport, IA: William H. Pratt, c1865]. 27 ½ × 21 inches

§ Designed and written by W. H. Pratt Davenport, Iowa. § Lith. and print. by A. Hageboeck, Davenport, Iowa. § [Copyright statement of W. H. Pratt dated 1865]

NOTE: Lithograph, the text forming an oval portrait of Washington, within an oval border of thirty-six state seals and pen flourishes beneath the American eagle, a banner in its beak with the motto E Pluribus Unum, the title in black letter with pen flourishes, the signatures in the same elaborately flourished round hand as the text. At the bottom are allegorical figures of Liberty and Justice. The copyright statement is effaced in the MWA and ViU copies.

DH MWA ViU

Swann Auction Galleries, New York, September 26, 2019, lot 98, $3,000

LATER EDITIONS AND ADAPTATIONS: ca. **1865?** 28 × 21 ¾ inches, as above, but the allegorical figures of Liberty and Justice have been replaced by penwork birds (NHi; *Swann Auction Galleries, New York, September 29, 2022, lot 137, $1,625*). **1876** 30 ¼ × 24 ¼ inches, the penwork birds design but with additional imagery in the eagle's beak, the banner accompanied by flags bearing the dates 1776 and 1876, the thirty-six state seals augmented by two territorial seals. The DLC copy has a copyright stamp dated 1876 (Fig. 38 DLC-PP; *Swann Auction Galleries, New York, April 14, 2015, lot 111, $1,063*). **1876** 18 × 15 inches, without the American eagle and the state seals but with a facsimile signature of Washington beneath the oval, § Designed & written by W. H. Pratt, Davenport, Iowa. § Published by A. Hageboeck Davenport, Iowa. § [Copyright statement of W. H. Pratt dated 1876] (DLC-PP; Holzer, "'Columbia's Noblest Sons,'" fig. 28).

FIGURE 60 *The Declaration of Independence.* Philadelphia: Art Publishing
Association, 1865 (no. 69). Albert and Shirley Small Special Collections
Library, University of Virginia.

71 *Freedom's Footsteps. The Thirteen United Colonies. In Order as They Adopted the Constitution. Declaration of Independence.* Nevada County, CA: Executed and published by John A. Fuller [c1866]. 26 × 20 inches

§ W. Vallance Gray. Lith: S. F. § [Copyright statement of John A. Fuller dated 1866] § Printed by E. Fletcher 308 Front St. S. F.

NOTE: Lithograph in red, blue, and black, the text in a uniform round-hand script in a central cartouche formed by a chain. A medallion with the national seal is enclosed in the text, which is followed by facsimile signatures, rendered so carelessly as to display no identifying features. Framed by Corinthian columns, the composition includes the American eagle perched on flags between the Constitution and the Farewell Address, names of states, biographical vignettes of sixteen presidents, and dates of Revolutionary War battles. ViU has a pen-and-ink preliminary sketch for this print "executed by John A. Fuller Nevada County Cal." Fuller was a gold rush prospector who worked in the Nevada County mines before going off to seek his fortune in Alaska. He then settled in Napa, where he became mayor of that city (*Napa Weekly Journal*, March 19, 1909). Obviously an amateur, he expected the artist William Vallance Gray to implement the design ideas in his sketch.

DH ViU

Bartleby's Books, Bookseller's Showcase, New York, January 23, 2015, $17,500

72 Declaration of Independence. In Congress July 4th. 1776. The Unanimous Declaration of the Thirteen United States of America. [Philadelphia: Gilman R. Russell, c1866]. 28 × 20 ¼ inches

§ The original designed and executed entirely with a pen by Gilman R. Russell Prof. of Penmanship. § The Great Centennial Memorial. § [Copyright statement of Gilman R. Russel dated 1866]

NOTE: Lithograph, title in ornamental scripts with flags, allegorical figures of Fame, and Masonic symbols, no signatures. Russell reused the design concept of no. 59 for this print, which also runs the text around a portrait of Washington inside a grapevine border. At the bottom of the border is a medallion portrait of Jefferson with quill pens at either side forming cartouches for Russell's imprint.

NN; Holzer, "'Columbia's Noblest Sons,'" fig. 30

Philadelphia Print Shop, website, January 28, 2018, $4,500

73 *In Congress, July 4th. 1776. The Unanimous Declaration of the Thirteen United States of America.* New York: Printed by Cooper & Stone, 141 Fulton [ca. 1866–67]. 30 ½ × 20 inches

NOTE: Lithograph, the ornamental text and facsimile signatures copied from Binns (no. 6), including a view of the Capitol and portraits of Washington, Lincoln, Sherman, and Grant. Some text has been trimmed off the bottom of the one copy I have seen.

NHi

74 *Read and Compare!* [Rock Island, IL: Joseph Baker Danforth Jr., 1868]. 24 ¾ × 9 ¼ inches

§ The Declaration of Independence. In Congress, July 4th, 1776. A Declaration by the Representatives of the United States, in Congress Assembled. § The New Declaration of Independence. Adopted July 4th, 1868. By the White Republicans, in Convention Assembled.

NOTE: Letterpress, in two columns, the Declaration on the left and a parallel text on the right containing an attack on Radical Reconstruction. The signatures are in type, Clymer misspelled Klymer, Smith misspelled Smyth, Gwinnett misspelled Gwinett. The signatures following the "New Declaration" include Andrew Johnson, members of the Supreme Court, and Francis P. Blair Jr., who was nominated for vice president at the Democratic National Convention, July 4–9, 1868. Danforth was the editor of the *Rock Island Evening Argus*, which printed the same text in the July 9, 1868, issue, with the same misspellings. It is possible that other broadside printings were distributed at Democratic Party events in the Rock Island area.

MoSHi PSt; Russell and Guerrero, "Sourcing a Reconstruction-Era Broadside."

75 *Declaration of Independence. July 4th, 1776.* [New York: William R. Knapp, c1868]. 22 × 32 inches

§ Fac-Simile of the Original Document in the handwriting of Thomas Jefferson. <Copied by permission from the MS. in the Department of State, at Washington.> § Painted by J. Trumbull. Photographed by W. R. Knapp. § American, Photo-Lithographic, Co. N. York. (Osborne's Process.) § [Copyright statement of W. R. Knapp dated 1868]

NOTE: Lithograph, the text a facsimile of the Rough Draft in two columns at either side of a mounted photographic reproduction of Trumbull's *Declaration*, beneath which are facsimile signatures and a key to the painting. The facsimile signatures are after Tyler, probably transmitted through one of the pamphlet facsimiles of the Rough Draft, misspelling Heyward as Hayward, Rutledge as Rutlidge. Since the key includes Robert R. Livingston, his signature had to be added at the bottom.

Fig. 34 Swann Auction Galleries, New York, September 29, 2022, lot 138, $375

LATER EDITION: **1869** 24 × 33 inches, same layout of the Rough Draft although some text has been moved from the left column to the right column, lithographic reproduction of Trumbull's *Declaration*, a larger key to the painting after no. 13, a vignette of Independence Hall, § Independence Hall as in 1776 § Painted by Trumbull § Am. Photo-Lith. Co. N.Y. (Osborne's Pro.) § [Copyright statement of A. F. Jayne dated 1869] (DLC-MSS).

76 *Declaration of Independence.* [s. l., ca. 1870s?]. 19 ¾ × 14 ½ inches

NOTE: Lithograph, the text in shorthand, two columns within an ivy border bearing patriotic mottoes on banderoles, the title in ca. 1870 decorative scripts beneath an American eagle and crossed flags.

ViU

FIGURE 61 *The Great National Memorial.* Lexington, KY?: Benjamin
Warren Smolk, 1871 (no. 77). Prints and Photographs Division, Library of
Congress, LC-DIG-ppmsca-09332.

77 *The Great National Memorial.* [Lexington, KY?: Benjamin Warren Smolk,
c1871]. 32 ½ × 42 ½ inches

§ The Declaration of Independence. Adopted by Congress, July 4, 1776. § Brief Syn-
opsis of the History of the United States of North America. § C. Inger. § [Copyright
statement of B. W. Smolk dated 1871] § T. Sinclair & Son Lith. Philada. Pa.

NOTE: Lithograph, vignettes of Columbus's landing in America and *Penn's Treaty with
the Indians* after Benjamin West; portraits of Washington, Jefferson, Jackson, Lincoln,
and Jefferson Davis each encircled by portraits of members of their cabinets; reproductions
of bank notes; the text of the Declaration followed by the signatures in type; the whole
within a rustic wood border containing notional portraits of the Signers. It is possible that
Smolk published this print while residing in Lexington, KY, where he issued a prospectus
for *B. W. Smolk's First Blue Grass Directory, For 1870 & 1871.*

Fig. 61 *DH* DLC-PP

78 *In Congress, July 4, 1776*[.] *The Unanimous Declaration of the Thirteen United
States of America.* [Washington, DC: Norris Peters, c1873]. 24 × 19 inches

§ N. Peters, Photo-Lithographer, Washington, D.C. § The above is a photo-Lithographic
fac-simile of the Original Document now on deposit in the Patent Office at

Washington, D.C., § [Authenticating signatures of the Secretary of the Interior, Columbus Delano, and the Commissioner of Patents, Mortimer D. Leggett] § [Copyright statement of Norris Peters dated 1873]

NOTE: Lithograph, a reproduction of the entire document although with substantive mistakes, some of which are noted on p. 120, facsimile signatures after Stone.

CSmH

LATER EDITIONS AND ADAPTATIONS: ca. **1873?** 27 ¼ × 19 inches, with a facsimile of Washington's commission as Commander in Chief of the Continental Army, the dates 1776 and 1876 above the title, some of the textual errors corrected, § N. Peters, Photo-Lithographer, Washington, D.C. § [Copyright statement of Norris Peters dated 1873] (DLC-MSS ViU). ca. **1889?** 24 × 18 inches, the textual errors uncorrected, issued after the death of Norris Peters, when his firm was reorganized as Norris Peters Company (*Evening Star* [Washington, DC], December 3, 1889), § The Norris Peters Co., Photo-Litho., Washington, D.C. (Fig. 44 *DH* NN; *Skinner, Marlborough, March 15, 2012, lot 1200, $59; Swann Auction Galleries, New York, February 4, 2016, lot 130, $406*).

79 *Centennial Memorial of American Independence*. [Philadelphia: Joseph Leeds, c1873]. 35 ¾ × 28 inches

§ [Copyright statement of Joseph Leeds dated 1873] § American Bank Note Company, New York and Boston.

NOTE: Engraved (on steel?), the text in a uniform italic script, facsimile signatures after Tyler, probably transmitted through one of the pamphlet facsimiles of the Rough Draft, misspelling Heyward as Hayward, Rutledge as Rutledge, the whole within a massive architectural frame bearing mottoes; thirteen state seals; allegorical figures of Piety, Prosperity, and Justice; portraits of Washington, Signers, and other Revolutionary War heroes; views of Independence Hall, the Capitol, and Carpenters' Hall; battle scenes; Jefferson's writing desk and the Liberty Bell in medallions; and vignettes of the Continental Congress in session, including a reproduction of Trumbull's *Declaration*. A Boston art gallery displayed it in 1876. A review of that exhibition stated that Leeds spent six years designing the picture and that the artists needed eighteen months to engrave it. What role the American Bank Note Company might have had in producing and distributing Leeds's work is unclear, although the company takes some credit for it in the imprint. The review notes that Leeds was selling it by subscription to raise money for an Independence Square historic district (*Boston Evening Journal*, May 11, 1876). The DLC copy has a copyright stamp dated 1876.

Fig. 1 *DH* DLC-MSS *MDT NhHi* NHi NN PPIn PPL; Hart, *Portraits of Washington*, no. 641

LATER EDITIONS AND ADAPTATIONS: Some copies may be restrikes by the American Bank Note Company.

80 *1776–1876. Centennial Memorial. In Congress, July 4, 1776. The Unanimous Declaration of the Thirteen United States of America*. [Philadelphia: Continental Publishing Company, c1874]. 20 × 15 inches

§ Engraved & Printed by Continental Publishing Co., Philadelphia, General Lithographers, Engravers & Printers on Steel, Copper, Stone and Wood. § [Certification statement of the Secretary of the Interior, Columbus Delano, dated January 28, 1874,

beneath the departmental seal printed in black] § [Copyright statement of James D. McBride dated 1874] § [Notice of the Continental Publishing Company offering to sell copies on plate paper 32 × 24 inches with a red seal and no advertising for $1]

NOTE: Lithograph, a reproduction of the State Department facsimile (no. 11), printed on imitation parchment with a view of Independence Hall in the lower right-hand corner, the whole within an ornamental border surmounted by flags and an American eagle on a stone-work pattern decorative frieze. The border is composed of fasces bound by straps of stars and festooned with oak leaves and olive leaves at the corners. The facsimile signatures begin with Richard Henry Lee in the upper left.

This Centennial souvenir appears in more variants than any other print in this checklist. It has been impossible to determine priority, and I have not been able to account for all the variants. At first McBride may have used two imprints, the Continental Publishing Company of Philadelphia, which sold copies without advertisements for $1, and the Columbian Publishing Company of New York, which sold copies without advertisements for fifty cents. The fifty-cent version was available as of May 1875, at which time McBride was calling himself the secretary of the Columbian Publishing Company (*The Meschacébé* [Parish of St. John the Baptist, LA], May 15, 1875). Copies with an advertisement for the Boston dry-goods dealers Churchill, Gilchrist, Smith & Co. are sometimes accompanied with a printed envelope dated June 17, 1875 (MWA). An advertisement for the Hanover Fire Insurance Company notes the amount of its assets as of January 1, 1875 (MWA). Changes in the facsimile portion of the print indicate that McBride published it at the reduced price with the New York imprint for some time after he stopped using the Philadelphia imprint. See also McBride's 1891 facsimile (no. 106), which copies the artwork of the *Centennial Memorial*.

DH MWA

Heritage Auctions, Dallas, February 21, 2008, lot 56054, $956

VARIANTS: **1.** As above but with an advertisement in the lower right-hand corner (*DH* MHi MWA). **2.** As variant 1 but with a notice of the Columbian Publishing Company offering to sell for fifty cents copies on plate paper with a red seal and no advertising, § Engraved & Printed by Columbian Publishing Company 116 Nassau St. New York. General Lithographers Engravers & Printers on Steel, Copper, Stone and Wood (DLC-MSS MHi MWA NHi NN ViU; *Heritage Auctions, Dallas, May 13, 2007, lot 43517, $106*). **3.** As variant 2 but with the departmental seal in red and a view of Independence Hall in the lower right-hand corner (*DH* NN). **4.** 32 × 24 inches, *In Congress, July 4, 1776. The Unanimous Declaration of the Thirteen United States of America*, the border reworked in the same style with US shields in the lower corners, the decorative frieze reworked in a lace pattern, the signatures beginning with Button Gwinnett, the departmental seal in red, the certification statement undated and extending along the lower border, copyright statement dated 1874–76, imprint of the Columbian Publishing Company. This is the premium version noted above (*Heritage Auctions, Dallas, April 13, 2005, lot 25679, $1,150*). **5.** 31 ½ × 23 ¾ inches, a premium version as variant 4 but with the imprint of the Continental Publishing Company (*DH* ViU). **6.** As variant 2 but with the facsimile text *In Congress, July 4, 1776* retouched, the decorative frieze reworked in a lace pattern, and the period after *Centennial Memorial* changed to a comma. The facsimile signatures begin with Arthur Middleton in the upper left. The certification statement is in a different hand and omits the date, § Columbian Publishing Company. 116 Nassau St. New York (*DH* MHi MWA NN ViU; *Cowan's Auctions, Cincinnati, August 9, 2009, lot 576, not sold*). **7.** As variant 6 but with the stonework pattern frieze and a different imprint, § Printed by Columbian Publishing Company, 116 Nassau St. New York (DLC-MSS ViU). **8.** As variant 6 but no advertisement in the lower

FIGURE 62
Portraits and Authograph Signatures of the Framers and Signers of the Declaration of Independence, Philadelphia, July 4th. 1776. Philadelphia: Centennial Portrait and Authograph Co., 1876 (no. 81). Prints and Photographs Division, Library of Congress, LC-DIG-pga-03858.

right-hand corner, the signatures beginning with Button Gwinnett, the first three signatures moved up toward the text, and the departmental seal in red (MWA). **9.** As variant 8 but the first three facsimile signatures have been moved up farther against the text, the notice offering copies for fifty cents does not mention advertising, and the departmental seal is in black (*Heritage Auctions, Dallas, April 2, 2014, lot 36135, $813*). **10.** *Centennial Memorial, 1776–1876. In Congress, July 4, 1776. The Unanimous Declaration of the Thirteen United States of America*, the facsimile signatures beginning with Arthur Middleton as variant 6 but moved up against the text and the signature of William Floyd placed next to that of John Hancock, the departmental seal in black, the certification statement as variant 6, advertisement in the lower right-hand corner, no mention of copies without advertisements, § Columbian Publishing Company, 56 Cortlandt. St. New York (Fig. 41 ViU; Swann Auction Galleries, New York, September 26, 2019, lot 99, $313). **11.** *Centennial Memorial, 1776, 1876. The Unanimous Declaration of the Thirteen United States of America*, as variant 10, § "Columbian Publishing Company, Mansfield, Ohio." (*DH*).

81 *Portraits and Authograph Signatures of the Framers and Signers of the Declaration of Independence, Philadelphia, July 4th. 1776.* Philadelphia: Published by the Centennial Portrait and Authograph Co., 1876. 23 × 19 ¼ inches

§ Declaration 1776 § Centennial 1876 § [Copyright statement of J. H. Hobart Jr., dated 1874] § Thos. Hunter, lith. Philada.

NOTE: Lithograph, the Liberty Bell and military gear in roundels, views of Carpenters' Hall and Independence Hall, facsimile signatures after Tyler with miniature portraits including Robert R. Livingston, who served on the Committee of Five and could have been considered a Framer rather than a Signer. One of the DLC copies has a copyright stamp. A reviewer (*The Press* [Philadelphia], May 1, 1876) commended "this beautiful lithograph," which was also noticed favorably in the *Sunday Dispatch* (Philadelphia), May 14, 1876, evidence that it was issued just in time for the Centennial celebrations.

Fig. 62 DLC-PP *DSI-MAH* PPL ViU

82 *Declaration of Independence. Guaranteed Correct Copy.* [Chicago: Rand, McNally & Co., 1876]. 20 ¼ × 15 inches

§ It is beyond doubt that had the gentlemen whose names are hereto attached been gifted with prophetic ken, they would have included in this Declaration a unanimous recommendation for the people of the United States, and their Territories, to travel via the Chicago, Milwaukee & St. Paul Railway, and thus vindicate their claim of being the most intelligent, upright and appreciative of the inhabitants of the world. § [Advertisement of Rand, McNally & Co. offering to sell copies on fine paper for fifty cents]

NOTE: Lithograph, a facsimile of the entire document printed on imitation parchment with the departmental seal (but no certification statement) and views of Independence Hall and Faneuil Hall in an ornamental border. No. 80 variant 8 or 9 may be the source of this print, which has the facsimile text *In Congress, July 4, 1776* in the retouched state and the facsimile signatures based on the layout in those variants but rearranged at the beginning to accommodate the advertisements.

MWA ViU

VARIANTS: **1.** 20 ½ × 14 ¾ inches, instead of the advertisement for the Chicago, Milwaukee & St. Paul Railway, an advertisement for the Chicago & North Western Railway offering the "best Overland Route" from California to the Centennial Exhibition. Here too Rand, McNally & Co. offers to sell copies on fine paper for fifty cents (CLU-C ViU). **2.** 19 ¾ × 15 inches, as variant 1 but listing an additional agent of the railway and omitting the fifty-cent offer (*DH; Swann Auction Galleries, New York, June 21, 2016, lot 134, $219*).

83 *The Declaration of Independence, in Congress, at Philadelphia, July 4, 1776.* [Philadelphia: Rex & Bockius], 1876. 19 × 12 inches

§ Printed on the Old Ephrata Press at the Centennial Exposition, 1876. On this press the Declaration of Independence was printed in 1776. § [verso:] The Old Ephrata Printing Press. § The Old Ephrata Printing Press, on which the Declaration of Independence was printed, and the Original House, No. 702 Market Street, in which it was actually written by Thos. Jefferson. § This press was loaned by the Historical Society of Pennsylvania to Messrs. Rex & Bockius, 614 Filbert Street, Inventors of Printing Presses, Gas Machines and other inventions, and exhibited by them, in contrast with modern machinery, at the Centennial Exhibition, Philadelphia, May 10th to November 10th, 1876, at which exhibition this sheet was printed upon it.

NOTE: Letterpress, three columns, facsimile signatures after Binns transmitted through no. 25. The verso contains a history of the press, an account of printing at the Ephrata Cloister, and two wood-engraved illustrations, both signed Smith Bros., Phila. Based on

hearsay, the historical text is mostly wrong about the origins and publications of the press. It was built in Philadelphia around 1804 (Gaskell, "Census of Wooden Presses," 29).

DLC-RBSC MHi MWA NN *MiU-C* ViU

84 *In Congress, July 4, 1776*[.] *The Unanimous Declaration of the Thirteen United States of America*. New York: Leggo Bros. & Co., Photo-Engravers and Photo-Lithographers, 1876. 22 × 17 ½ inches

NOTE: Letterpress, purporting to be a facsimile of the entire document but derived from the defective reproduction published by Norris Peters, no. 78. Includes an advertisement dated May 3, 1876 offering electrotype blocks of this facsimile in two sizes as well as prints made from the blocks in bulk quantities and reproductions of Trumbull's *Declaration* accompanied with a key.

DLC-MSS MWA NN *MiU-C*

Holabird Western Americana Collections, Reno, NV, August 26, 2018, lot 3358, not sold

85 *Signing the Declaration of Independence.* [New York: Leggo Bros. & Co., 1876]. 25 × 35 inches

NOTE: Photolithographic reproduction of Trumbull's *Declaration* on "heavy plate paper" with a key, priced at twenty-five cents a copy or ten to fifteen cents in quantities of 250 or more (advertisement in no. 84).

86 *In Congress, July 4, 1776*[.] *The Unanimous Declaration of the Thirteen United States of America*. New York: Frank Leslie [1876]. 23 ½ × 16 ¼ inches

§ Supplement (Gratis) to "Frank Leslie's Chimney Corner," No. 576. § Good News for the Boys and Girls. [an advertisement for *Frank Leslie's Boys' and Girls' Weekly* signed "Frank Leslie, 537 Pearl Street, New York."]

NOTE: Letterpress, the text and signatures printed from an electrotype block furnished by Leggo Bros. (no. 84).

MHi

87 *Lockwood's Memorial, Containing Four Illustrations Concerning the Inception of the Declaration of Independence. No. 1. First Prayer in Congress. No. 2. Where the Declaration was Written. No. 3. Ringing out the Declaration. No. 4. The Signing of the Declaration. Also, a Fac Simile of the Declaration of Independence and Signatures, Now in Independence Hall.* [New York: Howard Lockwood, 1876]. 20 × 16 inches

§ [verso:] *In Congress, July 4, 1776. The Unanimous Declaration of the Thirteen United States of America*, § [verso:] Fac-similes by Tanner, Vallance, Kearny & Co. Engraved in the office of the Secretary of State, from the Original Signatures.

NOTE: Letterpress, four wood engravings including a reproduction of Trumbull's *Declaration* signed F. J. Meeker, in the lower right a reproduction of the Binns facsimile

signatures transmitted through no. 25. On the verso is a reproduction of the State Department facsimile (no. 11), fairly accurate except that Binns's signatures have been substituted for Stone's. The DLC copy has a copyright stamp dated June 24, 1876.

DLC-MSS

88 *Memorial of 100 Years a Republic.* [Philadelphia?: T. J. Berry, c1876]. 27 ¾ × 21 ½ inches

§ Loag, Printer, Philadelphia. § [Copyright statement of T. J. Berry dated 1876]

NOTE: Tinted lithograph, text in the shape of the Liberty Bell, no signatures, within a border of state seals and the national seal, portraits of soldiers standing at either side, signed "C. H." An American eagle, a medallion portrait of Washington, views of Independence Hall and Carpenters' Hall at the top and the Centennial Exhibition grounds at the bottom. The DLC copy has a copyright stamp dated 1876.

Fig. 63 DLC-PP NHi ViU

89 *Portraits & Autographs of the Signers of the Declaration of Independence.* [Jersey City, NJ: Ole Erekson, c1876]. 28 × 36 ½ inches

§ [Copyright statement of Ole Erekson dated 1876]

NOTE: Lithograph, with views of Independence Hall, an American eagle, a seated figure of Liberty, and oval portraits of the Signers, each above a facsimile signature after Tyler, probably transmitted through one of the pamphlet facsimiles of the Rough Draft, misspelling Heyward as Hayward, Rutledge as Rutlidge.

DLC-PP

90 *Centennial Offering.* Philadelphia: Published by the Centennial Offering Co. 491 North Third St. [c1876]. 23 ¾ × 21 ½ inches

§ Fac Simile of the Original Draught by Jefferson of the Declaration of Independence In Congress 4th. July 1776. § [Copyright statement of Schaefer, Waeschle & Kohner dated 1876] § "Right of Translation Reserved."

NOTE: Lithograph, with thirteen state seals, views of Carpenters' Hall and Independence Hall, portraits of Thomas Jefferson and John Hancock, scenes of the American Revolution and a reproduction of Trumbull's *Declaration* forming a border around a facsimile of the Rough Draft in three columns above facsimile signatures after Tyler, the layout and facsimile signatures derived directly or indirectly from an illustration in the July 3, 1858, *Harper's Weekly.*

DLC-MSS

91 *Declaration of Independence.* Davenport, IA: Pubhshed by A. Hageboeck [c1876]. 24 × 19 ¾ inches

§ 1876 § 1776 § E Pluribus Unum. § Drawn, written and engraved personally by A. Hageboeck, Davenport, Iowa § [Copyright statement of A. Hageboeck dated 1876]

NOTE: Lithograph, the text forming an oval portrait of Washington, within an oval olive-leaf border, a facsimile signature of Washington beneath the oval, patriotic emblems and allegorical figures of Fame and Liberty in the corners. After printing no. 70, and publishing a revised version of it in 1876, Hageboeck copied the trompe l'oeil concept and the oval design for this publication on his own account. The DLC copy has copyright stamps dated 1876.

DLC-PP

92 *Centennial: "Westward the Course of Empire Takes Its Way."* New York: Published by James Miller 202 Ross St. Brooklyn. E. D. [c1876]. 28 × 40 ¼ inches

§ Designed and Executed with a Pen by Daniel T. Ames, 205 Broadway New York. § Ed. W. Welcke & Bro. Photo-Lithographers, 176 William St. N.Y. § [Copyright statement of D. T. Ames dated 1876]

NOTE: Tinted lithograph, the first word of the title illustrated with state seals and superimposed on a view of the Main Building of the Centennial Exhibition, the text of the Declaration of Independence enclosed in an oval with an inset portrait of George Washington, no signatures, the text of the Emancipation Proclamation enclosed in an oval with an inset portrait of Abraham Lincoln, views of a wilderness in 1776 and its transformation into a cityscape in 1876, other before and after vignettes including the Franklin wooden hand press and Hoe's ten-cylinder rotary press, historical scenes, battle scenes, views of

Independence Hall and the Capitol, the whole within a vine border intertwined with some of the vignettes.

Fig. 39 *CSmH* MWA PPL *TxFACM*

VARIANT: **I.** 21 × 30 inches, tinted lithograph, a reduced version of the same image (*DH ICN* MWA *Lincoln Financial Foundation Collection, Indiana State Museum*).

93 *Memorial Chart. Centennial Jubilee.* Philadelphia: David Kohn, Sole Proprietor & Publisher, 402 Walnut St. [ca. 1876]. 32 ½ × 21 ½ inches

§ Liberty, Equality, Fraternity to All Nations. § 1876. § Chas. J. Stauch, Artist. § A. L. Weise, Pr. § [Copyright statement of David Kohn]

NOTE: Tinted lithograph, an allegory of Liberty, Prosperity, and Justice surrounded by eighteen medallion portraits of presidents, a view of Memorial Hall, personifications of different nations, a panorama of Philadelphia, views of Philadelphia landmarks, portraits of Centennial Exhibition administrators, the text of the Declaration, the presidential proclamation in support of the Centennial Exhibition, the whole within a rustic wood border containing compartments for texts and vignettes.

Fig. 32 PPL

94 *Declaration of Independance of the United States of America 4th. July 1776.* [s. l., ca. 1876]. 30 ½ × 33 ½ inches

NOTE: Cotton handkerchief, printed in sepia, blue, and brown on cotton, a key based on no. 13 beneath a reproduction of Trumbull's *Declaration*. The title is corrected in some copies.

Fig. 31 *DeWint* ViU VtShelM; Collins, *Threads of History*, no. 418

Bauman Rare Books, website, May 4, 2023, $5,000

95 *Declaration of Independence.* [s. l., ca. 1876?]. 20 ½ × 16 ½ inches

NOTE: Letterpress, some text emphasized in ornamental types, facsimile signatures same as those in no. 66, thirteen state seals, eighteen portraits of presidents up to Ulysses S. Grant in a border of type ornaments, and a wood engraving of Trumbull's *Declaration* by Lossing & Barritt. The state seals and the wood engraving were also derived from no. 66.

NN photostat

96 *Declaration of Independence.* [Philadelphia?, ca. 1876?]. 22 × 24 inches

NOTE: Roller printed cotton handkerchief, the text in black inside a red border or in brown inside a blue border, facsimile signatures after Tyler, probably transmitted through one of the pamphlet facsimiles of the Rough Draft, misspelling Heyward as Hayward, Rutledge as Rutlidge. The border is composed of thirteen state seals, fasces, names of Revolutionary War heroes, and the Liberty Bell. Philadelphia is a likely place of publication inasmuch as the Pennsylvania state seal is larger than the others and the only one to include the state motto.

FIGURE 64 *Declaration of Independence*. Cotton handkerchief.
Philadelphia?, ca. 1876? (no. 96). Courtesy of Swann Auction Galleries.

Figs. 49 and 64 *DeWint* (red version) *DH* (red version) ViU (blue version) VtShelM (red and blue versions); Collins, *Threads of History*, no. 419

Swann Auction Galleries, New York, September 26, 2019, lot 100, $938 (red and blue versions)

97 *Declaration of Independence. July 4, 1776.* [s. l., ca. 1876?]. 17 × 13 ½ inches

NOTE: Letterpress, printed in gold and silver on paper tinted dark blue, the text in two columns, the signatures in type, misspelling Hewes as Hughes, Gwinnett as Gwinnet, the whole within a border composed of linked medallions and floral corner pieces.

NN

98 *Liberty Bell.* [s. l., ca. 1880s]. 6 ¼ × 6 ½ inches

§ Philada MDCCLIII § Proclaim Liberty Throughout the Land.

NOTE: Letterpress, text in the shape of the Liberty Bell, no signatures, beneath thirty-eight stars.

PPL

99 *Declaration of Independence. Photograph of the Fading Manuscript.* Washington, DC: A. G. Gedney, Publisher, No. 466 Pennsylvania Avenue [c1883]. 28 × 20 ½ inches

§ Negative taken by the Publisher July 25, 1883, from the Original Parchment in the Library of the Department of State. § Restoration of Signatures. From a copper-plate engraving in fac-simile made by order of President Monroe in 1823.

NOTE: Collotype, the text reproduced from a photograph, the signatures after Stone. Albert G. Gedney ran a printing firm following his father, Joseph F. Gedney, who had settled in Washington in 1854. His father obtained government contracts for illustration work and became "lithographer of the State Department" in 1889 (*The Evening Star* [Washington, DC], October 7, 1903). The DLC copy has a copyright stamp dated November 17, 1883.

DLC-MSS *NN PHi*

100 *Declaration of Independence.* [Chicago: Kurz & Allison, c1884]. 22 × 28 ¼ inches

§ Liberty. § Justice. § [Copyright statement of Kurz & Allison, Art Publishers, dated 1884]

NOTE: Lithograph, the text in two columns on either side of an angel holding laurel crowns above portraits of Lincoln and Garfield, above her a portrait of Washington in a laurel wreath, below, a portrait of Grover Cleveland in an oak-leaf wreath beneath the American eagle and between allegories of Liberty and Justice, each column within a border composed of oval portraits of twenty-two presidents joined by oak-leaf garlands, all the portraits numbered and keyed to the presidents' vital statistics tabulated in oak-leaf compartments, no signatures. Kurz & Allison's artist copied the conceit of the angel from other prints, e.g., an 1865 lithograph *Columbia's Noblest Sons*, in which an allegorical figure of the United States holds laurel crowns over portraits of Washington and Lincoln. The DLC copy is stamped with the date December 15, 1884.

Fig. 65 DLC-PP

LATER EDITION: **1886** 20 ¼ × 26 ¼ inches, color lithograph, no copyright statement, one of the tables revised to record the death date of Ulysses S. Grant in 1885 and the marriage of Grover Cleveland in 1886 (MWA).

101 *Fac-Simile of the Original Document of the Declaration of Independence.* [Baltimore: The Sun, 1887]. 23 × 21 inches

§ In the Hand-Writing of Th Jefferson § Supplement to The Sun. Baltimore, July 4, 1887. A. S. Abell & Co. The Sun Building.

FIGURE 65 *Declaration of Independence.* Chicago: Kurz & Allison, 1884
(no. 100). Prints and Photographs Division, Library of Congress, LC-DIG-
pga-01900.

NOTE: Letterpress, a facsimile of the Rough Draft in three columns, facsimile signatures
after Binns transmitted through no. 25. Jefferson's name is rendered as a facsimile
signature.

DLC-MSS *DSI-MAH* ViU

102 *In Congress, July 4th. 1776. The Unanimous Declaration of the Thirteen United
 States of America.* Durham, NC, and New York: Engraved and Printed by
 The Giles Lithographic and Liberty Printing Co. N.Y. for Mess. W. Duke
 Sons & Co. [ca. 1887–90]. 26 ¾ × 20 ½ inches

§ Copied from the original Declaration of Independence in the Department of State
at Washington, D.C. The punctuation, signatures and capitals being exact fac-similes
of the original Declaration as signed by our Great Patriots and Statesmen.

NOTE: Lithograph, a facsimile of Tyler's engraving (no. 3) printed on imitation parchment,
without the dedication to Jefferson but with the Richard Rush certification statement.

NN; MWA photostat

Kurt Gippert Bookseller, website, 31 July 2022, $3,500

VARIANT: **1.** 26 ½ × 20 inches, at the bottom of the sheet, printed in red, the terms of a premium scheme offering a mounted facsimile "ready for hanging" in return for tobacco box coupons (*DH*).

103 *Compliments of the Inquirer Printing Co. 1776. Declaration of Independence. 1888.* [Bedford, PA: Inquirer Printing Co., 1888]. 14 ¼ × 8 ½ inches

§ Inquirer. The Leading Paper in Bedford County

NOTE: Letterpress, printed in red and blue, the text in three columns beneath vignettes of newsboys and the American flag, no signatures, the whole within a red single-line frame.

PPL ViU

104 *Presidential Campaign Calendar. For 1888.* [Chicago?, 1888?]. 27 ¼ × 40 ¼ inches

§ Declaration of Independence of the Thirteen United States of America, In Congress, July 4th, 1776.

NOTE: Letterpress, printed in red and black, the text in italics above the national seal and facsimile signatures after Stone transmitted through no. 80 variant 6, a portrait of Washington beneath the title with wood-engraved views of the Auditorium Building in Chicago (site of the Republican National Convention) to the right and the St. Louis Exposition and Music Hall (site of the Democratic National Convention) to the left, portraits of the candidates in corner-piece compartments, the whole within a border of twenty-one presidential portraits up to Grover Cleveland. At least two of the portraits were stock cuts produced by A. Zeese & Co., an electrotyping firm in Chicago (*Chicago Tribune*, March 22, 1872; *Daily Inter Ocean* [Chicago], January 1, 1886). The DLC copy is stamped with the date July 13, 1888.

DLC-PP

105 *Facsimile of the Declaration of Independence.* Brooklyn: Compliments of the United States Printing Company [1890s?]. 26 ¾ × 19 ½ inches

NOTE: Lithograph, the title in an ornamental script of the 1890s era. The text is a facsimile of the Rough Draft (although reconfigured to make longer lines) followed by facsimile signatures after Binns transmitted through no. 25. The United States Printing Company employed five hundred people in the production of labels, show cards, and other kinds of job work in color (*The Brooklyn Daily Eagle*, November 8, 1896). The imprint in the two NHi copies appears to have been trimmed off.

NHi NN

106 *In Congress, July 4, 1776. The Unanimous Declaration of the Thirteen United States of America.* [Washington, DC?: James D. McBride, c1891]. 32 × 23 ¾ inches

§ [Certification statement of Secretary of State James G. Blaine dated December 18, 1891] § [Copyright statement of James D. McBride dated 1876 and 1891]

NOTE: Lithograph, a reproduction of the State Department facsimile (no. 11) within an ornamental border surmounted by flags and an American eagle on a lace pattern decorative frieze. Like McBride's *Centennial Memorial* (no. 80), the border is composed of fasces bound by straps of stars and festooned with oak leaves and olive leaves at the corners, but the frieze has been refashioned in the 1890s style. In addition to the print, DLC has a proof of the updated border, also copyrighted 1876 and 1891. The certification statement is accompanied with the State Department seal printed in red.

DLC-MSS

107 *In Congress, July 4, 1776. The Unanimous Declaration of the Thirteen United States of America.* [Baltimore: Baltimore American, 1895]. 26 ¾ × 17 ¼ inches

§ Supplement to Baltimore American, July 4th, 1895. Fac-simile of Declaration of Independence. § [Copyright statement dated 1895]

NOTE: Lithograph, a reproduction of the State Department facsimile (no. 11).

DH

108 *In Congress, July 4, 1776. The Unanimous Declaration of the Thirteen United States of America.* [Chicago: Sherwood Lithograph Company, ca. 1895]. 20 ¼ × 16 inches

§ Sherwood Lith. Co. Chicago.

NOTE: Lithograph, a reproduction of the State Department facsimile (no. 11). The imprint begins beneath the *at* in Matthew Thornton.

MWA

LATER EDITIONS AND ADAPTATIONS: ca. **1895** 19 ¾ × 16 ¼ inches, lithograph on imitation parchment, imprint "Sherwood Lith. Co. Chicago" beginning beneath the *Th* in Matthew Thornton (NHi). **1899** 17 ¼ × 15 inches, lithograph on paper, imprint "Sherwood Lith. Co. Chicago" beneath the *or* in Matthew Thornton, text and signatures in letterpress on verso with a patent notice of the Ladies' Patriotic Society Co. of Buffalo, NY, which issued it in a portfolio along with other facsimiles priced at fifteen cents (NHi; *Eclectibles, website, August 1, 2022, $100*).

109 *Fac-Simile of the Original Draught of the Declaration of Independence. In General Congress Assembled 4th. July, 1776.* [Chicago: Kurz & Allison, 76 & 78 Wabash Ave., c1896]. 55 × 43 ½ inches

§ [Copyright statement of Kurz & Allison dated 1896]

NOTE: Lithograph, the text a facsimile of the Rough Draft arranged in two columns within a border composed of the Signers' portraits, followed by facsimile signatures after Tyler transmitted through an illustration in the July 3, 1858, *Harper's Weekly*. The DLC copy has a copyright stamp dated November 14, 1896. A defective copy is illustrated in Savage, *The Mysterye of the Lost Title*.

Fig. 35 DLC-PP

110 *In Congress, July 4, 1776. The Unanimous Declaration of the Thirteen United States of America.* Albany, NY: The W. A. Choate Co., Publishers [1898]. 34 ¼ × 30 inches

NOTE: Lithograph, a reproduction of the State Department facsimile (no. 11), enclosed in red and blue line borders, the blue border decorated with thirteen stars at each corner. The W. A. Choate Co. sold schoolroom furniture and school supplies, including blackboards, globes, and wall charts. A facsimile edition produced by this firm was announced in the *American School Board Journal* 16 (June 1898): 12.

UkLU-K

FIGURE 66 *Declaration of Independence.* New York: Charles Magnus,
ca. 1855? (brochure version of no. 58). Albert and Shirley Small Special
Collections Library, University of Virginia.

NOTES

Chapter 1

1. Green, "Authors and Printers at War," 295–96; Maier, *American Scripture*, 31–34; Armitage, *Declaration of Independence*, 36–37. The date of publication is sometimes stated to be January 10, but the publisher's advertisements show that it appeared the day before.

2. Boyd, *Evolution* (1945), 39–40, document III.

3. Boyd, *Evolution* (1945), 11, 27–28, document V.

4. Hazelton, *Declaration*, 163–64.

5. Hazelton, *Declaration*, 166–84.

6. Boyd, *Evolution* (1945), 31–36; Goff, *John Dunlap*, 4. Jefferson's exculpatory copies of the Rough Draft are in Boyd, *Evolution* (1945), documents VI–IX.

7. Boyd, "Mystery of the Lost Original," 454–62; Fliegelman, *Declaring Independence*, 4–14; Goff, *John Dunlap*, 8; Joseph J. Felcone, "'My' American Declaration of Independence," AM (blog), June 21, 2016, https://www.amdigital.co.uk/about/blog/item/american-declaration-of-independence (accessed May 31, 2022).

8. Hazelton, *Declaration*, 171, 252, 552–55; Goff, *John Dunlap*, 34; Maier, *American Scripture*, 155–60; Fliegelman, *Declaring Independence*, 25.

9. The wafers are described in Hazelton, *Declaration*, 170, and are shown to best effect in Boyd, *Evolution* (1943), document X.

10. Hazelton, *Declaration*, 200, 491.

11. Hazelton, *Declaration*, 204; Cristobal, "Blackletter," 186n31, 187. Dunlap or one of his clients requisitioned parchment to print another Declaration broadside with a fresh setting of type sometime after July 4th (Walsh, "Contemporary Broadside Editions," no. 2). It is not known what the parchment printing was intended to achieve. Possibly someone thought that the various papers in the original edition were insufficiently prepossessing even though they were all imported and of exceptionally high quality.

12. Chamberlain, *Authentication*, 22, 26; Hazelton, *Declaration*, 204, 208–19, 508–31; Wills, *Inventing America*, 341. Attributed to Matlack in *Founders Online*, the commission was another prime candidate for facsimiles, e.g., no. 78.

13. Hazelton, *Declaration*, 204–5, 502. The 1823 Way and Gideon edition employs caps, italic caps, black letter, and black-letter caps to emphasize words in the last paragraph.

14. Walsh, "Contemporary Broadside Editions," no. 19.

15. Becker, *Declaration*, 173–74; Starr, "Separated at Birth."

16. Boyd, *Evolution* (1945), n38; Jefferson, *Papers* 1:416–17, 433; The Declaration of Independence (transcript), Office of the Law Revision Council, United States Code, https://uscode.house.gov/view.xhtml?path=/frontmatter/organiclaws/independence&edition=prelim (accessed June 1, 2022).

Chapter 2

1. *Democratic Press* (Philadelphia), July 14, 1810. This and other newspaper texts cited here are based on *America's Historical Newspapers*.

2. Sheppard, "Colonel John Binns," 56–57; Wilson, *United Irishmen*, 26–28; Binns, *Recollections*, 143–61.

3. Binns, *Recollections*, 176–96, 292.

4. Adams, *Memoirs*, 5:113, 6:18, 243; Wilson, *United Irishmen*, 73–74, 90; Binns, *Recollections*, 208–9, 252.

5. Cook, "Coffin Handbills"; Binns, *Recollections*, 245–46, 255–56.

6. *Sun* (Baltimore, MD), July 8, 1841; *Binns's Justice: Digest of the Laws and Judicial Decisions of Pennsylvania* (1840); *Democratic Press* (Philadelphia), March 26, 1816. Still bearing his name, the fourteenth edition of *Binns's Justice* appeared in two volumes, 1950–52.

7. Wilson, *United Irishmen*, 94–95; Binns, *Recollections*, 291–92.

8. *Democratic Press* (Philadelphia), March 26, 1816; *Niles' Weekly Register* (Baltimore), July 6, 1816; Groce and Wallace, *Dictionary of Artists*, 80–81, 219, 393, 462, 644. Binns and his artists may have been imitating Amos Doolittle's *A Display of the United States*, a patriotic engraving featuring a centerpiece portrait of Washington surrounded by interlinked state seals. The rudiments of that idea could be traced back to one of Franklin's designs for Continental Currency, a linked chain bearing the names of the thirteen colonies surrounding the motto AMERICAN CONGRESS. WE ARE ONE. For more on this design concept, see O'Brien, *Amos Doolittle*, 66.

9. Wills, *Inventing America*, 324; Detweiler, "Changing Reputation," 572.

10. Cushing, "Ezekiel Russell's Edition," 112–13; Walsh, "Contemporary Broadside Editions," no. 17. The origins of the London broadside have been hard to establish because it lacks an imprint. Walsh noted a London provenance for the copy he saw at the John Carter Brown Library. He made a separate entry for the Library Company of Philadelphia copy believing that it was issued without the portrait, but he did not take in account the peculiar squarish proportions of the sheet, which would be possible only if that portion had been trimmed off. The portrait was derived from mezzotints published in London by a pseudonymous C. Shepherd ca. 1775 (Gilder Lehrman Institute of American History).

11. John Binns v. William Woodruff. The 1816 figures are based on keyword searches in *America's Historical Newspapers*.

12. *National Advocate* (New York), July 4, 1817; *National Messenger* (Georgetown, DC), April 3, 1818; *Democratic Press* (Philadelphia), April 9, 1818.

13. The June 1816 proposals also appear in the *Niles' Weekly Register* (Baltimore), July 6, 1816, which reprints the original announcement of March 26, 1816 along with the subscription terms and a detailed account of the illustrations. A copy of the cover letter is in the *Thomas Jefferson Papers*, series 1, reel 49. When almost ready to go into production, Binns announced that subscribers could opt for copies printed on satin, the price not yet determined (*Susquehanna Democrat* [Wilkes Barre, PA], September 3, 1819). I have not yet seen any copies on satin, but Binns did make good on his promise to issue hand-colored copies.

14. *Kentucky Gazette* (Lexington, KY), March 17, 1817, probably reprinting a piece that originally appeared in February 1817. Measuring 36 × 25 1/2 inches, the largest copy of the Binns print I have found is at the New York Public Library. The Tyler and Stone facsimiles are somewhat smaller, and I know of no larger Declaration print until the publication of the Louis R. Menger lithograph in 1849 (no. 54). The Huntington Library has an untrimmed copy of *Washington's Farewell Address to the People of the United States* (Philadelphia: Gideon Fairman, Benjamin Howard Rand, and Charles Toppan, 1821) measuring 40 × 27 inches. The Fairman, Parker, and Binns consortium advertised it in several newspapers, including the *Franklin Gazette* (Philadelphia), July 23, 1818. Parker died in 1819, Binns dropped out around that time, and the reconstituted partnership solicited subscriptions in the *New-York Columbian*, July 1, 1820. Vestiges of Binns's original concept can be seen in the dedication to the people of the United States, a commercial feint worded in the same terms as the dedication in Binns's *Declaration* (see Cunningham, *Popular Images of the Presidency*, fig. 1-20). For more on the pairing of the Declaration and the Farewell Address see no. 60, no. 71, and Furstenberg, *In the Name of the Father*, 37–44, 238–39.

15. *National Intelligencer* (Washington, DC), April 20, 1819, October 23, 1819, and November 19, 1819; Adams, *Diary*, February 26 and April 17, 1819; Binns to Jefferson, July 27, 1819, *Founders Online*; Jefferson to Binns, August 31, 1819, *Founders Online*; Binns to John Adams, September 2, 1819, *Founders Online*; John Adams to Binns, September 20, 1819, *Founders Online*. Binns donated a copy of his print to the American Philosophical Society on November 19, 1819 just when he was putting it on sale (Binns to John Vaughan, November 19, 1819, American Philosophical Society Archives).

16. John Binns v. William Woodruff; *Democratic Press* (Philadelphia), November 23, 1818; *Franklin Gazette* (Philadelphia), April 30, 1819.

17. *Franklin Gazette* (Philadelphia), December 11, 1819; *National Gazette and Literary Register* (Philadelphia), June 22, 1822; *Salem Register*, September 5, 1844; Sutton, *Western Book Trade*, 80, 343.

18. Dated February 12, 1818, Tyler's prospectus was reprinted in his *Declaration*, 5–7.

Jefferson's letter first appeared in the *City of Washington Gazette*, April 20, 1818.

19. Tyler to Dolley Madison, February 14, 1845, *Dolley Madison Digital Edition*; Nash, *American Penmanship*, 38; *The Columbian* (New York), January 4, 1816.

20. Tyler, *Circular*, 6, 11; *United States' Telegraph* (Washington, DC), May 26, 1834. The *Eulogium* was reprinted in 1817 and probably several times after then; for its various states, see Nash, *American Penmanship*, nos. 83–85; Hart, *Portraits of Washington*, nos. 796, 796a, 796b; and Stephens, *Mavericks*, nos. 767a–c. As if anticipating the *Declaration*, a facsimile signature of George Washington was added in the third state of 1817.

21. Tyler, *Circular*, 10–11; Nash, *American Penmanship*, 114; *Daily National Intelligencer* (Washington, DC), February 6, 1818; Adams, *Diary*, March 15, 1820; Tyler to Alden Partridge, November 11, 1821, Norwich University Archives, Norwich, VT; *Grand National Lottery* (1820); *Grand National Canal Lottery* (1821); Fielding, *American Engravers*, no. 1508 (an 1828 caricature of Tyler engraved by William J. Stone).

22. Tyler, *Declaration*, 5–7, 16–17, 22; Tyler to Luther Bradish, March 27, 1851, New-York Historical Society.

23. Tyler, *Declaration*, 19; *United States' Telegraph* (Washington, DC), May 26, 1834; Tyler, *Circular*, 11; Tyler to Luther Bradish, March 27, 1851, New-York Historical Society. Tyler's subscription book is in the Albert and Shirley Small Special Collections Library, University of Virginia. A broadside version of Tyler's February 12, 1818 proposals is tipped in at the beginning. The shipment of forty copies is mentioned in a note by Maverick to Asher Durand cited in Hendricks, "Durand, Maverick and the *Declaration*," 69. The note is undated except for the heading "Wed. Feb 3d." Hendricks dated it in 1824 on the assumption that February 3rd fell on a Wednesday in that year and that Maverick was referring to Trumbull's *Declaration*. But Maverick fell out with Durand over that commission in 1820. It is much more likely that he was sending his former apprentice copies of the Tyler *Declaration* in 1819, another year when February 3rd fell on a Wednesday, when they were still on good terms, and when Maverick would have been helping Tyler not long after the print was published.

24. *Democratic Press* (Philadelphia), April 9 and 18, 1818; *Weekly Aurora* (Philadelphia), April 20, 1818. Like Binns, Tyler asked newspaper editors to tell his side of the story.

25. Tyler, *Declaration*, 23–40; Jefferson to William P. Gardner, February 19, 1813, *Founders Online*; William P. Gardner to John Adams, May 19, 1818, *Founders Online*. A copy of Tyler's pamphlet with manuscript corrections by Gardner is at the Library of Congress.

26. Binns, *Recollections*, 237; Tyler, *Declaration*, 26, 35–38; *National Intelligencer* (Washington, DC), July 2, 1818.

27. *Baltimore Patriot & Mercantile Advertiser*, July 21, 1818. Murray's rejoinder seems to have been lost in the crossfire between Binns and Tyler. Historians include this controversy in discussions of changing attitudes toward the Declaration, but they rely mainly on a single source (Fitzpatrick, *Spirit of the Revolution*, 16–20), which takes Tyler's side and repeats Gardner's accusations without realizing that there is evidence to the contrary. Maier's *American Scripture*, for example, follows Fitzpatrick and distorts Binns's role in this affair (p. 182); likewise Wills refers to Fitzpatrick in *Inventing America* (p. 324). More intent on the details, Cunningham used Gardner's correspondence and Tyler's *Declaration* in his *Popular Images of the Presidency* (pp. 91–94) but took their testimony at face value and believed them to be the injured parties.

28. William P. Gardner to John Adams, May 19, 1818, *Founders Online*; Adams, *Diary*, October 10, 1817, February 16, 1818, May 5, 1818, and July 1, 1818; John Adams to Tyler, May 24, 1818, *Founders Online*; Tyler to John Adams, May 16 and July 4, 1818, *Founders Online*.

29. Adams, *Diary*, July 19, 1824, August 2, 1824, and August 15, 1843; *United States' Telegraph* (Washington, DC), May 26, 1834; Tyler to John Quincy Adams, June 19, 1827, *Letters Received*, reel 481; John Quincy Adams to Tyler, March 1, 1836, *Letterbook*, reel 152; Tyler, *Circular*, 6–7.

30. *Daily National Intelligencer* (Washington, DC), May 29, 1822; Adams, *Diary*, March 13, 1821; Clay, *Papers*, 3:241–42, 5:370; Stephens, *Mavericks*, nos. 457a–c.

31. Adams, *Diary*, April 18, 1820; Marshall, *Papers*, 12:323–25; *A Fac-Simile of Jefferson and Jackson's Letters* (1834); Stephens, *Mavericks*, no. 1722. Engraved by Samuel Maverick, brother

of Peter Maverick, this print carries the usual certificate of authenticity, although Tyler was based in New York at this time and had to content himself with endorsements of comparatively obscure municipal officials.

32. Tyler to Luther Bradish, morning June 27, 1840, afternoon June 27, 1840, and July 1, 1840, New-York Historical Society. Dated April 16, 1840, a prospectus for *Westward the March of Empire* is included with these letters. The three lithographers Tyler hired for that print were George Endicott, John Childs, and Alfred E. Baker. It was deposited for copyright on July 28, 1840, and was followed by *Harrison, Union, Liberty, and Independence*, which was deposited on August 2, 1840. Copies of both prints are at the Library of Congress.

33. Seager, *And Tyler Too*, 245, 593–94; Tyler to John P. Van Ness, August 12, 1834, New-York Historical Society; Tyler to Luther Bradish, January 8, 1840, New-York Historical Society; Tyler to Dolley Madison, February 14, 1845, *Dolley Madison Digital Edition*; *Daily National Intelligencer* (Washington, DC), October 25, 1847.

34. *The Christian Era* (Boston), August 25, 1853; *The South-Western* (Shreveport, LA), January 24, 1855. Seth Kaller alerted me to the article in *The South-Western*.

35. Admission, August 17, 1858, and death, August 28, 1858, Almshouse Ledgers, 1758–1952, New York City Municipal Archives (transcribed in https://www.ancestrylibrary.com, accessed July 13, 2022); *Buffalo Evening Post*, December 6, 1859. Rick Stattler very kindly informed me of the entries in the Almshouse Ledgers.

36. Binns, *Recollections*, 235–36; *Washington Review and Examiner*, July 19, 1823; S. 6, 16th Cong. (1819); *Senate Journal*. 16th Cong., 1st sess., December 21, 1819, 41, and May 9, 1820, 392; *National Gazette and Literary Register* (Philadelphia), February 7, 1824, and April 6, 1824; Pennsylvania, General Assembly, *Journal of the Thirty-Fourth House of Representatives* (1823–1824), 563–67.

37. *National Intelligencer* (Washington, DC), April 20, 1819, and July 8, 1820; 4 *Cong. Deb.* 1229 (1828); Carrier, *White House*, 52–53. One of the frames is illustrated in Cunningham, *Popular Images of the Presidency*, figs. 3-5, but that one is on the reproduction, not the original. The curator of the Capitol, Farar Elliott, very kindly allowed me to examine the prints in the National Statuary Hall as well as another copy of the Binns original, currently hanging in the office of the Speaker's Deputy Chief of Staff.

Chapter 3

1. Adams, *Diary*, April 26, 1819, and May 13, 1819; Detweiler, "Changing Reputation," 573–74; Beutler, *George Washington's Hair*, 161.

2. Adams, *Diary*, July 27, 1820, October 2, 1822, April 11, 1823, and April 25, 1823; *City of Washington Gazette*, December 23, 1818; *National Intelligencer* (Washington, DC), March 10 and 12, 1845; McKitterick, *Old Books, New Technologies*, 106–7; Kaller, *America's National Treasure*, 14, 17; Ritzenthaler and Nicholson, "Declaration of Independence." In a bibliographical note, "Declaration of Independence Facsimiles," Randolph G. Adams suggested that the John Quincy Adams imprint had been engraved on the back of the plate, as if the printing surface on the front had to be kept pristine in accordance with the concept of an "exact" facsimile. In that case, the vellum copies would have gone through the press a second time. After printing them, Stone would have burnished off the lettering to forestall attempts

to produce more than the statutory limited edition. Indeed, there are gouge marks on the back of the plate, which might support this hypothesis, but measurements of their size and placement are inconclusive.

3. Adams, *Diary*, July 1, 1823; Resolution providing a place of deposit for the portrait of Columbus, and directing the distribution of certain copies of the Declaration of Independence, now in the Department of State, 2 *Stat.* 78.

4. John Quincy Adams to John Adams, June 24, 1824, *Founders Online*; John Quincy Adams to Jefferson, June 24, 1824, *Founders Online*; John Quincy Adams to Charles Carroll, June 24, 1824, printed in Sanderson, *Biography of the Signers*, 7:255–56; John Quincy Adams to Oliver Wolcott Jr., June 30, 1824, Gilder Lehrman Institute of American History; Kaller, "William J. Stone"; Nicholson, "Finding the Stones."

5. *National Intelligencer* (Washington, DC), June 7, 1823; Christie's, New York,

June 14, 2018, lot 86; Daniel Webster to Joseph Reed Ingersoll, December 14, 1841, State Department Letterbook, 32:124, https://www.fold3.com/document/11832624/vol-32-30-jul-1841-30-nov-1842-page-124-domestic-letters-of-the-department-of-state (accessed June 28, 2022); David Gary, "Major Discovery of William Stone Declaration Engraving on Paper," typescript, American Philosophical Society; John Quincy Adams to John Andrew Schulze, June 30, 1824, New York Public Library Digital Collections; annotated memorandum, May 29, 1969, General Records of the Department of State, 1763–2002, series: plates and facsimiles of the Declaration of Independence, 1823–1951, Record Group 59, National Archives, College Park, MD. David Gary very kindly brought the Webster and Adams letters to my attention. I am indebted to Amy Lubick for photographs of the plate and information about its conservation treatments in the National Archives.

6. Beers, "History of the U.S. Topographical Engineers," 290–91.

Chapter 4

1. Jaffe, *John Trumbull*; Prown, "John Trumbull as History Painter." Here and in the following, my biographical information about Trumbull is based on these sources as well as Helen A. Cooper's commentary in *John Trumbull: The Hand and Spirit of a Painter* and Trumbull's *Autobiography*, both the original 1841 edition and Theodore Sizer's 1953 edition, which includes a prefatory essay and explanatory notes.

2. Trumbull to Jefferson, December 28, 1817, *Founders Online*; *Proposals by John Trumbull, for Publishing by Subscription, Two Prints* (1790), 2; Cooper, *John Trumbull*, 14. The thirty-six life portraits are also noted in an 1822 broadside advertisement, *Declaration of Independence* (Adams, *Letters Received*, reel 463).

3. James Barbour to Jefferson, January 9, 1817, *Founders Online*; Jefferson to James Barbour, January 19, 1817, *Founders Online*; *Annals of Congress*, 14th Cong., 2nd Sess., 64, 78–79, 761–63; Resolution to employ John Trumbull, to compose and execute certain paintings, 3 *Stat.* 400; Jaffe, *John Trumbull*, 236–37; Adams, *Diary*, September 13, 1817, and September 1, 1818. The original painting is in the Yale University Art Gallery.

7. Goff, "Peter Force," 4–6; *National Intelligencer* (Washington, DC), November 6, 1848.

8. Kaller, *America's National Treasure*, 15–16; Nicholson, "Finding the Stones."

9. Hunnisett, *Steel-Engraved Book Illustration*, 187–98; Larson, "Separately Published Engravings," 7; *National Intelligencer* (Washington, DC), March 10, 1845; *Daily National Journal* (Washington, DC), November 13, 1828; Adams, *Diary*, December 30, 1830.

10. *S. Doc. No. 3*, Appendix 55, 32nd Cong. 1st Sess. (1852); Rapport, "Fakes and Facsimiles," 26; General Records of the Department of State, 1763–2002, series: plates and facsimiles of the Declaration of Independence, 1823–1951, Record Group 59, National Archives, College Park, MD. Amy Lubick and Netisha Currie very kindly provided scans of some items in Record Group 59, including an 1895 document concerning the alto plate and a typescript account of the basso plate.

11. Alvey A. Adee to Almon F. Rockwell, June 29, 1883, Gilder Lehrman Institute of American History.

4. Trumbull to Jefferson, October 23, 1818, *Founders Online*, with newspaper clipping enclosure; Jaffe, *John Trumbull*, 241–45; Mulcahy, "Congress Voting Independence," 78–79; Pohrt, "Reception and Meaning," 119; *Annals of Congress*, 15th Cong., 2nd Sess., 1142–46.

5. *Proposals by John Trumbull, for Publishing by Subscription, Two Prints* (1790); *Proposals by John Trumbull, for Publishing by Subscription, Two Prints, One Representing the Death of General Warren, at the Battle of Bunker's-Hill, the Other the Death of General Montgomery, at the Attack of Quebec* (1807); Jaffe, *John Trumbull*, 151–54, 187, 222.

6. *National Intelligencer* (Washington, DC), February 19, 1818. Other versions of the proposals were issued after the painting was completed. *Founders Online* transcribes similar but not identical solicitation letters (Trumbull to John Adams, December 26, 1817; Trumbull to James Madison, December 26, 1817; Trumbull to Jefferson, December 28, 1817) and cites a letter from Trumbull to James Monroe, December 29, 1817.

7. *Declaration of Independence: Published by John Trumbull* (1822). A copy of this

broadside prospectus is in Adams, *Letters Received*, reel 463.

8. Jaffe, *John Trumbull*, 239; Craven, "Asher B. Durand's Career," 45, 50–51.

9. Hendricks, "Durand, Maverick and the *Declaration*," 67–71; Hart, *Asher B. Durand*, 4–5 and no. 234. On the other hand, compromises may have had to be made on the manufacturing end. According to Hart, such a large and complex composition proved to be beyond the powers of local plate printers, and a master printer had to be brought over from England for that purpose.

10. *New-York Daily Advertiser*, December 29, 1820; *New-York Evening Post*, November 17, 1821. The 1820 advertisement prints the text of Trumbull's copyright application, dated December 22, 1820, although the copyright statement in the print is dated December 20, 1820. He sent a copyright deposit copy to John Quincy Adams after the print was finished in 1823 (Trumbull to John Quincy Adams, October 20, 1823, *Letters Received*, reel 463). The proof copy illustrated in figure 26 has an abridged version of the title but includes due credit to Durand.

11. *Commercial Advertiser* (New York), September 17, 1823; Trumbull to Charles Wilkes, March 10, 1822 (William Reese Co., item WRCAM49021); Jaffe, *John Trumbull*, 240–41, 271. Eventually, he collected subscriptions from seven senators and twenty-seven representatives. By 1823 Trumbull was dealing with another agent, Wolcott Huntington, who delivered prints to subscribers and sold them on his own account (Trumbull to John Vaughan, December 13, 1823, American Philosophical Society Archives).

12. Trumbull, *Autobiography* (1841), 356–67.

13. "Great National Picture," *National Advocate* (New York), ca. October 20, 1818; *Thomas Jefferson Papers*, series 1, reel 50; "Declaration of Independence," *Boston Patriot and Daily Chronicle*, December 8, 1818; Benjamin Waterhouse to Jefferson, January 15, 1819, *Founders Online*. Writing as Tempus and Philo Tempus, Waterhouse also complained about the neglect of Samuel Adams.

14. Trumbull to Detector, ca. October 20, 1818, *Founders Online*; Jefferson to Trumbull, November 11, 1818, *Founders Online*; *Declaration of Independence* (Adams, *Letters Received*, reel 463).

15. Jefferson to Samuel Adams Wells, May 12, 1819, *Founders Online*. Painted in 1832,

the third *Declaration* is at the Wadsworth Atheneum. Edward Savage's painting *Congress Voting Independence* (ca. 1796–1817) is considered to be more accurate in respect to the interior if less felicitous in design and composition. In 1803 Savage issued proposals for a print, which was never published. After seeing Trumbull's proposals in 1818, Edward Savage Jr., offered to sell the colonel his father's "nerely conpleated" painting as well as the copperplate, which needed only a few weeks of work. Trumbull rejected the offer on the grounds that his painting was just as close to completion and no less authentic inasmuch some portraits had been made thirty years ago. As to the print, his would not appear for several years, but he was not disposed to buy off the competition (Edward Savage to Jefferson, February 7 and March 10, 1803, *Founders Online*; Mulcahy, "Congress Voting Independence," 88). Savage's painting is at the Historical Society of Pennsylvania; his plate is at the Massachusetts Historical Society along with modern proof impressions.

16. Jaffe, "Trumbull's *The Declaration of Independence*," 44–48. Keys were hung beneath each of the four Rotunda paintings in 1826 although Trumbull wanted to replace them with engraved illustrations in a guidebook (Trumbull to Charles Bulfinch, November 28, 1826, Gilder Lehrman Institute of American History).

17. *Proposals by John Trumbull, for Publishing by Subscription, a Print from the Original Picture Now Painting by Him . . . Representing the Declaration of Independence* (New York, 1818).

18. Jaffe, "Fordham University's Trumbull Drawings," 6–13; Jaffe, *John Trumbull*, 114–17.

19. The earliest advertisement I have found for the engraved key is in the *Massachusetts Spy* (Worcester, MA), December 24, 1823, but it was probably produced closer to September 1823, when the print was delivered to the subscribers.

20. New Orleans Auction Galleries, October 16, 2016, lot 969; Jaffe, "Trumbull's *The Declaration of Independence*," 48.

21. Stein, *Worlds of Thomas Jefferson*, 162; Trumbull to Thomas Jefferson, October 1, 1823, *Founders Online*; Cloquet, *Souvenirs*, 266–68; Christie's, New York, November 22, 1985, lot 194; Trumbull, *Autobiography* (1841), 402. The caption texts in Cloquet can be translated as

"offered to General Lafayette by a congressional resolution in May 1824" and "Declaration of Independence of the United States. Engraving."

22. Trumbull, *Description*; Trumbull, *Letters*.

23. *Albany Argus*, November 22, 1833, and November 26, 1833; *New-York Mirror*, November 6, 1841, and November 5, 1842; *Evening Post* (New York), November 25, 1843. The Yale University Art Gallery has a worn impression of the print (1998.10.1).

24. At one point, Ormsby was involved in the publication of *The Columbian Lady's and Gentleman's Magazine*, for which he supplied a number of illustrations. Volume seven (1847) bears the imprint of Ormsby & Hackett, a firm operating at his 116 Fulton Street address. In 1848 one could take out an annual subscription for four dollars and receive a copy of the print gratis. Subscriptions to *The Knickerbocker* were offered on similar terms.

25. In "Trumbull's *The Declaration of Independence*," 45, Jaffe tried to account for the anomalies in the Metzeroth key by linking it to the 1817 exhibition in the hall of the House of Representatives. Given his slipshod treatment of the print, however, it would have been out character for him to have consulted a key dating that far back. The print does include at least one

detail he could have seen only in the Rotunda, the carpet on the dais, but otherwise he depended on an earlier print to expedite his work. That approach makes for an easier explanation than the research project conjectured by Jaffe. Although he got off on the wrong foot, he could have numbered the heads correctly by referring to the Mercein key in Trumbull's *Description*, a source still easily accessible at that time. A broadside version of the Mercein key is at the New-York Historical Society. For a typical use of the modernized key, see *Art in the United States Capitol*, H. R. Doc. No. 94–660, 94th Cong., 2nd Sess. (1978).

26. Ford, *Edward Hicks*, 66. Priced at $1.50, *The Lives of the Signers* was one of Barnes's Centennial publications (*Publishers' Weekly*, July 1, 1876).

27. *The Great National Exhibition of the Signers of the Declaration of Independence* (Boston: W. W. Clapp, printer, 1837).

28. Maass, "Declarations of Independence" contains an account of the Armand-Dumaresq *Déclaration* with illustrations of a painting in a French collection and a print published in the 1880s. Maass was not aware that another version had been donated to the White House (*New York Times*, May 24, 1961), where it is still on display.

Chapter 5

1. A copy of the parody is at the American Antiquarian Society: *The United Estates of Labor . . . Unanimous Declaration of Temperance* (Boston: Devereux & Brown, 1842).

2. *Baltimore Patriot*, April 16, 1818, and April 1, 1819; Tyler subscription book, Albert and Shirley Small Special Collections Library, University of Virginia; Benjamin Owen Tyler v. Sanderson & Ward.

3. *Baltimore Patriot*, December 17, 1818.

4. *Franklin Gazette* (Philadelphia), April 8, 1820, and November 17, 1820; *Proposals by Joseph M. Sanderson, for Publishing by Subscription a Biography of the Signers to the Declaration of Independence* (Philadelphia: Joseph M. Sanderson, 1819 or 1820).

5. Maier, *American Scripture*, 176; Lauer, "Traces of the Real," 160; *Proposal by R. W. Pomeroy, for Publishing by Subscription Biography of the Signers to the Declaration of Independence* (Philadelphia: R.W. Pomeroy, 1823). I am grateful to John Garcia, who found

this broadside tipped in a canvassing book at the Kislak Center for Special Collections, Rare Books and Manuscripts, University of Pennsylvania.

6. Bidwell, "Epic Ambitions," 342; *The Declaration of Independence of the United States of America, 1776, and Washington's Farewell Address to the People of the United States, 1796* (Boston: Printed by order of the City Council, 1876).

7. *The Declaration of Independence* (Troy, NY: Empire Publishing Company, 1876). A handbill promoting the Empire publication is in the Graphic Arts Collection, American Antiquarian Society. For the photolithographic process, see Reps, *Views and Viewmakers*, 36. The earliest Rough Draft pamphlet to my knowledge is *The Declaration of Independence* (New York: Seaver & Company, and H. G. Lawrence, 1860).

8. McDonald, "Thomas Jefferson's Changing Reputation."

9. Becker, *Declaration*, 141–84; Maier, *American Scripture*, 236–41; and Wills, *Inventing America*, 379–84.

10. Detached copies of Sears's folding plate are often found without comment in print collections, one reason why I mistakenly described it as an independent print in the 1988 Declarations checklist.

11. Goff, *John Dunlap*, 10; Walsh, "Contemporary Broadside Editions"; David W. Dunlap, "A Clear Declaration of Intent Is Now Even Clearer," *New York Times*, July 3, 2012.

12. *Democratic Press* (Philadelphia), January 28, 1820; Tyler, *Declaration*, 6; Beutler, *George Washington's Hair*, 31; *New York Times*, June 29, 1859.

13. Wilentz, *Chants Democratic*, 43; inventory of Garret Sickels, December 18, 1822, filed April 28, 1823, New York City Municipal Archives; Cometti and Gennaro-Lerda, "Presidential Tour of Caro Vidua," 398; Farkas, *Journey in North America*, 85–87. By "Signers thereto," the compilers of the Sickels inventory might have meant Woodruff's separately published facsimile signatures (no. 7). Wilentz thought that they were describing portraits of the Signers, but Trumbull's portraits were not published until September 1823.

14. Roth, *Facts*, 21–22; National Archives and Records Service, *Documents from America's Past* (1975), 2; Stathis, "Returning the Declaration of Independence," 183.

15. *The American Magazine of Useful and Entertaining Knowledge* 1, no. 4 (December 1834), advertisements; Whitmore, "Abel Bowen," 44; Hamilton, *Early American Book Illustrators*, 78, 81; *Columbian Centinel* (Boston), April 20, 1836; *Catalogue of Elegant Wood Cuts, to be Sold at Auction on Thursday, January 19, 1837* (Boston: Bayley & Hatch, 1837).

16. Tyler subscription book, Albert and Shirley Small Special Collections Library, University of Virginia.

17. Marzio, *Democratic Art*, 20.

18. Holzer, "'Columbia's Noblest Sons,'" 61, figs. 27–30.

19. A publication notice calls Ames's print "A Picture of Progress" (*The World* [New York], March 20, 1876).

20. Patterson and Dougall, *Eagle and the Shield*, 295.

21. Johnson, *Papers*, 15:409; *Fortieth Congress U.S. Second Session. House of Representatives. Resolved, February 24th 1868, That Andrew Johnson . . . Be Impeached* (Mansfield, OH: James D. McBride, 1868); *Fortieth Congress U.S. Second Session. Senate Chamber. May 16th. and 26th. 1868. The Vote of the Senate, Sitting as a High Court of Impeachment* (Mansfield, OH: James D. McBride, 1868). Both prints are at the Library of Congress. The signatures in the House of Representatives impeachment print replicate those in the Gilder Lehrman manuscript (GLC05274.01) with just a few exceptions.

22. *The Daily Critic* (Washington, DC), February 22, 1875; *The Meschacébé* (Parish of St. John the Baptist, LA), May 15, 1875. I have not found a copy of this print.

23. *The Meschacébé* (Parish of St. John the Baptist, LA), May 15, 1875; *In Congress, The Delegates of the United Colonies . . . to George Washington, Esquire* (Philadelphia: Continental Publishing Co., ca. 1874–1876). A copy at the American Antiquarian Society has an advertisement, the seal in black, and a note offering copies without advertising for a dollar.

24. *Plain Dealer* (Cleveland, OH), October 12, 1876; Patterson and Dougall, *Eagle and the Shield*, 374–77; "Centennial Memorial," *H. R. Doc. No. 94*, 45 Cong., 3rd Sess. (1879); Heritage Auctions, Dallas, December 11–12, 2012, lot 38122; *New York Herald*, August 30, 1878.

25. 23 *Cong. Rec.* 6342 and 6382 (1892); 26 *Cong. Rec.* 8037 (1894).

26. 28 *Cong. Rec.* 4407–9 and 5576–78 (1896); *New York Tribune*, May 23, 1896; Patterson and Dougall, *Eagle and the Shield*, 294–304; "History of the Federal Elections," *S. Doc. No. 1018*, 62 Cong., 2nd Sess. (1912); *Official Summary of Electoral Votes Cast for Each President of the United States of America* (Washington, DC: James D. McBride Co., 1912); 58 *Cong. Rec.* 7444–45 (1919).

27. *The Meschacébé* (Parish of St. John the Baptist, LA), May 15, 1875.

28. Nugent, "American People and the Centennial," 57, 63–64; Stathis, "Returning the Declaration of Independence," 173–75; McCabe, *Illustrated History of the Centennial Exhibition*, 751–52.

29. *Bay City Times-Press* (Bay City, MI), June 18, 1902.

Chapter 6

1. Tyler, *Declaration*, 17; Adams, *Diary*, April 17, 1819.

2. Stathis, "Returning the Declaration of Independence," 176; *Evening Post* (Washington, DC), February 12, 19, and 22, 1875; 4 *Cong. Rec.* 1364 (1876); Ritzenthaler and Nicholson, "Declaration of Independence."

3. *Daily Evening Bulletin* (San Francisco), June 15, 1883; *Daily Inter Ocean* (Chicago), July 17, 1889.

4. *Evening Star* (Washington, DC), October 7, 1903.

5. Henry L. Bryan, "The Declaration of Independence as It Is To-Day," *Ladies' Home Journal* 15 (July 1898): 3; Ritzenthaler and Nicholson, "Declaration of Independence"; Gustafson, "Empty Shrine"; Calmes, "NARA Monitors Charters of Freedom." A print from Handy's negative is in the Manuscripts Division, Library of Congress.

6. Lauer, "Traces of the Real," 150, 155; Draper, *Essay on the Autographic Collections*; Fields, "Completed Sets," 16–17. Morgan gave one of his sets to the Library of Congress; the other two are described in Draper, Fields, and the Morgan Library & Museum online catalog (http://corsair.themorgan.org).

7. Draper, *Essay on the Autographic Collections*, 38, 77.

8. Draper, *Essay on the Autographic Collections*, 86; Fields, "Completed Sets," 17; Chamberlain, *Brief Description*, 4, 22–24. The Thomas Lynch Jr. signature is not authentic, but that defect has been excused because the Boston Public Library also has a genuine example.

9. The Hay certification appears on lithograph facsimiles in the Massachusetts Historical Society, the New-York Historical Society, the New York Public Library, and the Graphic Arts Collection of the Smithsonian Institution. Some versions are configured like the McBride facsimiles, others like the Binns family but with the state seals in color.

10. Keynes, "Engraved Facsimile by John Pine"; *Democratic Press* (Philadelphia), March 26, 1816.

11. Amar, "Our Forgotten Constitution"; Cross, "'Done in Convention.'"

12. Tyler to John Adams, May 16, 1818, *Founders Online*.

FIGURE 67 *Declaration of Independence, and Geographical Chart of the U. States of America. In Congress, July 4th, 1776: The Unanimous Declaration of the Thirteen United States of America.* Philadelphia: Thomas Morrison, 1832 (no. 29). Courtesy of Swann Auction Galleries.

BIBLIOGRAPHY

Adams, John Quincy. *Diary, Letters Received, and Letterbook: Microfilms of the Adams Papers Owned by the Adams Manuscript Trust and Deposited in the Massachusetts Historical Society*. Boston: Massachusetts Historical Society, 1954–59.

———. *The John Quincy Adams Digital Diary*. Massachusetts Historical Society. Accessed June 10, 2022. https://www.masshist.org/publications/jqadiaries/.

———. *Memoirs of John Quincy Adams, Comprising Portions of His Diary from 1795 to 1848*. Edited by Charles Francis Adams, 12 vols. Philadelphia: J. B. Lippincott, 1874–77.

Adams, Randolph G. "Declaration of Independence Facsimiles [Notes and Queries]." *Colophon*, new ser., no. 2 (1937): 294.

Allen, Danielle. *Our Declaration: A Reading of the Declaration of Independence in Defense of Equality*. New York: Liveright, W. W. Norton, 2015.

Amar, Akhil Reed. "Our Forgotten Constitution: A Bicentennial Comment." *Yale Law Journal* 97 (December 1987): 281–98.

America's Historical Newspapers. Accessed June 24, 2022. https://infoweb-newsbank-com.ezproxy.princeton.edu.

Amory, Hugh, and David D. Hall, eds. *A History of the Book in America*. Vol. 1, *The Colonial Book in the Atlantic World*. Cambridge: American Antiquarian Society; Cambridge University Press, 2000.

Armitage, David. *The Declaration of Independence: A Global History*. Cambridge, MA: Harvard University Press, 2008.

Becker, Carl L. *The Declaration of Independence: A Study in the History of Political Ideas*. New York: Alfred A. Knopf, 1956. First published 1922 by Harcourt, Brace (New York).

Beers, Henry P. "A History of the U.S. Topographical Engineers, 1813–1863." *Military Engineer* 34 (June 1942): 287–91.

Benjamin Owen Tyler v. Sanderson & Ward, Civil Appearances, June Term 1819, Circuit Court of the District of Columbia, "Inventories of Household and Other Goods Seized by City Marshal." RG 21 E6, Law, Appellate and Criminal Case files, 1802–63, National Archives, Washington, DC.

Beutler, Keith. *George Washington's Hair: How Early Americans Remembered the Founders*. Charlottesville: University of Virginia Press, 2021.

Bidwell, John. "American History in Image and Text." *Proceedings of the American Antiquarian Society* 98 (1988): 247–302.

———. "Declaration of Independence Prints and Their Script Type Spinoffs." In *A Festschrift for Michael Winship*, edited by Molly Hardy, Matt Cohen, and Nicole Gray, 35–41. Buxton, ME: Privately printed, 2023.

———. "Epic Ambitions: The Publication of Joel Barlow's *Columbiad*." In Bidwell, *Paper and Type: Bibliographical Essays*, 311–44. Charlottesville: Bibliographical Society of the University of Virginia, 2019.

———. "The Sources of the Sussex Declaration: A Reconsideration." In *Studies in Bibliography*, forthcoming.

Binns, John. *Recollections of the Life of John Binns: Twenty-Nine Years in Europe and Fifty-Three in the United States. Written by Himself, With Anecdotes, Political, Historical, and Miscellaneous*. Philadelphia: Printed and for sale by the author, and by Parry and M'Millan, 1854.

Bouquin, Corinne, and Élisabeth Parinet. *Dictionnaire des imprimeurs-lithographes du XIXe siècle* [Biographical dictionary of nineteenth-century printer-

lithographers], Éditions en ligne de l'École des chartes. Accessed December 30, 2022. http://elec.enc.sorbonne.fr/imprimeurs.

Bowen, Eli. *Rambles in the Path of the Steam-Horse.* Philadelphia: Wm. Bromwell and Wm. White Smith, publishers; Baltimore: S.B. Hickcox, agent, 1855.

Boyd, Julian P. *The Declaration of Independence: The Evolution of the Text as Shown in Facsimiles of Various Drafts by Its Author; Issued in Conjunction with an Exhibit of these Drafts at the Library of Congress on the Two Hundredth Anniversary of the Birth of Thomas Jefferson.* Washington, DC: Library of Congress, 1943.

———. *The Declaration of Independence: The Evolution of the Text as Shown in Facsimiles of Various Drafts by Its Author, Thomas Jefferson.* Princeton, NJ: Princeton University Press, 1945.

———. *The Declaration of Independence: The Evolution of the Text.* Rev. ed. Edited by Gerard W. Gawalt. Washington, DC, and Charlottesville, VA: Library of Congress in association with the Thomas Jefferson Memorial Foundation, 1999.

———. "The Declaration of Independence: The Mystery of the Lost Original." *Pennsylvania Magazine of History and Biography* 100 (1976): 438–67.

Calmes, Alan. "NARA Monitors Charters of Freedom." *National Preservation News* 8 (October 1987): 9–10.

Carrier, Thomas J. *The White House, the Capitol, and the Supreme Court: Historic Self-Guided Tours.* Charleston, SC: Arcadia, 2000.

Chamberlain, Mellen. *The Authentication of the Declaration of Independence, July 4, 1776.* Cambridge, MA: John Wilson and Son, 1885. First published in *Proceedings of the Massachusetts Historical Society,* 2nd ser., 1 (November 1884): 273–98.

———. *A Brief Description of the Chamberlain Collection of Autographs Now Deposited in the Public Library of the City of Boston.* Boston: Published by the Trustees, 1897.

Clay, Henry. *The Papers of Henry Clay.* Edited by James F. Hopkins and Mary W. M. Hargreaves, 10 vols. and supplement. Lexington: University Press of Kentucky, 1959–92.

Cloquet, Jules. *Souvenirs sur la vie privée du général Lafayette* [Recollections of the private life of General Lafayette]. Paris: A. et W. Galignani et Cie., 1836.

Collins, Herbert Ridgeway. *Threads of History: Americana Recorded on Cloth 1775 to the Present.* Washington, DC: Smithsonian Institution Press, 1979.

Cometti, Elizabeth, and Valeria Gennaro-Lerda. "The Presidential Tour of Carlo Vidua with Letters on Virginia." *Virginia Magazine of History and Biography* 77 (1969): 387–406.

Cook, William C. "The Coffin Handbills—America's First Smear Campaign." *Imprint: Journal of the American Historical Print Collectors Society* 27 (2002): 23–37.

Cooper, Helen A., ed. *John Trumbull: The Hand and Spirit of a Painter.* New Haven, CT: Yale University Art Gallery, 1982.

Craven, Wayne. "Asher B. Durand's Career as an Engraver." *American Art Journal* 3, no. 1 (1971): 39–57.

Cristobal, Kasia Solon. "From Law in Blackletter to 'Blackletter Law.'" *Law Library Journal* 108 (2016): 181–216.

Cross, Jesse. "'Done in Convention': The Attestation Clause and the Declaration of Independence." *Yale Law Journal* 121 (March 2012): 1236–70.

Cunningham, Noble E., Jr. *Popular Images of the Presidency from Washington to Lincoln.* Columbia: University of Missouri Press, 1991.

Cushing, John D. "Ezekiel Russell's Edition of Jonathan Mitchell Sewall's 'War and Washington': A Bibliographical Note." *Proceedings of the Massachusetts Historical Society,* 3rd ser., 93 (1981): 109–14.

Detweiler, Philip F. "The Changing Reputation of the Declaration of Independence: The First Fifty Years." *William and Mary Quarterly,* 3rd ser., 19 (October 1962): 557–74.

Draper, Lyman C. *An Essay on the Autographic Collections of the Signers of the Declaration of Independence and of the Constitution.* New York: Burns & Son, 1889.

Dupont, Christian Y., and Peter S. Onuf, eds. *Declaring Independence: The Origin and Influence of America's Founding*

Document. Charlottesville: University of Virginia Library, 2008.

Earnest, Russell, and Corinne Earnest with Edward L. Rosenberry. *Flying Leaves and One-Sheets: Pennsylvania German Broadsides, Fraktur and Their Printers*. New Castle, DE: Oak Knoll Books, 2005.

Eaton, Linda. *Printed Textiles: British and American Cottons and Linens, 1700–1850*. New York: Monacelli, 2014.

Farkas, Alexander Bölöni. *Journey in North America (Kolozsvár, 1834)*. Translated and edited by Theodore and Helen Benedek Schoenman. Vol. 120, *Memoirs of the American Philosophical Society*. Philadelphia: American Philosophical Society, 1977.

Fielding, Mantle. *American Engravers upon Copper and Steel: Biographical Sketches and Check Lists of Engravings, a Supplement to David McNeely Stauffer's American Engravers*. Philadelphia: n.p., 1917.

Fields, Joseph E. "The Completed Sets of Signers of the Declaration of Independence." *Autograph Collectors' Journal* 3 (1951): 15–19.

Fitzpatrick, John C. *The Spirit of the Revolution: New Light from Some of the Original Sources of American History*. Boston: Houghton Mifflin, 1924.

Fliegelman, Jay. *Declaring Independence: Jefferson, Natural Language, and the Culture of Performance*. Stanford, CA: Stanford University Press, 1993.

Foner, Philip S., ed. *We, the Other People: Alternative Declarations of Independence by Labor Groups, Farmers, Woman's Rights Advocates, Socialists, and Blacks, 1829–1975*. Urbana: University of Illinois Press, 1976.

Ford, Alice. *Edward Hicks: Painter of the Peaceable Kingdom*. Philadelphia: University of Pennsylvania Press, 1998.

Founders Online. Washington, DC: National Archives; Charlottesville: University of Virginia Press, Rotunda, 2010–. https://founders.archives.gov.

Fowble, E. McSherry. *Two Centuries of Prints in America, 1680–1880: A Selective Catalogue of the Winterthur Museum Collection*. Charlottesville: Published for The Henry Francis du Pont Winterthur Museum by the University Press of Virginia, 1987.

Furstenberg, François. *In the Name of the Father: Washington's Legacy, Slavery, and the Making of a Nation*. New York: Penguin, 2006.

Gaskell, Philip. "A Census of Wooden Presses." *Journal of the Printing Historical Society* 6 (1970): 1–32.

Goff, Frederick R. *The John Dunlap Broadside: The First Printing of the Declaration of Independence*. Washington, DC: Library of Congress, 1976.

———. "Peter Force." *Papers of the Bibliographical Society of America* 44 (1950): 1–16.

Green, James N. "Authors and Printers at War: *Common Sense*." In *A History of the Book in America*, vol. 1, *The Colonial Book in the Atlantic World*, edited by Hugh Amory and David D. Hall, 295–96. Cambridge: American Antiquarian Society; Cambridge University Press, 2000.

Griffiths, William H. *The Story of the American Bank Note Company*. New York: American Bank Note Company, 1959.

Groce, George C., and David H. Wallace. *The New-York Historical Society's Dictionary of Artists in America, 1564–1860*. New Haven, CT: Yale University Press, 1957.

Gustafson, Milton O. "The Empty Shrine: The Transfer of the Declaration of Independence and the Constitution to the National Archives." *American Archivist* 39 (1976): 271–85.

Hamilton, Milton W. *The Country Printer, New York State, 1785–1830*. New York: Columbia University Press, 1936.

Hamilton, Sinclair. *Early American Book Illustrators and Wood Engravers, 1670–1870: A Catalogue of a Collection of American Books Illustrated for the Most Part with Woodcuts and Wood Engravings in the Princeton University Library; With an Introductory Sketch of the Development of Early American Book Illustration by Sinclair Hamilton*. Princeton, NJ: Princeton University Library, 1958.

Hart, Charles Henry. *Catalogue of the Engraved Portraits of Washington*. New York: Grolier Club, 1904.

———. *Catalogue of the Engraved Work of Asher B. Durand.* New York: Grolier Club, 1895.

Hazelton, John H. *The Declaration of Independence, Its History.* New York: Dodd, Mead, 1906.

Hendricks, Gordon. "Durand, Maverick and the *Declaration*." *American Art Journal* 3, no. 1 (1971): 58–71.

Holden, Edwin Babcock. *Catalogue of the Very Important Collection of Rare Americana and Fine Engravings Formed by the Late Edwin Babcock Holden.* New York: American Art Galleries, 1910.

Holzer, Harold. "'Columbia's Noblest Sons': Washington and Lincoln in Popular Prints." *Journal of the Abraham Lincoln Association* 15 (1994): 23–69.

Hunnisett, Basil. *Steel-Engraved Book Illustration in England.* Boston: David R. Godine, 1980.

Jaffe, Irma B. "Fordham University's Trumbull Drawings; Mistaken Identities in *The Declaration of Independence* and Other Discoveries." *American Art Journal* 3, no. 1 (1971): 5–38.

———. *John Trumbull: Patriot-Artist of the American Revolution.* Boston: New York Graphic Society, 1975.

———. "Trumbull's *The Declaration of Independence*: Keys and Dates." *American Art Journal* 3, no. 2 (1971): 41–49.

Jefferson, Thomas. *The Papers of Thomas Jefferson.* Edited by Julian P. Boyd et al. Princeton, NJ: Princeton University Press, 1950–.

———. *Thomas Jefferson Papers.* Presidential Papers Microfilm. Washington, DC: Library of Congress, 1974.

John Binns v. William Woodruff, U.S. Circuit Court for the Eastern District of Pennsylvania, Equity Records, 1819–43, box no. 14075, National Archives at Philadelphia.

Johnson, Andrew. *The Papers of Andrew Johnson.* Edited by LeRoy P. Graf et al. 16 vols. Knoxville: University of Tennessee Press, 1967–2000.

Kaller, Seth. *America's National Treasure: The Declaration of Independence and William J. Stone's Official Facsimile.* Washington, DC: Foundation for Art and Preservation in Embassies, 2014.

———. "William J. Stone, First 'Exact' Facsimile of the Declaration Working Census," last modified June 6, 2021. https://www.sethkaller.com/stone-census.

Kaminski, John P., et al., eds. *The Documentary History of the Ratification of the Constitution.* Digital ed. Charlottesville: University of Virginia Press, Rotunda, 2009. https://rotunda.upress.virginia.edu/founders/RNCN.

Keynes, Simon. "The Engraved Facsimile by John Pine (1733) of the 'Canterbury' Magna Carta (1215)." In *English Legal History and Its Sources: Essays in Honour of Sir John Baker*, edited by David Ibbetson, Neil Jones, and Nigel Ramsay, 223–44. Cambridge: Cambridge University Press, 2019.

Larson, Judy L. "Separately Published Engravings in the Early Republic: An Introduction to Copperplate Engraving and Printing in America Through 1820." *Printing History* 11 (1984): 3–24.

Lauer, Josh. "Traces of the Real: Autographomania and the Cult of the Signers in Nineteenth-Century America." *Text and Performance Quarterly* 27 (2007): 143–63.

Law, Edward J. "The Introduction of Anastatic Printing to America." *Journal of the Printing Historical Society*, new ser., 14 (2009): 41–55.

Maass, John. "The Declarations of Independence." *Magazine Antiques* 110 (July 1976): 106–10.

Madison, Dolley. *The Dolley Madison Digital Edition.* Edited by Holly C. Shulman. Charlottesville: University of Virginia Press, Rotunda, 2004. https://rotunda.upress.virginia.edu/founders/DYMN.

Maier, Pauline. *American Scripture: Making the Declaration of Independence.* New York: Alfred A. Knopf, 1997.

Marshall, John. *The Papers of John Marshall.* Edited by Herbert A. Johnson et al. 12 vols. Chapel Hill: University of North Carolina Press, 1974–2006.

Martinez, Katharine, and Page Talbott, eds. *Philadelphia's Cultural Landscape: The Sartain Family Legacy.* Philadelphia: Temple University Press, 2000.

Marzio, Peter C. *The Democratic Art, Chromolithography 1840–1900: Pictures for a*

19th-Century America. Boston: David R. Godine, in association with the Amon Carter Museum of Western Art, 1979.

Matyas, Stephen M., Jr. *Declaration of Independence: A Checklist of Books, Pamphlets, and Periodicals, Printing the U.S. Declaration of Independence, 1776–1825.* Haymarket, VA: Stephen M. Matyas Jr., 2009.

McCabe, James D. *The Illustrated History of the Centennial Exhibition.* Philadelphia: National Publishing Company, 1876.

McDonald, Robert M. S. "Thomas Jefferson's Changing Reputation as Author of the Declaration of Independence: The First Fifty Years." *Journal of the Early Republic* 19, no. 2 (1999): 169–95.

McKay, George L. *A Register of Artists, Engravers, Booksellers, Bookbinders, Printers and Publishers in New York City, 1633–1820.* New York: New York Public Library, 1942.

McKinstry, E. Richard. *Charles Magnus, Lithographer: Illustrating America's Past, 1850–1900.* New Castle, DE: Oak Knoll Press; Winterthur Museum, Garden & Library, 2013.

McKitterick, David. *Old Books, New Technologies: The Representation, Conservation and Transformation of Books Since 1700.* Cambridge: Cambridge University Press, 2013.

Mulcahy, James M. "Congress Voting Independence: The Trumbull and Pine-Savage Paintings." *Pennsylvania Magazine of History and Biography* 80 (1956): 74–91.

Nash, Ray. *American Penmanship, 1800–1850: A History of Writing and a Bibliography of Copybooks from Jenkins to Spencer.* Worcester, MA: American Antiquarian Society, 1969.

Nicholson, Catherine. "Finding the Stones: National Archives Discovers Several Engravings of the Declaration." *Prologue* 44, no. 2 (2012): 22–29.

Nugent, Walter. "The American People and the Centennial of 1876." *Indiana Magazine of History* 75 (March 1979): 53–69.

O'Brien, Donald C. *Amos Doolittle: Engraver of the New Republic.* New Castle, DE: Oak Knoll Press; American Historical Print Collectors Society, 2008.

Patterson, Richard S., and Richardson Dougall. *The Eagle and the Shield: A History of the Great Seal of the United States.* Washington, DC: Published by the Office of the Historian, Bureau of Public Affairs, Department of State, under the auspices of the American Revolution Bicentennial Administration, 1976 [*sic*; 1978].

Pohrt, Tanya. "Reception and Meaning in John Trumbull's *Declaration of Independence.*" *Yale University Art Gallery Bulletin* (2013): 117–19.

Prown, Jules David. "John Trumbull as History Painter." In *John Trumbull: The Hand and Spirit of a Painter,* edited by Helen A. Cooper, 22–41. New Haven, CT: Yale University Art Gallery, 1982.

Rapport, Leonard. "Fakes and Facsimiles: Problems of Identification." *American Archivist* 42 (1979): 13–58.

Reps, John W. *Views and Viewmakers of Urban America: Lithographs of Towns and Cities in the United States and Canada, Notes on the Artists and Publishers, and a Union Catalog of their Work, 1825–1925.* Columbia: University of Missouri Press, 1984.

Ritzenthaler, Mary Lynn, and Catherine Nicholson. "The Declaration of Independence and the Hand of Time." *Prologue Magazine* 48, no. 3 (2016). https://www.archives.gov/publications/prologue/2016/fall/declaration.

Roth, Philip. *The Facts: A Novelist's Autobiography.* New York: Penguin, 1989.

Russell, John, and Jose Guerrero. "Sourcing a Reconstruction-Era Broadside." *Papers of the Bibliographical Society of America* 115 (2021): 373–75.

Sanderson, John, et al., eds. *Biography of the Signers to the Declaration of Independence.* 9 vols. Philadelphia: Joseph M. Sanderson, Ralph W. Pomeroy, etc., 1820–27.

Savage, Robert Hull. *The Mysterye of the Lost Title: The Declaration of Independence.* New York: Printed by Cosmos Communications for Ionian Pictures, 2002.

Seager, Robert, II. *And Tyler Too: A Biography of John and Julia Gardiner Tyler.* New York: McGraw-Hill, 1963.

Sheppard, J. Havergal. "Colonel John Binns: United Irishman, Prominent Publisher and American Patriot, 29 Years in Europe; 53 Years in America." *Journal of*

the *American Irish Historical Society* 29 (1930–31): 55–66.

Silver, Rollo G. "The Convivial Printer: Dining, Wining, and Marching, 1825–1860." *Printing History* 7/8 (1982): 16–25.

Starr, Thomas. "Separated at Birth: Text and Context of the Declaration of Independence." *Proceedings of the American Antiquarian Society* 110 (2000): 153–99.

Stathis, Stephen W. "Returning the Declaration of Independence to Philadelphia: An Exercise in Centennial Politics." *Pennsylvania Magazine of History and Biography* 102 (1978): 167–83.

Stauffer, David McNeely. *American Engravers upon Copper and Steel*. 2 vols. New York: Grolier Club, 1907.

Stein, Susan R. *The Worlds of Thomas Jefferson at Monticello*. New York: Harry N. Abrams, in association with the Thomas Jefferson Memorial Foundation, 1993.

Stephens, Stephen DeWitt. *The Mavericks: American Engravers*. New Brunswick, NJ: Rutgers University Press, 1950.

Sutton, Walter. *The Western Book Trade: Cincinnati as a Nineteenth-Century Publishing and Book-Trade Center*. Columbus: Ohio State University Press for the Ohio Historical Society, 1961.

Tatham, David. "John Henry Bufford, American Lithographer." *Proceedings of the American Antiquarian Society* 86 (April 1976): 47–73.

Trumbull, John. *The Autobiography of Colonel John Trumbull, Patriot-Artist, 1756–1843*. Edited by Theodore Sizer. New Haven, CT: Yale University Press; London: Oxford University Press, 1953.

———. *Autobiography, Reminiscences and Letters of John Trumbull, from 1756 to 1841*. New York: Wiley and Putnam; New Haven, CT: B. L. Hamlen, 1841.

———. *Description of the Four Pictures, from Subjects of the Revolution, Painted by Order of the Government of the United States, and Now Placed in the Rotunda of the Capitol*. New York: Printed by William A. Mercein, 1827.

———. *Letters Proposing a Plan for the Permanent Encouragement of the Fine Arts, by the National Government, Addressed to the President of the United States*. New York: Printed by William Davis Jr., 1827.

Tyler, Benjamin Owen. *A Circular Addressed to the Governor & Council and Members of the Legislature of Vermont, Montpelier, Nov. 1833*. Montpelier, VT: Knapp & Jewett, printers, 1833.

———. *Declaration of Independence: A Candid Statement of Facts, in Answer to an Unwarrantable Denunciation of My Publication of the Declaration of American Independence, Made by Mr. John Binns, Editor of the Democratic Press, in His Paper of the 9th and 18th of April, 1818*. Washington, DC: [Benjamin Owen Tyler], 1818.

Walsh, Michael J. "Contemporary Broadside Editions of the Declaration of Independence." *Harvard Library Bulletin* 3 (1949): 31–43.

Whitmore, William Henry. "Abel Bowen." *Bostonian Society Publications* 1 (1886–88): 27–56.

Wilentz, Sean. *Chants Democratic: New York City and the Rise of the American Working Class, 1788–1850*. New York: Oxford University Press, 1984.

Wills, Garry. *Inventing America: Jefferson's Declaration of Independence*. New York: Vintage Books, 2018.

Wilson, David A. *United Irishmen, United States: Immigrant Radicals in the Early Republic*. Ithaca, NY: Cornell University Press, 1998.

INDEX

PREVIOUSLY PUBLISHED TITLES IN THE PENN STATE SERIES IN THE HISTORY OF THE BOOK

Peter Burke, *The Fortunes of the "Courtier": The European Reception of Castiglione's "Cortegiano"* (1996)

Roger Burlingame, *Of Making Many Books: A Hundred Years of Reading, Writing, and Publishing* (1996)

James M. Hutchisson, *The Rise of Sinclair Lewis, 1920–1930* (1996)

Julie Bates Dock, ed., *Charlotte Perkins Gilman's "The Yellow Wall-paper" and the History of Its Publication and Reception: A Critical Edition and Documentary Casebook* (1998)

John Williams, ed., *Imaging the Early Medieval Bible* (1998)

Ezra Greenspan, *George Palmer Putnam: Representative American Publisher* (2000)

James G. Nelson, *Publisher to the Decadents: Leonard Smithers in the Careers of Beardsley, Wilde, Dowson* (2000)

Pamela E. Selwyn, *Everyday Life in the German Book Trade: Friedrich Nicolai as Bookseller and Publisher in the Age of Enlightenment* (2000)

David R. Johnson, *Conrad Richter: A Writer's Life* (2001)

David Finkelstein, *The House of Blackwood: Author-Publisher Relations in the Victorian Era* (2002)

Rodger L. Tarr, ed., *As Ever Yours: The Letters of Max Perkins and Elizabeth Lemmon* (2003)

Randy Robertson, *Censorship and Conflict in Seventeenth-Century England: The Subtle Art of Division* (2009)

Catherine M. Parisian, ed., *The First White House Library: A History and Annotated Catalogue* (2010)

Jane McLeod, *Licensing Loyalty: Printers, Patrons, and the State in Early Modern France* (2011)

Charles Walton, ed., *Into Print: Limits and Legacies of the Enlightenment; Essays in Honor of Robert Darnton* (2011)

James L. W. West III, *Making the Archives Talk: New and Selected Essays in Bibliography, Editing, and Book History* (2012)

John Hruschka, *How Books Came to America: The Rise of the American Book Trade* (2012)

A. Franklin Parks, *William Parks: The Colonial Printer in the Transatlantic World of the Eighteenth Century* (2012)

Roger E. Stoddard, comp., and David R. Whitesell, ed., *A Bibliographic Description of Books and Pamphlets of American Verse Printed from 1610 Through 1820* (2012)

Nancy Cervetti, *S. Weir Mitchell: Philadelphia's Literary Physician* (2012)

Karen Nipps, *Lydia Bailey: A Checklist of Her Imprints* (2013)

Paul Eggert, *Biography of a Book: Henry Lawson's "While the Billy Boils"* (2013)

Allan Westphall, *Books and Religious Devotion: The Redemptive Reading of an Irishman in Nineteenth-Century New England* (2014)

Scott Donaldson, *The Impossible Craft: Literary Biography* (2015)

John Bidwell, *Graphic Passion: Matisse and the Book Arts* (2015)

Peter L. Shillingsburg, *Textuality and Knowledge: Essays* (2017)

Steven Carl Smith, *An Empire of Print: The New York Publishing Trade in the Early American Republic* (2017)

Colm Tóibín, Marc Simpson, and Declan Kiely, *Henry James and American Painting* (2017)

Filipe Carreira da Silva and Mónica Brito Vieira, *The Politics of the Book: A Study on the Materiality of Ideas* (2019)

Colm Tóibín, *One Hundred Years of James Joyce's "Ulysses"* (2022)

Melvyn New and Anthony W. Lee, eds., *Notes on Footnotes: Annotating Eighteenth-Century Literature* (2022)

Jeffrey M. Makala, *Publishing Plates: Stereotyping and Electrotyping in Nineteenth-Century US Print Culture* (2022)

Samuel V. Lemley, ed., *The Four Shakespeare Folios, 1623–2023: Copy, Print, Paper, Type*